Moose Peterson's Guide to Wildlife Photography
Conventional & Digital Techniques

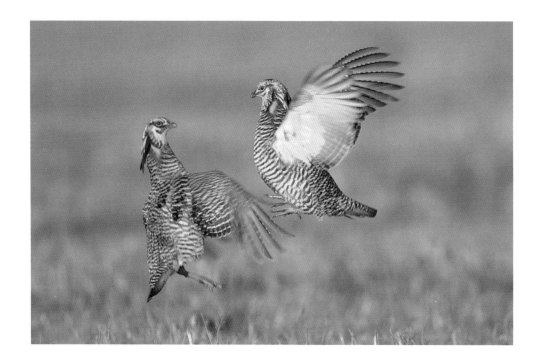

Dedication

From the very beginning, she's been my extra set of eyes but as time has passed on, she's become the extra heart and soul that inspires me. My wife Sharon, along with our boys Brent and Jake, are the inspiration that supports my crazed obsession to photograph the world around us. It's to their love that I dedicate this work.

B. Moose Peterson

Moose Peterson's Guide to Wildlife Photography
Conventional & Digital Techniques

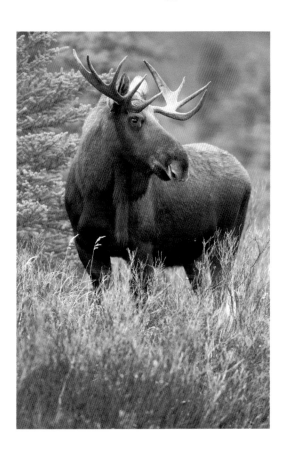

LARK BOOKS

A Division of Sterling Publishing Co., Inc.
New York

Cover Design: Barbara Zaretsky
Cover Photographs: © B. Moose Peterson / WRP
Book Design and Layout: Michael T. Robertson
Photographs: © B. Moose Peterson / WRP

Library of Congress Cataloging-in-Publication Data

Peterson, B. (Bruce), 1959-.
 Moose Peterson's guide to wildlife photography : conventional &
digital techniques / B. Moose Peterson.-- 2nd ed.
 p. cm.
 Rev. ed. of: Nikon guide to wildlife photography. Rochester, NY : Silver
Pixel Press, 1993.
 Includes index.
 ISBN 1-57990-482-3
 1. Wildlife photography. I. Title: Guide to wildlife photography. II.
Peterson, B. (Bruce), 1959-. Nikon guide to wildlife photography. III.
Title.
 TR729.W54P4822 2003
 778.9'32--dc21

 2003004387

10 9 8 7 6 5 4 3 2 1

Published by Lark Books, a division of
Sterling Publishing Co., Inc.
387 Park Avenue South, New York, NY 10016

© 2003, B. Moose Peterson / WRP

Distributed in Canada by Sterling Publishing,
c/o Canadian Manda Group, 165 Dufferin Street
Toronto, Ontario, Canada M6K 3H6

Distributed in the U.K. by Guild of Master Craftsman Publications Ltd., Castle Place, 166 High
Street, Lewes, East Sussex, England
BN7 1XU
Tel: (+ 44) 1273 477374, Fax: (+ 44) 1273 478606,
Email: pubs@thegmcgroup.com, Web: www.gmcpublications.com

Distributed in Australia by Capricorn Link (Australia) Pty Ltd.,
P.O. Box 704, Windsor, NSW 2756 Australia

The written instructions, photographs, designs, patterns, and projects in this volume are intended
for the personal use of the reader and may be reproduced for that purpose only. Any other use, espe-
cially commercial use, is forbidden under law without written permission of the publisher. All prod-
uct names are registered trademarks of their respective manufacturers.

Every effort has been made to ensure that all the information in this book is accurate. However, due
to differing conditions, equipment, and individual skills, the publisher cannot be responsible for any
injuries, losses, and other damages that may result from the use of the information in this book.

If you have questions or comments about this book, please contact:
Lark Books
67 Broadway
Asheville, NC 28801
(828) 253-0467

Manufactured in China

ISBN 1-57990-482-3

Contents

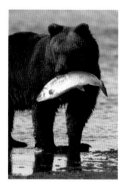

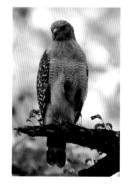

Contents

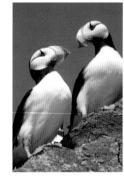

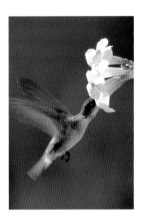

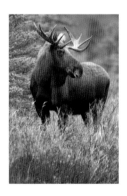

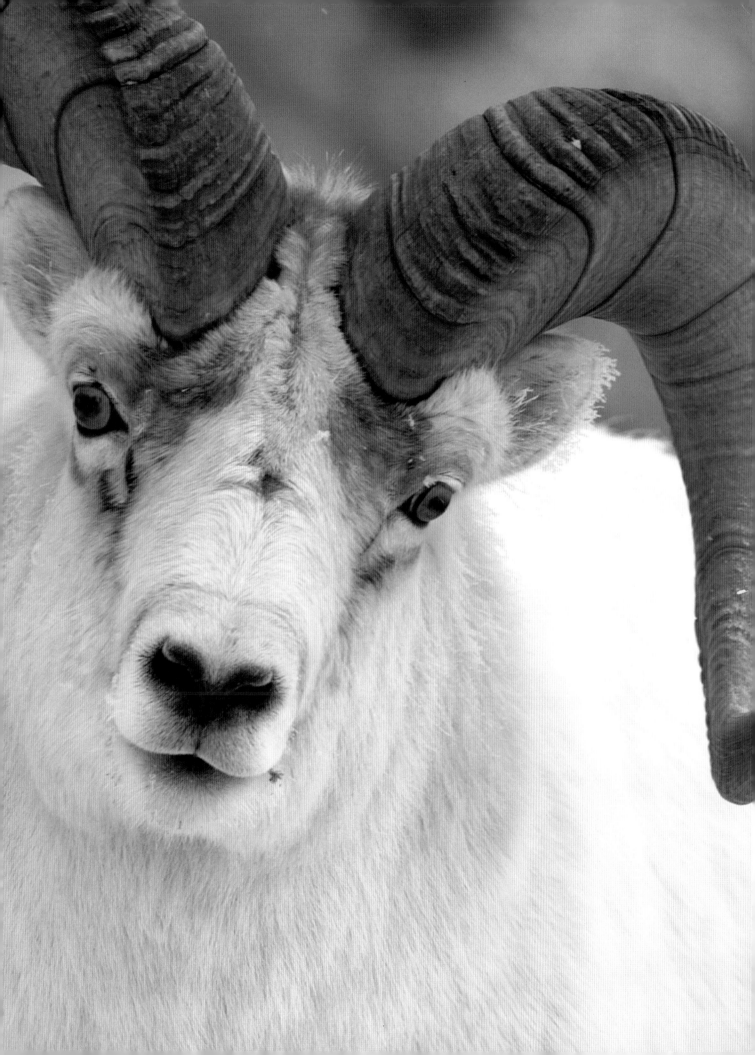

Introduction

I've busted my hump for the third day, climbing a mountainside in the Yukon Territory of Alaska in late November. With winter well on its way, daylight spans only five hours and the temperature hovers around minus 10 degrees. The slope is partially loose shale covered in hoarfrost. The rest of the slope is covered with snow so deep that I'm up to my waist with each step. I climb 1,100 vertical feet in a little over a mile in big, clunky, warm winter boots. Resting on my shoulder is my tripod mounted with a 400mm f/2.8 AF-S with a D1H attached, ready to be swung down and used in a heartbeat. In my backpack are a couple of extra lenses and emergency gear, in case I get caught up on the mountain in severe weather. What brings me to such a beautifully austere environment in the dead of winter? A passion for seeing the magical world of our wild heritage, and wildlife photography, of course!

I was up on that slope, with all the tools and techniques that twenty years of experience had taught me, to photograph the Dall sheep. It was an experience of a lifetime for me, and one I will never forget! How did I do? I came back with some great images, but I also missed some great ones (as you'll find out later). I was able to use much of what I learned from the past, while at the same time I learned some new things. It's that same learning experience that makes me want to get out every day with a camera! Yeah, I like capturing the great image. But the knowledge that I'm going to learn something new about myself, or about things biological or photographic, gets me out every possible moment I can. It's that excitement about wildlife photography and its rewards that I want to impart to you!

What this book contains is just a beginning, a sound starting point but not every answer. (I ran out of pages.) I have a lot of answers to questions about photographing wildlife to share with you, which come from shooting for a long time. I've been at this wildlife photography thing for twenty years now. To celebrate my first decade of shooting, we came out with the *Nikon Guide to Wildlife Photography*, so it only seemed appropriate to celebrate our second decade with *Moose Peterson's Guide to Wildlife Photography*. While this is really the second edition, we changed the title so there would be no confusion that this book is for every wildlife photographer regardless of his equipment!

These pages contain the knowledge I have accumulated over the last twenty years. I've tried to share just as much as I can cram into these pages, including a whole lot of photographs. (There are no repeats from the first book.) It is important that you understand that what you see is what I captured. There are no cropped images or Photoshop corrections. I strove to get the image right, right from the start. This means you can see what I saw with my heart and captured for you to enjoy.

I have also not included any product shots this time around. Why? One reason is space. I wanted to use all the space I could for images that will help you learn. The vast majority of you know what a 600mm f/4 Nikon or Canon lens looks like. If you don't, you can easily look on the Web to see them. So, by not including product shots, I can expand on other, more important topics.

The majority of my work still centers around California's threatened and endangered wildlife. My projects are all long-term, the longest being my work with the giant kangaroo rat. I began that in 1987! I travel mostly around the western United States and Alaska. Alaska is an incredible land with more wonders than a thousand lifetimes can take in. I travel to all of these places to work on projects where my images can help make a difference in a species' preservation. This is the key reason why Sharon and I have dedicated ourselves to sharing all we have learned. We're depending on you to take up the challenge to capture the world you explore with your camera and share it with us. While seemingly a simple task, your actions can change the world! We've seen it happen over and over again and we hope that, in the future, your images will share parts of the world with us that we haven't witnessed ourselves.

It's from the images themselves that we all can learn the most! Whether they're mine or someone else's, look at the photographs you admire and figure out what it is about them that you like. Figure out what tools, techniques, or approaches make the image special. By doing this over and over again, I guarantee, when you look through your viewfinder, you'll know what to use when. I know of no greater satisfaction than creating the great image when all the elements, light, subject, tools, and passion come together. I hope I bring you a little closer to that same satisfaction in your own photography with this book

Photo, page 7
Dall Sheep.
Photo captured by D1H,
400mm f/2.8D ED-IF AF-S,
on Lexar digital film.

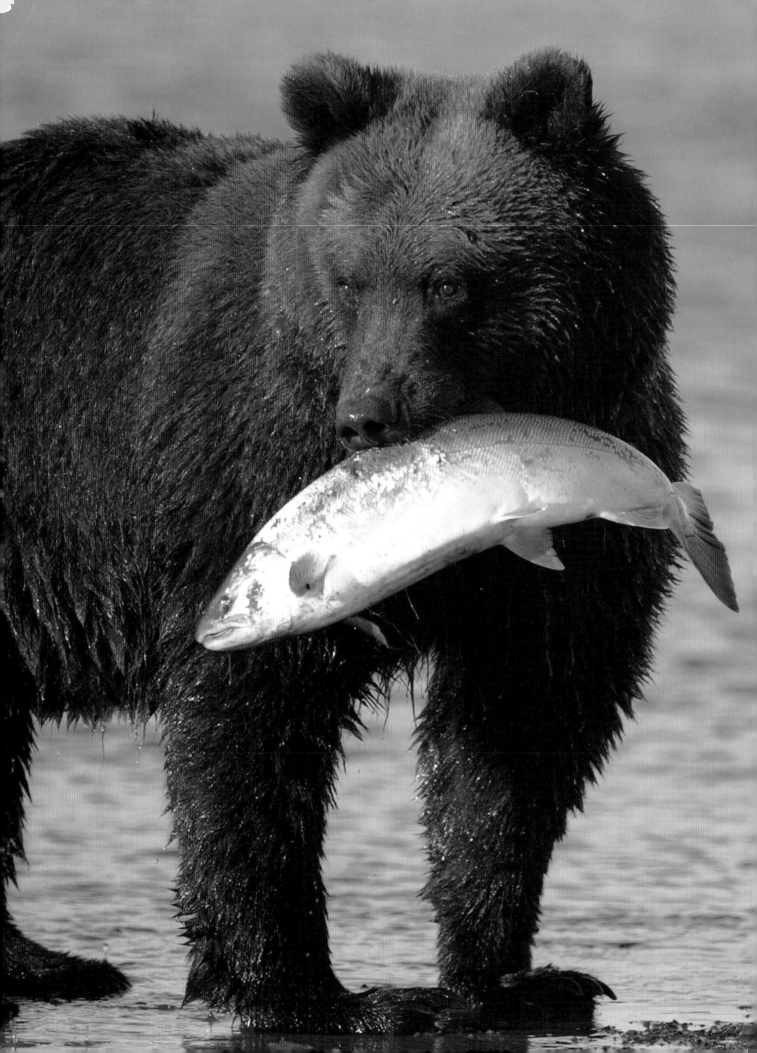

Chapter I

Selecting and Using the Right Tools

We wildlife photographers sure do love our camera gear. (We also love the great outdoors!)

I was in Alaska for the first time to photograph coastal grizzly bears (not a biological description, strictly a personal one). The sun was setting, lighting up Mount Iliamna's plume of steam. It cast a golden glow over the creek where I was standing with a good friend fly-fishing. Our lenses were on top of tripods that were in the water—just far enough behind us so our back casts wouldn't snag them by accident. I was there to photograph the bears, but at that moment in time, life couldn't have been any better even though I wasn't behind the lens. Then we heard the splash.

It came from far up the creek and at first we assumed it was just salmon fighting. Then we saw a moving brown mass. It was hundreds of yards away and it was moving fast. Running down the creek was a massive male grizzly bear, as dark as sin, with a very determined look on its face. It was making a beeline right at us and seemed to straighten out the creek as it came running toward us. When it was on the right bank, less than a hundred yards away, we reeled in our lines and moved over to our cameras.

By the time the griz was about 50 yards away, I had ripped off my first roll of film and was loading the second. At this point, with the griz bearing down on us, I asked my good friend if we should be moving. But because we were in the middle of the creek with the griz still running full bore, there really wasn't any place for us to go. So I did what comes naturally: I fired the camera. The body attitude of the griz was totally non-threatening, but it was running right toward us. Just about when this thought entered my mind, I realized I could no longer focus on the bear with my 400mm f/2.8—it was too close! I looked up in time to see this 900-pound bear running right past us!

He kept running until he reached the mouth of the creek, where he picked up a fish carcass. This scene of a bear running from a great distance once it picked up the scent of a dead salmon would play out many times in the Alaskan summers to come, but none so engraved itself in my soul as this first time. I was standing there with just the one lens and body and I got what was to become one of my favorite images—one that I share only with my family. That's what wildlife photography is all about!

There seems to be an unspoken myth that the more gear we have in our bag, the better the odds of capturing the image. Quantity and quality of gear have been mistakenly associated with quantity and quality of images. This, despite all the published lists of pros' camera bag contents showing that they carry a minimal amount of gear. Why is that? What do pros know about gear that you don't? There are two determining factors that they think about when it comes to camera gear that you might not have reflected on.

**Coastal Grizzly Bear.
Photo captured by D1H,
400mm f/2.8D ED-IF AF-S,
on Lexar digital film.**

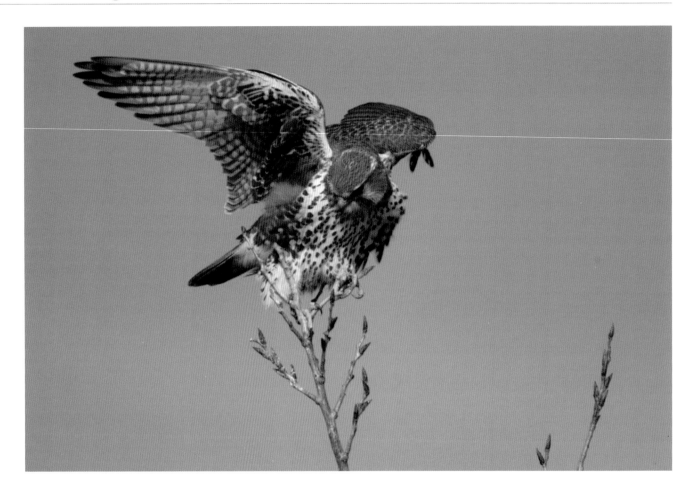

**Prairie Falcon.
Photo captured by D1H,
600mm f/4D ED-IF AF-S
with TC-20E, on Lexar digital film.**

The Lens

Vision and Money

The biggest factor is vision! Most of the great photographers when they see the subject know before they even put the camera to their eye what they want to do photographically. The subject has been mentally composed, all the elements placed within the frame, exposure calculated, and end use pondered prior to the lens ever being focused. Before even this, a pro's lens selection is influenced by his experience and the way he prefers to communicate in a visual world.

The other big factor is money. The working photographer has a minimal bag of gear for simple business reasons. Capital tied up in gear that is not producing is capital taken away from photographic projects. Those in the business look at equipment acquisition either in terms of buying or renting. Which costs less (or makes more money) in the long run? There are always those pieces of gear we'd love to own for this or that reason, but if a pro is in business, the gear that makes money is the gear most often found in his camera bag.

Where does this leave you, the newcomer? You might still be at the point where you are just happy to get an image in focus, let alone worry about your next camera gear purchase. You could be at the point where you have a couple of lenses and one body and want to move up to the next piece of gear to add to your arsenal. You could be contemplating your first big piece of glass, an anxious time for most. I suggest you look at camera gear with one goal in mind. Select gear with the thought that each piece must multitask, solving more than

one photographic problem. These are the tools that make us the most effective communicators. This plan of course saves you money since you're buying less gear but it does more. Most important is the perfect marriage of the camera gear and the person behind it. You cannot ever forget: It's the person behind the camera that counts.

I usually finish with this line, but I'm going to start this book with it because it is so important. This is because there is no right or wrong answer when it comes to camera gear. Whether you're a Nikon or Canon shooter, conventional or digital, shooting stills or film, you've got to find the gear that solves the problems you face so you can communicate what you see to others!

When I say "see," I'm not referring to just the visual world either. Clean, good photographs may have all the basic elements you read about each month in the magazines. But great photographs also have emotion, and this is not captured with the eyes but with the heart. While we're reduced to talking about focal lengths and apertures when we talk about lenses and frames per second (fps) and features for bodies, the right gear for you permits you to capture the emotions you wish to express in your images. The most important element in a photograph is passion, which comes from within and not a store shelf!

Brands / Manufacturers

Brand loyalty is really strong in photographers. A lot of wasted time and energy is put into the debate about which is the best, Nikon or Canon or the like. Yeah, I shoot with Nikon and it's the brand I write about. For me personally, Nikon makes the tools that are the best marriage with the way I want to solve problems to communicate what I see (but if you think about it, I would have to know about Canon to know Nikon is the best for me). My best friend, whom I shoot with in Alaska, is a Canon shooter

because it offers for him the same thing Nikon offers me. While we can't share lenses and accessories, we can share everything else, which includes making great images.

My very first telephoto lens was a 1976 Vivitar 400mm f/5.6 for my Minolta SRT 202. The lens was pretty sharp but it lasted for perhaps a year. One day when I took the lens out of the camera bag, I looked down to see the front element resting on the bottom of the bag. Up until that point, the lens had performed and captured sharp images. There are many after-market lens manufacturers today producing vastly superior optics in incredible lens designs built much better than my old Vivitar. I have no doubt that you could take a brand new 300mm f/2.8 Nikon, Canon, Tamron, or Tokina out of the box and find they all deliver the same optical results even though there is a giant difference in price.

One of the determining factors in lens selection for me is not the manufacturer as much as the ability of the lens to integrate with the way I operate. A great example of what I'm talking about is the one common thread in all of my Nikkor lenses. They are all AF-S (highly specialized zooms incorporating Nikon's Silent Wave motor technology). AF-S is important to me and my photography not because of the faster focusing or quieter motor but because of the M/A (Manual/Autofocus) feature that is only available from Nikon on Nikkor AF-S lenses. The M/A feature permits you to autofocus and manual focus at the same time. When you need to manual focus because the composition places the subject outside one of the five AF sensors, you don't have to turn off the AF! You simply shoot like normal in AF mode and when you want to manual focus, you just manually focus. To go back to AF, simply take your finger off the shutter release then depress it again. This is a feature only found in Nikon lenses, and for me and for my style of photography, it's very important!

Selecting and Using the Right Tools

**Willow Ptarmigan.
Photo captured by F5,
Tokina 300mm f/2.8,
on Agfa RSX 100.**

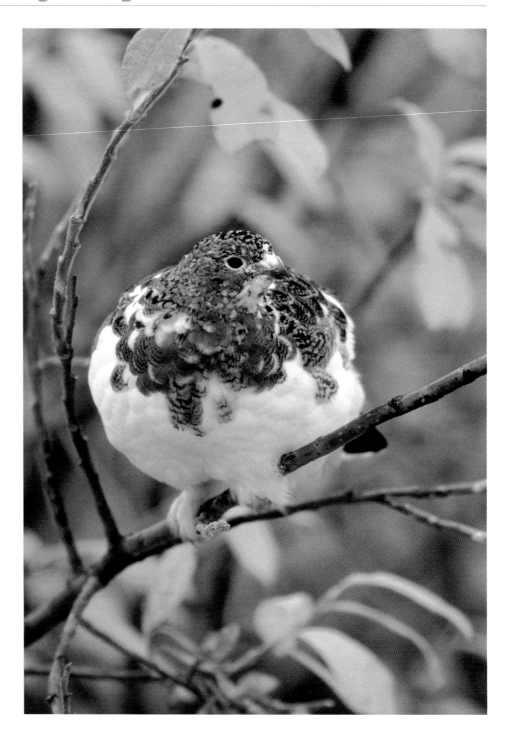

Did you know you can kind of get this same AF/manual operation in some Tokina lenses? Are you like my good friend Artie Morris, who loves to stack multiple teleconverters on his 600mm f/4? If you are, then the IS (Image Stabilizer) feature of Canon lenses might be really important to you, because when you're at 2400mm, you'd better not move! I could go on and on about how each manufacturer offers this or that special feature and how it could be important to your photography. My point is that camera gear are tools to unlock your imagination. Don't get caught up in the brand game. Think through your style of shooting and find the manufacturer that offers you the means to work efficiently in the field. When you do this, you will find the best equipment for you.

It Determines Your Style

In subtle but important ways, camera gear, especially the lenses, determines your style of photography. And in turn, this determines your style of communicating! Many will ask, "Is style really that important, especially if I'm still just trying to get the photograph in focus?"

We could line up fifty photographers, provide them all with the exact same camera, lens, and subject, and you know what? They would come up with fifty different images! Yeah, many would be very similar but there would be enough of a difference for you to tell them apart. We all see and want to communicate things differently. This is why I don't hesitate to provide the info I've learned over the decades! That's the grand thing about photography; we can all share in it while being different. And a great part of that difference, which I call style, is determined by the gear you use to capture your passion.

When I was explaining this once to a safari participant, he asked if I had a formula to figure this all out. (He was an engineer in his day job.) Style is something that doesn't fit into a formula. While the basics of photography, such as f/stops and shutter speeds, are carved in stone, most of the elements of great photography come from processes barely describable in words, let alone in a formula. Most elements that make up style are so minute that when I attempt to describe them, folks think I'm making them up. What I'm trying to describe here might be better understood with an example.

I'm not an "eyeball" photographer who shoots tight close-ups. My style is distinctive in that I incorporate the subject's world along with the subject in the photograph. I might use a 600mm lens with a 1.4x teleconverter to accomplish this and the subject might still be small in the frame, but you do see the world in which it lives. I use the long lens, as you will discover, not to get an "eyeball" but to isolate the subject while telling the story.

Now the photographers standing next to me might have the exact same lens setup as I, but their styles are different. Where I stand back to get the whole world, they might move in closer to get the eyeball. Even though we have the same lens, our styles of communicating with it are different. But in either case, the final image is dictated by the lens in use.

Does this hold true for camera bodies as well? In a sense it does, because each camera body offers different features, permitting us to work differently with a subject. Motorized film advance, measured in frames per second (fps), can greatly influence your style of photography, especially if you're after great action shots.

The moral here, if there is one, is to keep in mind that the camera gear you use can greatly influence your success in communicating. Selecting the 400mm lens for a portrait or scenic might be a better option than the typical 105mm for a portrait or 14mm for a landscape. Photographing the bird at the nest might be more dramatic with the 14mm than the 400mm!

You might have e-mailed me at one time or another, asking which lens you should buy. You more than likely received a response from me saying something like, "I don't advise photographers what lens to buy because I don't know them, their abilities, or their styles." This is a very sincere sentiment. As you'll discover throughout this entire book, I will take the entire 40,000 words allotted me here just to communicate to you how I use the gear I have to communicate visually—this, after twenty-plus years refining how I communicate. Don't expect the answers to come quickly for you, for your style to one day just stand up and smack you in the face. That is part of the fun of the journey into wildlife photography. Don't rush it, enjoy it!

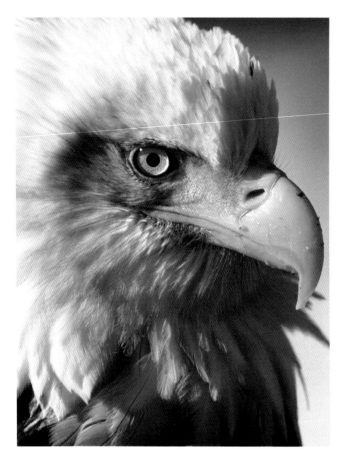

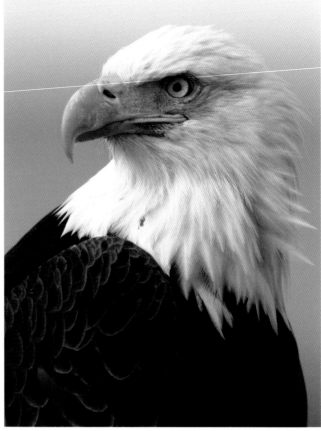

Left:
**Bald Eagle.
Photo captured by F5,
400mm f/2.8D ED-IF AF-S,
on Agfa RSX 100.**

Center:
**Bald Eagle.
Photo captured by D1,
400mm f/2.8D ED-IF AF-S,
on Lexar digital film.**

Far right:
**Bald Eagle.
Photo captured by F5,
400mm f/2.8D ED-IF AF-S,
on Agfa RSX 100.**

Rent First!

Have you noticed that this wildlife pho-tography thing can get really expensive? Of course you have and, sadly, the price has probably put the brakes to some of your ideas at one time or another. I sure know it has for me on more than one occasion. This feeling of greatest frustra-tion probably comes most often with new lens acquisition. Not only do you have to decide which focal length and f/stop to buy, but you have to base this on price point. That stinks!

Every photographer including myself has at one point or another bought a lens that, not too long after the purchase, he regretted buying. For one reason or another the lens just doesn't fit in with your camera bag or ideas. You're stuck with an expensive purchase, which shades every purchase you make from that time forward. When it comes to buying the "big lenses," those with the big, four-figure price tag, fear is a real typical word photographers use when

they start considering which one to buy. To avoid this, I highly recommend you rent first!

No matter where you are in the country, there are stores that rent camera gear. Be it camera bodies, lenses, lights, meters, you can rent them and try before you buy. Yes, you will pay for the rental but, if you decide to buy, most stores deduct the rental fee from the purchase price. The worst-case scenario is you don't like what you've rented, but all you lose is the rental fee. That's a lot better than buying a lens or camera body and then finding out you don't like it!

I highly recommend you rent the gear when you know you're going to be shooting hot and heavy! You want to give it a really hard workout. You want to make sure that it fills the hole you're try-ing to fill and that it fits within your sys-tem as you had envisioned. You want to

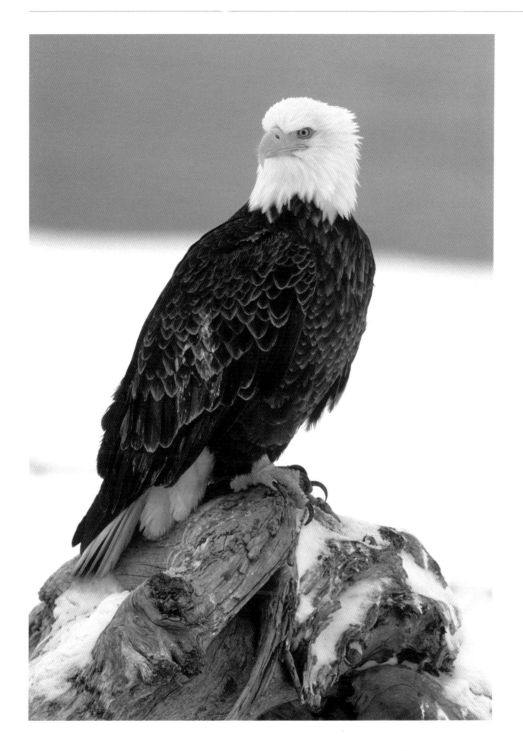

make sure that it captures the images as you envisioned it would! This all can happen only if you're shooting lots of images and creatively being challenged. If you're going to rent, make it count!

One of the fringe benefits of going on a workshop is the large array of camera gear that is present. It is very common for a fellow participant to have a lens

you've always wanted to try or buy. You might ask if you can try out the lens. I've never seen a person with such a request be turned down, and quite often the owner of the lens is more than willing to give you their two cents' worth on the lens. This is a great help! But when you have that lens, either one you borrowed or rented, give the lens a true test.

**Greater Sandhill Crane.
Photo captured by D1H,
600mm f/4D ED-IF AF-S
with TC-14E, on Lexar digital film.**

No matter the focal length, check to see how close it focuses and take a photo at that distance. Next, focus on a subject at infinity and take another photo. Then, find a distance in between and take one more photo. And if you want to give the lens a "Moose review," take these shots using all available apertures to see what the depth of field (DOF) options are with the lens. Trying before you buy not only saves you money and permits you to buy the right gear, but also removes a lot of the frustration associated with new gear acquisition. You owe it to yourself and your photography!

Which Lens Is Really the Right One?

When I was really young, ten at most, I peered through my first telephoto lens.

I'll never forget the evening my cousin came to the house with his Nikon F. (I didn't know it was a Nikon F back then.) He attached it to a 200mm f/4 chrome barrel (brand new) and told me to look at the Union 76 gas station ball that was lit up across the valley. Wow, it was really something to see that orange ball filling up the frame. It made an everlasting impression on me. My love of lenses started that moment many years ago and has never faded!

Nowadays, when I post an announcement or review of any new lens on our website (and I'm not making this up), my mailbox is instantly filled with a minimum of 100 e-mails asking, "Is this the right lens for me?" I counted once, finding I'd received this question over 450 times in a one-month period! The answer I provide 99.9 percent of the time to folks who ask this question is simple: "I can't help you, as I don't know you, your style, or abilities."

Understandably, this answer is of no real help. It is the most honest answer that I can provide and the most help I can be. It's my intention that by the time you finish reading this piece, this answer might make more sense to you. I also plan to provide you with the information you need to answer this question for yourself. I recognize I've had over 30 years of experience looking through lenses that helps me to know which lens is right for me. This is probably not the case for you and, with the dollars we're talking about for lenses, it's important to get the right lens to start with!

I'm going to put in writing how I select the lenses I use in the hope it might provide you with insight into your own lens selections. This is by no means a review of any one particular lens or manufacturer or a stamp of approval that these are the only lenses worth buying! Take this information and put it through your brainpan, work through the problems you face photographically, and see if any of my reasoning or answers I've found for myself also answers your lens questions.

What Makes the Right Lens?

A very wise teacher/photographer once told me, "The right lens is the one that captures what it is you want to communicate." It's very tempting to leave just this one sentence in place of this whole section but I doubt that would help folks. But this is the simple truth in selecting the right lens, one I've tried to hold to (but being human, I have bought lenses I want rather than need).

There are so many options, descriptions, definitions, and manufacturers of lens designs these days: Nikon, Canon, Tokina, Sigma, AF-S, IS, VR, ED, APO, Aspherical, IF, USM, CRC, EF, Macro, Tele . . . HELP!

It's my personal opinion you can buy any manufacturer's lens brand-new and they will all deliver great results, no matter the price you paid. Computer design has brought optics a long way—and with all the lenses I've shot with, I'm more than confident of this. The real question for me is, though: Does the lens still deliver the same factory-new performance and sharpness after a year of continual use? I'm talking about a year of being carried around and used, flown in planes and bounced around in the back of a vehicle, a year's use and not just used on the weekends every now and then! This is the test where I think many lenses may fall woefully short. When I get a lens to "test," I normally have it for only two weeks to a month. I wish I had an "aging" method to accelerate a lens to that one-year point to see if it maintains the same new standard, but that's not the case.

That brings us back to what makes the right lens? Thankfully, my oldest brother taught me from the start of my photography hobby that you get what you pay for and when it comes to cameras and lenses, buy the best to start with. I have always followed this advice in my lens purchases and it has never let me down. Yes, the initial shock of laying down thousands of dollars for a lens can lead to a code blue. But in the long run it

makes you money. Higher-priced lenses have a higher resale value when it's time to move on. Higher-priced lenses have the features you want (big factor in lens selection) and the features you need but might be ignoring. Higher-priced lenses, most importantly, have the long-term quality you must have to succeed!

There are many aftermarket big zooms on the market right now that are very, very popular for good reason. For a relatively low price, you can get a zoom that goes, say, from 50 to 500 mm, providing the photographer with incredible range and flexibility in one lens. The quality of the images these lenses deliver new from the box is gorgeous. But I bet within a year's use (continuous use, not once or twice a month in the backyard) they won't zoom as smoothly or be as sharp. If you look at the track record of some of the previous "tele-zooms" which were touted as the greatest thing ever when they were first introduced, you'll find them now lining the back shelves of used equipment in most camera stores.

The bottom line, and it's a crass one, is that the right lens usually starts out as the most expensive. (Exceptions exist, but they're few and far between!)

What Does Moose Look for in a Lens?
Simple, one that does several jobs and does them all extremely well! Please note that lens sharpness is not part of what I focus on (bad pun, had to do it). Many are going to argue with me about this, but lens sharpness is not a criterion I use to decide if a lens belongs in my camera bag. I've been shooting wildlife "professionally" going on twenty years now (other subjects before wildlife, so it's actually longer). I've had my work in print for more than twenty years, working both ends of the business behind the camera and behind the press, and in all of that time I've come to learn that lens sharpness itself does not make or break an image (blasphemy, I know). As I was taught and as I've repeated for over

twenty years, it's the person behind the camera that counts.

I work on the KISS theorem: Keep It Simple, Stupid! With all that goes on in my life and business, this is important and directly influences the lenses I own. I carry in my DigitalPro MP1 bag the following Nikkor lenses: 600mm f/4 AF-S or 400mm f/2.8 AF-S, 80-400mm VR, 70-200mm VR, 24-85mm G AF-S, 17-35mm f/2.8 AF-S, 14mm f/2.8 AF, and the TC-20E and TC-14E and that's all. In addition, I own the 300mm f/2.8 AF-S II and 300mm f/4 AF-S, but they are for special projects/purposes. I bet these are a lot fewer lenses than many of you own! Each and every one of these lenses serves different functions in my quest to be a successful communicator. Each and every lens must be flexible enough to solve multiple problems. Having the right war chest means selecting the right lens to use—one that is simple, fast, and predictable in the results it delivers. This speeds me up, which means I can work faster, allowing me to capture the image.

This also means I know what each lens in my arsenal can and, more importantly, can't do. For example, the 80-400mm VR lens provides great flexibility in focal length range and after nearly a year of pounding, it keeps on delivering sharp images. But it is not a fast-focusing lens, especially compared to an AF-S lens; since I recognize this, I know what I can and cannot do with it. The 600mm f/4 AF-S is no small puppy, but it's deadly sharp and lightning-fast. If my subject is at the top of a mountain, do I carry the smaller but slower 80-400mm VR or faster and bigger 600mm f/4? You do the math. It's a no-brainer: the 80-400mm, because on the D1 it's a 120-600mm lens. If I'm working on a tripod and not climbing mountains, the 600mm f/4 AF-S is my preferred choice.

Autofocus has become a mainstay in my lens selection. Keeping my mind on the subject is essential to the way I shoot. Autofocus helps me by taking care of

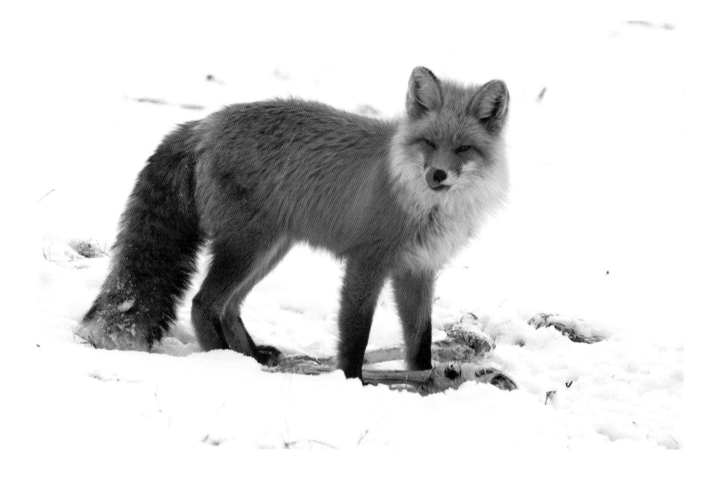

Moose's Camera Bag

the focusing chore nearly as fast as I can think about it so I don't have to think about it, which allows me to concentrate on just the subject. To this end then, AF-S makes a huge difference in my lens choice. While some lenses I shoot with have AF-S, it doesn't really make a difference in focusing speed, but with the big lenses it does. I couldn't imagine going back to my old 800 mm f/5.6 manual lens after shooting all these years with the 600mm f/4 AFI and then AF-S!

This brings up the 80-400mm VR and whether it should be AF-S, as so many have e-mailed and asked. To be frank, my thoughts on the topic don't matter because it's not AF-S; it is what it is. Would this be a great feature to incorporate into the lens? It depends on what it costs, both in lens design, weight, and the final price tag. For my photography needs, I don't need an AF-S 80-400mm.

Where do you start? These words of wisdom don't offer one word of advice when it comes to the first lens or camera body you should buy, nor the second, third, or so on. The building of your bag of confidence, which is how I refer to my camera bag, is a personal thing. I think, though, I can give you some direction, ideas at least, by explaining what's in my camera bag and why.

In the old days when you bought a camera body, it came with a 50mm lens. There were no other options. The 50mm was the standard packaged lens because it was considered "normal" in that it was thought to replicate what the human eye sees (which is not true). But this standardized lens gave folks a basic starting point, which helped them decide what should be their next lens. For example, if you find yourself photographing lots of portraits, then you

Arctic Red Fox.
Photo captured by D1H,
400mm f/2.8D ED-IF AF-S,
on Lexar digital film.

FIELD TIP

When I go out shooting, all my gear goes with me in my MP1 backpack. Once I'm on site, I take out of the backpack (which I typically leave in the truck) only that gear which I think I will need right then. For example, if I'm off to photograph moose (my favorite subject), I'll normally grab my 400mm f/2.8 AF-S and mount it on the tripod. I then will have a second lens, such as the 24-85G on a second body hanging from my shoulder and a third lens, such as the 14mm in my DigitalPro MP3 fanny pack. While I have all my gear "with me" in a sense, I only have a couple of pieces in the field at any given moment. I very, very, very rarely put the backpack on my back and head out into the field with every piece of gear.

might have gone for an 85 or 105mm lens. What if you find yourself always backing up to get everything into the photo? Then a wide-angle might be the way to go. And if you're after wildlife, 400mm or longer would be the option. While most don't have the benchmark of 50mm anymore, you get the idea of how to think through what should be your next lens.

I'm in no way suggesting you must go out and duplicate what I own to be successful! In fact, everything I wrote above basically advises against doing that. I am suggesting that in reading what I own (yes, I bought all of my gear, it was not given to me) and how I use it, you can think the options through and find your own answers for camera purchases. If you're wondering if I bought the right gear the first time from the beginning, the answer is, not exactly but pretty darn close. As I mentioned, I have followed the words of wisdom from my oldest brother, to buy the best I could at the time.

My camera bag evolves, slowly, with time. The introduction of the F5 was its first radical overhaul, because it introduced an autofocus system that fit my style of photography. Little has changed in my bag for the last decade when it comes to lenses, but the contents have changed radically when it comes to bodies. All I've shot since December 1999 is digital. But I'm jumping ahead of myself. Let's start talking about lenses for the wildlife photographer.

Ultra-Wides:
Fixed and Zooms

My very first visit with a camera to the mighty giant redwoods in the Sierra foothills of California was one I won't forget. There I stood at the base of these towering, 300-foot giants, barely able to see the blue sky through the canopy. With a 24mm lens in hand, I pointed it up towards the heavens and to my horror, I was not able to capture the

majesty in front of me. Simply put, I had more subject than lens, I couldn't capture all I could see and wanted to communicate. This sent me on my quest for the ultra-wide, a quest I'm still on in many ways!

It wasn't too long before I stood at the base of those same mighty redwoods, but this time with a Nikkor 15mm f/3.5 in my hand. This lens, with its 110° angle of coverage, just blew my socks off! It takes in so much of the world it can almost be a dizzying experience. Back in 1982, it was the ultimate! I wasn't too far from the redwoods on that same trip when I had an even more dizzying experience with an ultra-wide. I was atop Glacier Point in Yosemite National Park, California, shooting with the 15mm, when I noticed another photographer standing next to me. He was shooting with a lens that had an even larger front element than mine! I instantly recognized he was shooting with the 13mm f/5.6. Wow! We started talking and I asked if he'd mind switching lenses for a moment. We did and wow, what an ultra-wide! This experience instantly impressed on me that, for my style of photography, ultra-wides would always play an important role.

There are many options when it comes to ultra-wides, which include fixed and zoom lenses. You have choices in fixed focal lengths from 14mm to 20mm in nearly every f/stop and manufacture you can think of these days. My personal favorite is the Nikon 14mm f/2.8D ED AF. A radical departure from the days of the 13mm and 15mm lenses, the 14mm is physically smaller than either lens but it produces beautiful images with minimal lens flare. It has an angle of view of 114°, which, for me, captures a whole lot of the world. I love it!

The most obvious use for ultra-wides is in scenic or landscape photography. There is no doubt that being able to photograph a field of wildflowers that carpet the land stretching to the horizon is a killer way to use an ultra-wide.

Mew Gull.
Photo captured by D1,
14mm f/2.8D ED AF,
on Lexar digital film.

But many make the mistake of pigeonholing the ultra-wide as useful only for this application. There are many uses for the ultra-wide. For example, my portrait on the back cover was taken with a 14mm lens. You'll find a lot of images throughout this book, photographs of animals taken with an ultra-wide. This goes back to my desire that my gear multi-task. It means that I never pigeonhole anything or limit my imagination, but let it all run wild (that's a scary thought, huh?)!

Obviously if there is a subject in the frame and you're shooting with an ultra-wide, you're going to have to get close physically to make it appear in the photo. With most scenic/landscape subjects, such as rocks, this is not a problem. But what about wildlife? You'll have to read chapter three (page 118) to find out those answers. My point right now is that with ultra-wides, you'll have to work really hard to make the subject, no matter what it is, visually pop so the viewer

of your images sees the subject as well as the story you're telling about it. This is how I personally apply the 14mm to my photography: getting up close physically while making the subject pop visually.

Another lens that I use starts in the ultra-wide world but ends up in the normal end of the spectrum. That's the 17-35mm f/2.8D ED IF AF-S lens. There are a number of options these days when it comes to ultra-wide zooms, like Nikon's 18-35mm f/3.5-4.5D AF or Canon's beautiful 16-35mm f/2.8L USM. Why do I have a lens in my bag that's so close to the 14mm, since the 17-35mm has coverage of 104° to 62°? The reasons are as many as the focal lengths contained within this dynamo package!

There are two reasons but they really are intertwined. Having all these focal lengths in one lens makes the lens incredibly versatile for many different subjects. I also work on many projects where weight is a limiting factor.

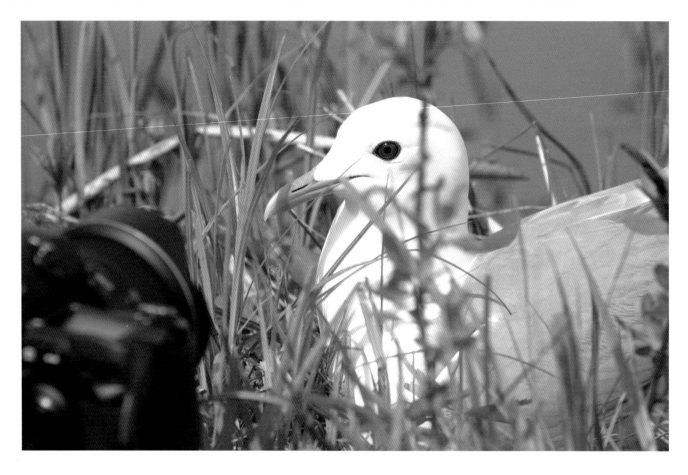

Mew Gull.
Photo captured by D1,
400mm f/2.8D ED AF-S,
on Lexar digital film.

Losing all the weight I can makes the difference. For example, when I'm working out of a helicopter, the weight load can only be so much in order to accomplish the tasks at hand.

The reason I selected the 17-35mm over the 18-35mm, for example, is two-fold. The main reason is that the 17-35mm is an AF-S lens, which as I mentioned earlier permits me to manually focus even though I'm in AF mode. This is very important to me in ultra-wides (one thing I miss with the 14mm) because I often place the subject where there is no AF sensor. The other important aspect of the 17-35mm is the f/2.8 component of the lens. Ultra-wides do tend to have everything in focus and while this is a great attribute of the lens, it can at times be more than I want. The f/2.8 reduces the depth of field, especially when you're really close to the subject.

When I go out shooting, do I have both lenses with me? They are both in my camera bag but I will carry only the 14mm or the 17-35mm when I go make images. What determines which one I take along? Like everything you'll read in this book, it's the subject that determines everything! When it comes to these two lenses, I'll typically take the 14mm when the scenics are a no-brainer; the space is just so grand that it requires little technical effort on my part. I also take it when I'm working with folks so I can get in close physically without getting in their way.

I take the 17-35mm when I'm working with folks as well as critters and I need to give them some space. That's where the zoom feature really earns its keep. I take the 17-35mm when I need to massage a scenic/landscape by using a filter to enhance the light or drama. And finally, I take the 17-35mm when I think there might be some cool macro shots. I'm not a macro shooter. Moose getting down just isn't a pretty sight! But I will shoot some macros

Black-legged Kittiwakes.
Photo captured by D1H,
28-70mm f/2.8 ED-IF AF-S,
on Lexar digital film.

FIELD TIP

I don't really get into landscape photography in this book, but I want to pass along this one tip. When shooting with ultra-wides, get down, get close, and eliminate all the junk you can from the image. Point the lens down to minimize the sky while extenuating the middle ground. If you're shooting with the Nikon system, set the AF sensors to the center sensor to maximize your DOF no matter what f/stop you use. Most of all, place an element in the foreground of the photo to give the mind a mental anchor, so it can go out, visually explore the rest of the image, and then return to its starting point.

using the 17-35mm, which focuses really close while providing some wide-angle drama.

Mid-Range Lenses

What the heck are mid-range lenses? This is kind of a catchall term for lenses in the range of 28mm to 200mm. These

are the lenses most typically used for what I call wildlife scenics. They are also the lenses I most typically use when I'm working with biologists and telling the story of their work with wildlife. These are definitely not the most glamorous lenses in wildlife photography; they're more the working man's lenses. Wildlife photographers tend to put a lot of importance on big lenses like the

Selecting and Using the Right Tools

600mm and more or less ignore or take for granted the lenses in this range. This is a big mistake!

The lenses within this range are typically carried by wildlife photographers either on a second body or in a fanny pack. If you look at many of the great wildlife images from the great shooters, you'll notice something very important. Those great images were captured with lenses under 200mm. Why is this? Probably— and this is just my own theory—it's because the shorter lenses permit greater vision. This greater vision is not just photographic. This vision is full of emotion and passion and we're using photographic tools to make the subject pop while telling the story. I think I can safely say that the lenses in this range are the most difficult ones to use but produce the most rewarding results when used correctly!

You're probably saying to yourself, "Whoa, you're using these lenses for wildlife and not scenics?" It's important to remember that, at least in my experience, every lens can be successfully used in every application and the only limitation is a person's imagination. The lenses within this range, especially the many incredible zooms, bring an amazing flexibility to the aware wildlife photographer. You can these days buy incredible quality for so little money, it's hard not to overdose and buy them all! Let's get down to specifics so you can better understand where I'm coming from.

I've owned many lenses within this range over the years, normally dictated by the projects I was currently focusing on (Get it? Focus on, lenses?). My favorite lenses have been the 25-50mm f/4, 35-200mm f/3.5-4.5, 35-70mm f/2.8 AF, the 28-70mm f/2.8 AF-S, and now the 24-85mm f/3.5-4.5 G AF-S. The first thing you'll notice about my lens selection is that there is no obvious rhyme or reason to it. Unless you understand what I was concentrating on at the time, there wouldn't be, so let me explain where I was and where I am coming from.

Hopefully in this account, you'll discover the best lens for you.

I shot for the first five years of my career with a Nikkor 400mm f/5.6 ED IF as my longest lens (often used with a TC-14). During this time, I had a number of fixed focal length lenses that I would bring along with me either in a vest pocket or on a second body. I remember those days, they were painful! I never seemed to have the right focal length when I needed it. Then I saw the first 25-50mm f/4 and that's when my addiction to zooms began. This lens fit in pretty darn well with my shooting needs (and budget). The mid-range lens' application was really simple in the beginning. I used it to photograph the scenics I came across while I was working.

When I bought the 800 f/5.6 ED IF, I knew that I needed a greater range for a second lens than just the 25-50mm because when I went out I wanted a minimal amount of gear to interfere with the 800mm f/5.6 and tripod. At the same time, I wanted to be able to capture anything that came my way. This is when I obtained the 35-200mm. That was a great lens! For the majority of my projects, the versatile range of the 35-200mm made many images possible that otherwise I would have totally missed.

Using first the 25-50mm and then the 35-200mm, I started to look at the photos I had taken, how I had taken them, and the results. I noticed (this was around the end of the '80s) that my personal preference for photographing biologists in the field as well as wildlife scenics favored the wider rather than longer lenses. Getting in close, bringing drama to the photograph with a large middle ground expanse, and the compact size of the lens were all determining factors in my lens selection.

My camera bag got its first shaking up when the N8008 was introduced. With its smaller size and flash capabilities and new set of AF lenses, I started to rethink my system. At the same time, the new

35-70mm f/2.8 AF was introduced. This very sharp, compact zoom with a great macro (especially with the 6T close-up attachment added) perfectly dovetailed into the projects I was starting. At this time, the early '80s, I started my quest to photograph all the small mammals of California. My primary lens for doing this for nearly a decade was the 35-70mm f/2.8 AF. This one lens let me photograph a small kangaroo rat and then turn, zoom, focus, and photograph the biologist. Those are incredible problem-solving capabilities!

The introduction of the F5 changed nearly all the contents of my camera bag. One of the great changes was the addition of the 28-70mm f/2.8 AF-S. Besides being a big, sexy lens, it is tack sharp with a really nice range that fit the projects I was moving into. I started about this same time to do a lot of work in Alaska with moose (the four-legged kind) and grizzly bears. Since they are big and dark and live in dark places, the 28-70mm f/2.8 worked perfectly with my projects. I captured thousands and thousands of images with that lens and, even after the introduction of the D1, I kept shooting with it. It wasn't until the summer of 2002 that I made my next change.

I've already explained my preference for AF-S lenses. The 28-70mm f/2.8 AF-S with its M/A feature was key to my getting a number of my favorite images. Any lens in this mid-range would have to be modeled after the 28-70mm and it would have to be an AF-S lens to replace it. When I first picked up the 24-85mm G AF-S, what went through my mind instantly was, "Wow, it's so light!" I then noticed not only its range, but also that it was an AF-S lens. The wheels in my mind started to turn, could this be a better alternative to my old faithful 28-70mm f/2.8? To decide, I rented the lens for a month and took it to Alaska. It took very little time to win me over: so small, so sharp, and so darn easy to shoot with!

Dall Sheep.
Photo captured by D1H, 400mm f/2.8D ED-IF AF-S, on Lexar digital film.

Snow Geese.
Photo captured by D1H,
24-85mm f/3.5-4.5G AF-S at 24mm,
on Lexar digital film.

The one big drawback to the 24-85mm G is its filter size. You might have noticed (if you read ahead like most do) that all of my working lenses have a common filter size of 77mm. The 24-85mm G, being 67mm, doesn't work into that plan of consistent filter sizes. Oh well, I love the lens too much to let that deter me.

Just how do I use the lens? The vast majority of the time, this is my second lens, my first being a big lens, a 300mm f/2.8 AF-S II, 400mm f/2.8 AF-S, or 600mm f/4 AF-S. The 24-85mm G is either on a second body hanging from my shoulder or in a fanny pack. The 24-85mm G is a real workhorse in all that it does for me. One moment I could be stooped over photographing a semi-macro shot, next I might stand up and take a grand scenic, and then turn and photograph the person next to me who is shooting something else.

I might be stalking a moose through deep brush, using the 300mm f/2.8 as

my prime lens. But I might end up so close that the 300mm is too much lens. The 24-85mm then becomes the main lens as I approach, move, frame, and crop to get the shot. The lens is incredibly sharp and since it's so easy to hand-hold, I don't hesitate to shoot with it. You might, though, be wondering what I do to control depth of field? The 28-70mm f/2.8 has a maximum aperture of f/2.8 and the 24-85mm f/3.5-4.5 obviously is variable between f/3.5-4.5. There are times when I wish I had the f/2.8 when shooting with the 24-85mm G because I just want a tad less in focus. In these cases, I try to the best of my ability to simply move my physical location to eliminate those elements I want to disappear.

You might be wondering why I've not talked about the 80-200mm class of lenses. They most definitely fit within this range and are pounded by wildlife photographers on a daily basis. I've owned two 80-200mm lenses in my day.

Moose.
Photo captured by D1H,
24-85mm f/3.5-4.5G AF-S at 24mm,
on Lexar digital film.

Loved them. There was a short time during one project when one was my only lens. The one reason why they fell out of favor with me was their continuously expanding size. The 80-200mm AF-S is a physically big lens and while it has a great range and is really sharp and incredibly fast-focusing, it was simply no fun to use!

There is a very old saying about photography that is painfully true. Photography is a compromise. But what many call the trick (and what I think of as experience) is making the compromises work in your favor. It's still the person behind the camera that counts!

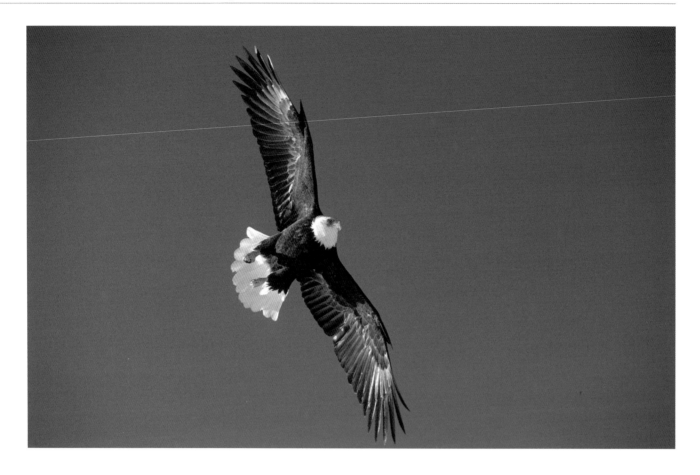

Bald Eagle.
Photo captured by F5,
80-200mm f/2.8D ED-IF AF-S,
on Agfa RSX 100.

Telephotos

The range of lenses in this category has a very small focal length range, only 300 to 400mm. I also include zooms, such as Canon's 100-400mmm IS, Nikon's 80-400mm VR, and the like. In my own mind, I have pigeon-holed these lenses. I think of them as lenses for birds in flight, big game, and backyard birds. This isn't fair because these lenses can be used for everything and anything. There is no limit. But when it comes to photographing wildlife, this is how I think of these lenses after twenty years.

Most photographers feel they've made it as a wildlife photographer when they obtain their first telephoto. There is no doubt that the doors to wildlife photography fly open and a whole lot more subjects and great opportunities appear when that telephoto is attached to your body. This is an exciting time in a photographer's career!

Typically, the first telephoto is either a 300mm f/4 or 400mm f/5.6. The 400mm f/5.6 was my first lens and the vast majority of my basic techniques were defined by my first years with this lens. This was my bird lens! Whether it was a bird in flight or one teed up nice and pretty, this was the lens I went after it with. Because I often shot the 400mm f/5.6 with a TC-14, 1.4x attached, I worked with this combo on a gunstock.

When it comes to photographing birds and you can only afford one telephoto, I highly recommend going with nothing less than a prime 400mm. Yes, you can get to 420mm with a 300mm and a 1.4x but, as you'll learn later, with this combo there are compromises you may not be willing to make.

On the other hand, if you're going after mostly deer and elk and other big game, you might want to start with a 300mm telephoto. There are many reasons for

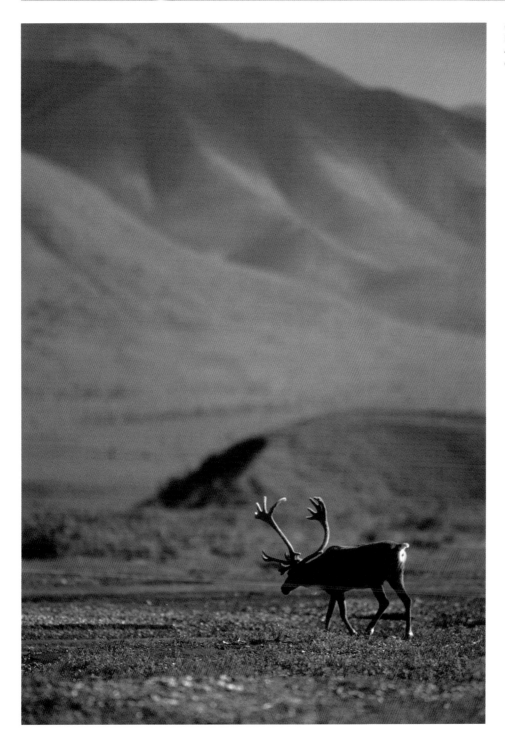

Caribou.
Photo captured by F5,
400mm f/2.8D ED-IF AF-S,
on Agfa RSX 100.

this, which I'll discuss in a moment. If you're undecided, I highly recommend you start off your telephoto collection (don't let your spouse see that word, "collection") with one of the excellent zooms in this range. The Canon 100-400mm IS and Nikon 80-400mm VR are the two I recommend you check into. These very sharp lenses with their versatile zoom range assist you in finding the focal length that works best for what you want to communicate. Don't worry about the fact they are zooms. These two lenses deliver great quality!

In this range of lenses, I only have one prime lens that is a constant member of my camera bag, the 400mm f/2.8D ED

31

Snowy Egret.
Photo captured by F5,
Tokina 400mm f/5.6,
on Agfa RSX 100.

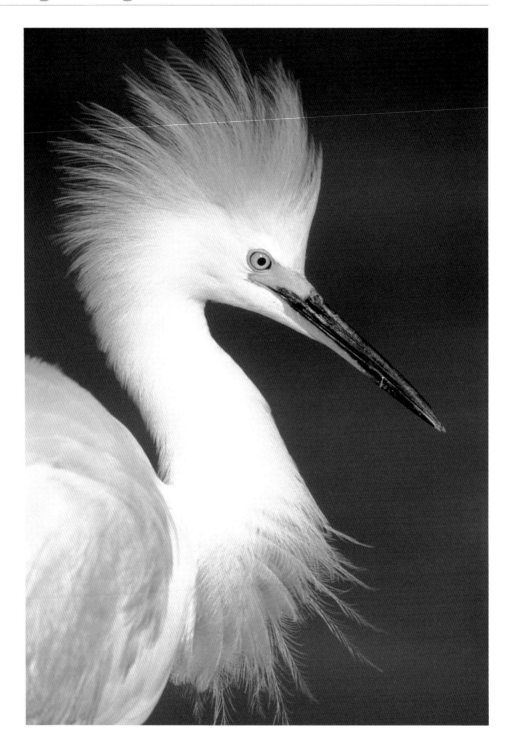

IF AF-S. (There are two others that fall within this range that you'll learn about later in the section called Moose's Specialty Lenses on page 39). Simply put, this is my big-game lens. This really gets to the heart of what I'm talking about throughout the book, communicating! And while it might seem that I'm pigeonholing this one lens as my big-

game lens (after I've warned you not to do it), once you read what I have to say, I think it will all make sense to you.

Another important consideration you might need to think through in your lens choice is lens speed. While you might be thinking autofocus speed, I'm not directly talking about that right this moment

(though you'll note the 400mm f/2.8 is an AF-S lens). What I'm referring to is the maximum aperture. Depending on what you're photographing, lens speed can make a really big difference in your effectiveness as a photographer!

You'll note that I'm selecting only the fastest lenses in my telephotos. The reason for this it two-fold: depth of field and focusing speed. The first one is real obvious. A fast lens minimizes depth of field and this is real important for communicating, as we'll learn in chapter two (page 80). But what might not be obvious is how a fast aperture can help the AF system focus faster.

When shooting in low-light situations, the amount of light going through the lens and reaching the autofocus system can be minimal. When this occurs, the autofocus system (no matter the manufacture) might not be able to operate as fast as normal. Most commonly, the lens will "search" in these situations since there is not enough light to lock onto the subject. This normally happens at the worst moment! This is the reason why I prefer the fastest lenses the majority of the time.

I have become quite dependent on autofocus (AF). The reason is not because my eyes are failing me, but because I want to eliminate every variable possible when I'm shooting. If the camera can lock onto the subject in a heartbeat, I can concentrate on the subject and not on turning the focusing ring. I have a much better chance of capturing the shot I have in mind. The fastest AF operation in these dark situations comes from, sorry to say, the most expensive telephotos!

Super Telephotos

These are by far the demigods of the wildlife photographer, the giant front elements reflecting back the light in a rainbow of colors while at the same time a glint comes off the lens barrel. Some even consider the sweat and pain to carry these monsters into the field a mark of studliness. If you own one of these, you've made it into the fraternal order of wildlife photographers. Does this all sound silly? It does, but this is how many view these very expensive yet essential tools of the wildlife photographer!

While we're only talking about lenses in the 500 to 600mm range, these are quite often used with a 1.4x or 2x converter, putting us in the 750 to 1200mm range (and some demented souls stake two 2x converters on 600s!). This is the range of the super telephoto. These focal length behemoths are most often than not pointed at itty-bitty subjects: birds. I've shot with the 600mm f/4 (AFI and now AF-S) since I first switched to the F5. The vast majority of the time, as in 99.99 percent, I use the 600mm f/4 AF-S with the TC-14E 1.4x attached. This is my bird lens!

The combination of focal length and its very narrow angle of view, and aperture, permits me to capture what it is I want to communicate. The combination of a small aperture to minimize DOF and the narrow angle of view, so I can easily manipulate the background, lets me make the subject pop while telling a story. Long ago, I came to the conclusion that 800mm was the focal length I wanted for photographing birds because all these factors come together in that one focal length. I shot for a long time with the 800mm f/5.6 ED IF (in fact, many of the images in the first edition of this book were taken with it). But this lens doesn't work smoothly with the F5 or with today's digital bodies. When the F5 came out, I moved on reluctantly from my cherished 800mm f/5.6 to the 600mm f/4 and 1.4x combo. The 600mm f/4 and 1.4x combo gets me to 840mm f/5.6, which has been for nearly two decades my preferred choice for photographing birds.

The 600mm f/4 is not the lens for everybody. It's a big, heavy sucker and many simply can't put it on their shoulders and go hiking out into the marsh to

FIELD TIP

When I'm heading out to photograph birds, be it big old herons or small little shorebirds, I'm going to head out with the 600mm f/4 AF-S, TC-14E on a tripod. When I do this, I take along the caps for the 1.4x in my pocket. I do this because there are times when I want less lens. When this happens, I need to take off the 1.4x but I don't want naked elements rubbing around in my pocket. So I have the caps to prevent any problems.

Selecting and Using the Right Tools

Great Blue Heron.
Photo captured by D1,
600mm f/4D ED-IF AF-S
with TC-14E, on Lexar digital film.

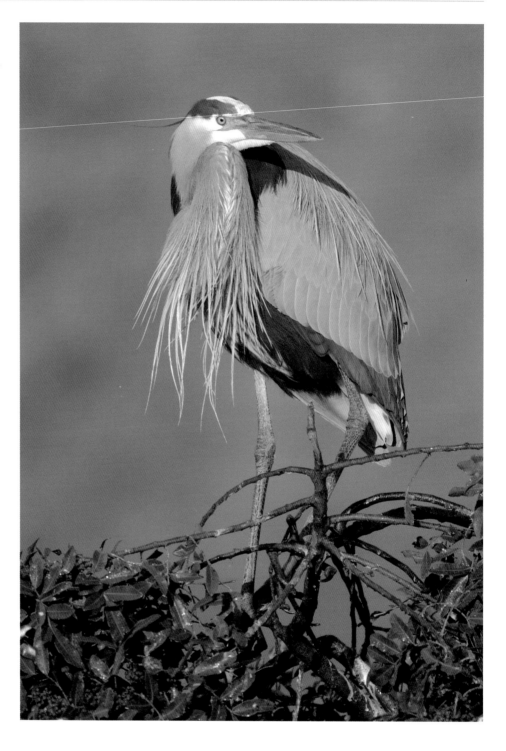

shoot. For that reason, I would go with a 500mm f/4, either Canon's or Nikon's. I personally don't like the 500mm focal length because it doesn't afford me the benefits I described from the 600mm, but let's be realistic here. My good friend has bad knees and, for a while, he suffered the 600mm f/4 and the discomfort it caused him. But he wasn't having any

fun! Then one day, he made the change to the smaller and lighter 500mm f/4 and he no longer had sore knees. My point is that selecting a lens is a personal thing. Reasons as personal as sore knees are just as valid for picking one lens over another as any other reason. It's got to stay fun, that is a key ingredient to photographic success!

Whereas the 400mm f/2.8 AF-S is my big-game lens, the 600mm f/4 AF-S with the TC-14E is my bird lens. Does this mean I won't use the 400mm to photograph a bird or the 600mm for big-game? No matter what lens I have, if I see a photograph, I will go after it with whatever I have. But my preference, and what I'll take out of my bag, is the 400mm for big game and the 600mm for birds.

Teleconverters

There's no way wildlife photographers can complete their bags of confidence without the addition of at least one teleconverter. The 1.4x is by far the most common and most popular. The 2x teleconverter is the one many have when first starting out because it's the most inexpensive way of getting to super-telephoto focal lengths. The way teleconverters work and how you use them, though, is often lost in the mere fact that they make a lens' focal length longer. Depending on how you use them, they can help or hinder your photography.

The very basics of the teleconverter are the only things about them that are simple. The teleconverter has glass elements that change the optical formula of the lens it is attached to and in doing so, increases the effective focal length. The 1.4x increases the lens' focal length by 40%. The 2x increases the lens' focal length by 100%. If we attach a 1.4x to a 100mm lens, we end up with the effective focal length of 140mm. If we attach a 2x to the same 100mm lens, we have a 200mm lens. We are optically changing the focal length by using teleconverters.

At the same time, the glass in the teleconverter that is increasing the focal length is also reducing the effective amount of light reaching the film plane or digital sensor for a given f/stop. There's no way around this; it is a fact of the photographic world. The 1.4x reduces the light by one stop, the 2x by two stops. This light loss changes the f/stop of the prime lens to what is called the effective f/stop. For example, if a prime lens has a maximum f/stop of f/4, with a 1.4x attached the maximum effective f/stop becomes f/5.6 (because of the loss of one stop of light). Attach a 2x to the same lens and the maximum effective f/stop becomes f/8 (because of the loss of two stops of light). It's called effective because, while it changes "exposure," it doesn't change the original, physical size of the aperture of the prime lens. But the depth of field is reduced. This is, for most shooters, the hardest thing to comprehend.

First and foremost, when you do the math, it appears that the difference in the depth of field is minimal at best. And while this is true on paper, when it comes to photographing subjects that are physically close and to being an effective communicator, the impact of this difference is huge. Depth of field is one of the best tools you have to make the subject visually pop in a photograph.

As a rule of thumb, I figure that with a 1.4x attached, you have approximately 40% depth of field of the effective f/stop. With a 2x, you have approximately 50% depth of field of the effective f/stop. In other words, if you attach a 1.4x to create an effective f/stop of f/5.6, the depth of field you now have at f/5.6 is only 40%, or equal to f/4.6. With the 2x attached, producing an effective f/stop of f/8, the depth of field would be only 50%, or equal to f/6.3. In both of these examples, the prime lens was at f/4, the effective f/stop was either f/5.6 or f/8, and the resulting depth of field only a percentage of either effective f/stop.

In case you're wondering why this is so, it's actually very simple. Depth of field is based on the relationship of focal length and aperture. When we add a teleconverter, we change the focal length but not the aperture opening. Since we don't change the actual dimension of the aperture opening, we have a loss of depth of field for the effective f/stop. Unless you want to win a game of Photography

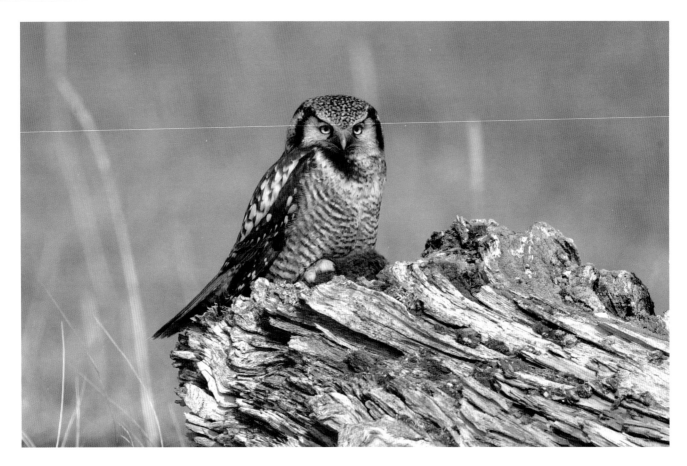

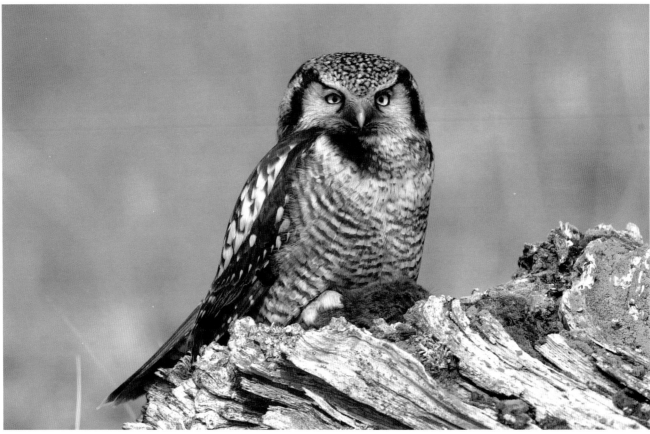

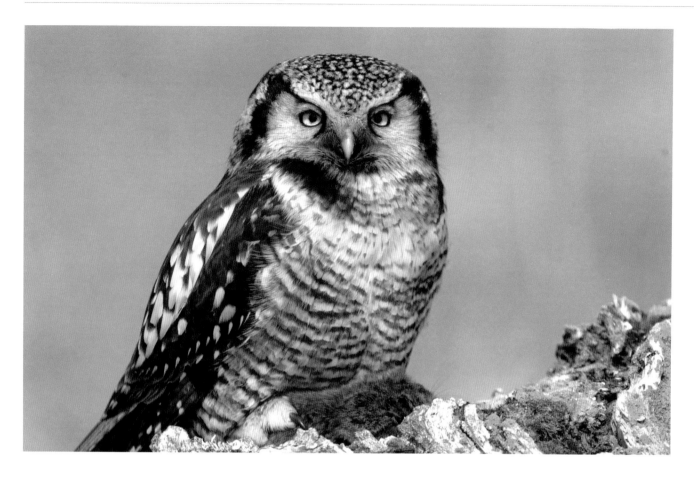

Trivia, this isn't information you need to memorize. What you need to realize is how this can be used to help or hinder your photography.

The most obvious thing is, if you need more depth of field, you need to make a compromise. You either decide not to use a teleconverter or to close down the aperture so you end up with more depth of field. When you remove the teleconverter, you of course have less lens but you gain depth of field for the actual f/stop in use. If you close the lens down to gain DOF with the teleconverter attached, how much do you close the aperture down by to make a difference? My own rule of thumb is to simply close down the lens one more stop or set the prime lens's f/stop to the f/stop for the depth of field desired. If the prime lens is f/4 for example and you add a 1.4x, you make the effective f/stop f/5.6. If you want the depth of field of f/5.6, set the lens to f/5.6, changing your effective f/stop to f/8.

And if you need less depth of field but you can't open up a lens anymore, attach a teleconverter. You can really manipulate one of the most effective ways we have to communicate, depth of field, this way. This is one of the biggest benefits a teleconverter brings to my photography. Limiting the depth of field makes the subject visually pop. This is a real simple method of making elements in the background, like grass stems, disappear.

Why Own Both the 400mm f/2.8 and 600mm f/4?

This is a common question, and it's a good one. This is a lot of capital investment, so I must have a good reason why I bought both. Many elements must go into an image to meet my own standards of excellence. Key elements of light, background, and composition are important in every photograph and I'll discuss them later on in the book. My point right now is how I want to communicate the

These three photos of a Northern Hawk Owl were captured with the D1 and 600mm f/4D ED-IF AF-S on Lexar digital film. A TC-14E was added for the picture on the lower left and a TC-20E was used to capture the picture above

Mule Deer.
Photo captured by D1H,
600mm f/4D ED-IF AF-S,
on Lexar digital film.

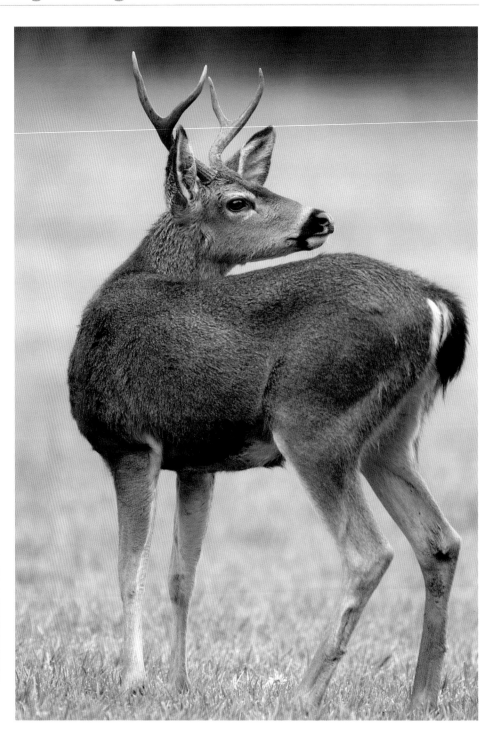

FIELD TIP

While I have both the 400mm and 600mm, I only take one lens or the other into the field. I will have either the 400mm or 600mm in the MP1 backpack when I leave my office, but not both. My determining factor is what I'm going after, bird or mammal. Whatever my main subject or project is going to be determines which lens goes and which lens stays home.

subject to the viewer of my photograph. If I isolated the subject from the background, what would I be saying about the subject as it stands on its own? This is why I own both the 400mm f/2.8 and 600mm f/4; it's all about the subject. (Bear with me while I spell this out.)

When you poll the average person and ask them to describe "wilderness," often

the animals bear, moose, elk, bighorn sheep, and deer are mentioned. Big game and predators are symbols of the very essence of wilderness to the public. These critters are bigger than life in folk's minds! These preconceived ideas, often instilled and reinforced by various television programs (which never lie, exaggerate, or manipulate the truth, of course), set the stage for what we as wildlife

photographers at times must match but more often beat to be successful communicators. This makes these bigger than life symbols of the wilderness a real photographic challenge.

It used to be said that you have eight seconds to grab the attention of a person flipping through a book or magazine with your photograph. You have eight seconds in which to grab their attention and make them want to stop and read the caption and then the article accompanying it. That was twenty years ago. A recent conversation I had with an advertising executive informed me that many in the industry now think it's less than a second! Your photograph has one second to grab the viewer's attention. The viewer's attention span has become so short because of all the media the public is exposed to in the war of communication. What has this got to do with my considering the 400mm f/2.8 a big-game lens and the 600mm f/4 my bird lens? Hang in there with me.

There is a visual compression that can occur as you shoot with longer and longer lenses. The best description I can provide you of this comes from Hollywood. When you see that great car chase scene on the screen, the cars appear as if they are bumper to bumper. You wonder, how can they drive that close and not get in an accident while filming the scene? But are they really that close? In actuality, they are some distance apart. Those scenes are shot with super telephotos, often the exact same lens you might have in your camera bag. The long lens compresses the subjects so they are squashed together and in this case, they appear to be bumper to bumper. It's thanks to these factors of preconceived ideas of wilderness, one-second attention span, and visual compression that I have both the 400mm and 600mm.

I want my images to smack the viewer right between his eyes and grab his attention as well as his heartstrings. The 400mm f/2.8 is my big-game lens because I don't want to compress these

animals' big, hulking presence. I want to communicate it in a way that's as big and majestic as their wilderness aura can fill! The 400mm f/2.8 does not compress these giants, so their big-game stature is as big and as powerful on film as it is in real life. So this explains why I have the 400mm, but not why I have the 600mm. Why not just shoot with the 400mm and a 2x for birds, take the 2x off for mammals, and not even have the 600mm?

Remember that my preference for birds is 800mm, which is what a 2x attached to a 400mm creates. The problem with this combo is that, while the 400mm is a f/2.8 lens and has an effective f/stop of f/5.6 with the 2x attached, in order to get approximately the same depth of field, you have to close the lens down to f/11! You realize how much light you must have to work at f/11 with a 2x attached? What if you want more depth of field when photographing a bird, then what?

It hurts the working budget, but photographically, I've been richly rewarded by having the 400mm and 600mm in my equipment arsenal. And while I have these two lenses for the reasons I just listed, don't think that if a great bird shot comes up when I have the 400mm I ignore it or if I come across a mammal shot that I don't shoot with the 600mm. I'll also use these lenses to photograph people and scenics, I don't pigeonhole any lens, but every lens I own has a primary use or function. They are all tools with a main purpose as well as many other secondary purposes. That's how I can solve the problems I face in the field with so few lenses!

Moose's "Specialty" Lenses

I hope you didn't skip to this section thinking I was manufacturing my own lenses. While I have a few designs I would like to come out with, that's not what I'm referring to here. There are three lenses in my locker that I pull out only for special shoots. These lenses do not reside in my MP1 backpack. I get

Western Tanager.
Photo captured by D1,
300mm f/2.8D ED-IF AF-S II,
on Lexar digital film.

them out of the locker just for special photographic applications.

The 60mm f/2.8 AF micro is a lens I have for basically one purpose and that's photographing small mammals in one of my custom tanks. I have this lens because its minimum focusing distance is so close that the flash I'm using to light

the subject can't be seen bouncing off the tank's surface.

The 300mm f/4 AF-S is a killer lens! I mainly use it to photograph birds in the feeders on our property. The ability to focus incredibly fast at a minimum focusing distance of 5 feet (1.5 m), and its really small size makes it a sweet

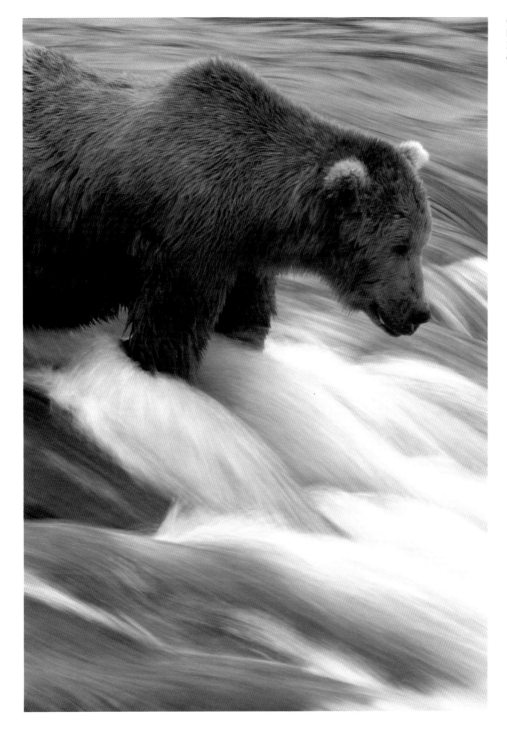

Coastal Grizzly Bear.
Photo captured by D1H,
300mm f/2.8D ED-IF AF-S II,
on Lexar digital film.

lens. On the digital body, it's the perfect bird lens. I also use this lens for photographing birds in flight. Personally, I find this lens to be ideal for this application!

The 300mm f/2.8 AF-S II is the last one in my locker. Why do I have the 300mm f/2.8 AF-S II and the 300mm f/4 AF-S, two 300mm lenses? They serve very special yet separate purposes in my photography.

The 300mm f/2.8 AF-S II is primarily used in the winter when my sons are cross-country skiing and racing. Since most races are held when it's cloudy or snowing, I need the f/2.8 so the camera

can autofocus the fastest that it can. The depth of field of f/2.8 is important so the subject visually pops from the pack of skiers behind them.

Lastly, the 300mm f/2.8 AF-S II is used for certain moose shoots, where I know I will be physically close to the moose. Typically, I'll also be working in dense growth where I have to get close to get a clean shot.

Minimum Focusing Distance and Extension Tubes

A very important consideration one needs to make when buying any lens, especially telephotos and super-telephotos, is minimum focusing distance (MFD). Minimum focusing distance describes the closest distance from subject to film plane at which the lens will focus. With some lenses, very close focus may be achieved in macro or macro mode. With other lenses, this is simply the end of the focusing ring. Why is this so important?

Minimum focusing distance is not important if you're photographing an elephant but it sure is when you go after small critters like sparrows or squirrels. In the vast majority of the images I take, I'm an average of 60 feet (18 m) or less from the subject. For most small critters like sparrows or squirrels, I'm 7 to 11 feet (2.1 to 3.3 m) away. For most lenses, this distance might not be obtainable. You have two options. Be real careful and buy lenses with a really great MFD, or always carry extension tubes.

Some of the greatest benefits of the new lenses, The Nikon AF-S II series and the latest Canon IS series, for example, are their minimum focusing distances. For example, the Nikon 600mm f/4 AF-S focuses at 20 feet (6 m) whereas the new 600mm f/4 AF-S II focuses at 17 feet, 6 inches (5.33 m). That 2-1/2-foot (76.2 cm) gain means that with the AF-S II 600, you don't need an extension tube whereas you

would with the AF-S 600. Now, like I said, this isn't critical when going after elephants but it sure is when trying to photograph little critters.

If your lens can't focus close enough, then you need to rely on extension tubes. This is where Canon shooters have it all over Nikon folks. Canon has a great line of fully operational extension tubes. Nikon has none! Nikon shooters have to rely on Kenko Extension Tubes, which do work but aren't the best-machined tubes on the planet. Part of the problem is that the two companies don't seem to talk to each other, and neither do their tubes all the time. While not the best, this is all Nikon shooters have at their disposal.

Extension tubes are nothing more than metal tubes; they have no optics. They increase the distance between the optical center of the lens and the film plane and, by doing so, decrease a lens' MFD. At the same time, when an extension tube is attached to a lens, it will no longer focus at infinity. The advantage of extension tubes is that you can decrease the MFD of a lens with the more extension you add. The most common length I add to my 600mm is just 8mm, but that makes a big difference. It reduces the MFD of the 600mm AF-S from 20 to 16-1/2 feet (6 to 4.95 m). That can make a radical difference in getting a large image size of a small subject.

There is no trick to using extension tubes, no hidden hoops to jump through. They are simply a means to permit you to get close to your subject and be able to focus on it.

Eastern Cottontail.
Photo captured by D1H,
400mm f/2.8D ED-IF AF-S, with
TC-14E, 18mm extension tube,
on Lexar digital film.

The Body

One of my heroes is wildlife photographer George Shiras III. You've probably never heard of him. Not surprising. George was photographing wildlife back in 1889! One of the first wildlife photographers for National Geographic, George did such things as remote photography and flash, back when remote firing meant a string and flash meant powder in a pan. George photographed wildlife back in the days when photographers had to coat a piece of glass with emulsion in a tent before loading it in the camera. George was a problem solver. Not happy with the restriction of having

just one frame to work with, George would have two cameras loaded and ready to go so he could shoot two frames. Can you imagine what this very ingenious wildlife photographer would have done with cameras firing 10fps and TTL (through-the-lens) flash?!

Camera bodies for wildlife photographers have vastly changed since the days George stalked light. Just a decade ago, the Nikon N90s was the hot ticket, but was then completely blown out of the water by the Nikon F5 and Canon EOS 1V in the late 90s. And while many still shoot conventional film (as in 35mm film), to me, the biggest change to come to wildlife photography in nearly a century is digital!

"Camera bodies are no more than glorified film transport systems," as I used to say a lot, because you can capture the image with the most basic of bodies. But having a body that does more than just hold film and operate a shutter, but has other options, can make your wildlife photography more fun and more productive. In deciding which body is the best one for you, be it conventional or digital, you need to take into account many factors. I can't tell you which camera body or manufacturer is the best. That's a very personal thing dictated by the problems you face and how you want to solve them. I can relate to you what is important to me and how certain features solve the problems I face in capturing the image. In this dialogue, perhaps the light bulb will come on for you and you'll know which features you need in the camera body you select.

The Digital Wildlife Photographer

That's me! Why did I switch? Because digital is so much darn fun!

Digital photography has opened up for me a whole new world of wildlife photography. (So much so, I'm out reshooting many of my conventional images!) After nearly two decades of exposing film, you'd think a photographer like me would be pretty set in his ways. But after all that time, you also learn the limitations and workarounds you need to be successful. Because of that, exploring new tools for new solutions is easy to do. What is it about digital that first caught my attention? Instant gratification! Being able to instantly see what I captured, to confirm what I did right and what I could improve, really caught my imagination. I saw it as a way of vastly improving my photography (and it has).

What has digital brought to wildlife photography that conventional doesn't have? All the benefits of digital are derived from the very medium of digital. All digital bodies on the market incorporate features you'd find in conventional bodies, such as exposure modes, TTL flash, autofocus, focus tracking, and the like. So at that level, you're at least on the same plane as conventional. It's the extras you find with digital that put it ahead, stemming from the fact that the image is captured by a computer and transformed magically from ones and zeros, the language of computer code, into full-color photos! The magic of digital still boggles my mind every time I depress the shutter release. It's a magic that cannot be found with conventional film, a magic that makes better images.

Five Benefits of Digital

To me, digital offers five major technical benefits to the wildlife photographer that are not found in conventional photography. These are features that can solve problems for which I found no other solutions prior to digital. The five features that really make the difference for me and my photography are: five-stop film latitude, nearly unlimited frames, longer lenses, flash sync speed, and an incredibly fast learning curve. And if I went into the business benefits of digital, we would never get on with talking about wildlife photography.

Five-Stop Range

The five-stop latitude is a benefit many will not understand at first. We talk about light in stops, and the fewer the stops, the better the quality of the light, generally speaking. We lust over light that's within a three-stop range, during those magical hours just after sunrise and just before sunset. We also describe film latitude in terms of the number of stops of light in which film can hold detail. Slide or positive film can hold detail in shadows and highlights generally within only within a three-stop range. Digital "film" (which is actually computer files contained on Compact-Flash cards) can hold detail in the shadows and highlights in a five-stop range. If you do not understand light and film, this concept can be hard to grasp (for a more in-depth explanation, refer to chapter two, page 80).

This five-stop latitude, which can be a great boost to your photography, needs to be used with care. I say this because we're accustomed to seeing the great photos with only three stops. All the luscious light we see in print was generally captured in three stops or less, so our preconceived ideas of great light are biased. Viewing an image with five stops of information tends to mess with the mind. We see more information than we are used to and more detail in that information. While at the moment this might look a little odd to the mind and subconscious, in time we will come to enjoy and depend on the extra information to successfully communicate. That's a digital advantage!

The five-stop range of digital might cause you a couple of extra electrons of thought to make everything work the way you are used to with conventional film. Where normally we would dial compensation in 1/3-stop increments with conventional film to make small changes in exposure, this increment doesn't make a big difference with digital and its five-stop range. You'll probably find yourself wanting to use 1/2-stop increments instead. This makes

subtle exposure differences in digital images that you're used to seeing in conventional. Fill flash also might need more exposure compensation with digital than conventional for this same reason. And on that same note, you might need to use a three-stop split-graduated neutral density filter with digital rather than the two-stop one that worked so nicely with conventional film.

The extended latitude of digital also extends your shooting. Depending on the early morning or late afternoon light, or the moment that perfect cloud comes between your subject and the sun, can really limit your shooting day. Working with an image capture system that can hold five stops instead of three extends your shooting day. The mere problem-solving ability of having a five-stop latitude is nothing compared to being able to shoot longer. That means more subjects, more time, more fun!

How can you not get excited about digital wildlife photography, knowing just this one attribute?

Virtually Unlimited Frames and Film Supply

Ever find yourself on frame 35 right when the action begins? How about when right in the middle of rewinding your film or changing it, the killer shot unfolds right in front of your eyes? I know it has happened to me more than once and it drove me nuts! This is not the case with digital. You have nearly unlimited frames with digital (at least shooting the way I do). A quick example of this is when you use a 512MB 24x Lexar CompactFlash card. Capturing Fine files, you can capture approximately 440 images on one card. That's nearly 12 rolls of film at your disposal, all in one roll of film! You can get more or fewer images, depending on the size of the files you're capturing and the type of card, but that's up to you and not the film.

Digital means no more frame 35, film rewinding, taking off gloves to change

FIELD TIP

Did you know one of your most powerful tools for communicating photographically is exposure? The combination of film latitude, light range, and exposure compensation can dramatically change what you're saying. Sadly, exposure compensation is thought of more as a way of fixing exposure rather than its truer purposes of improving and refining it. If you don't know what I mean, read and reread chapter two.

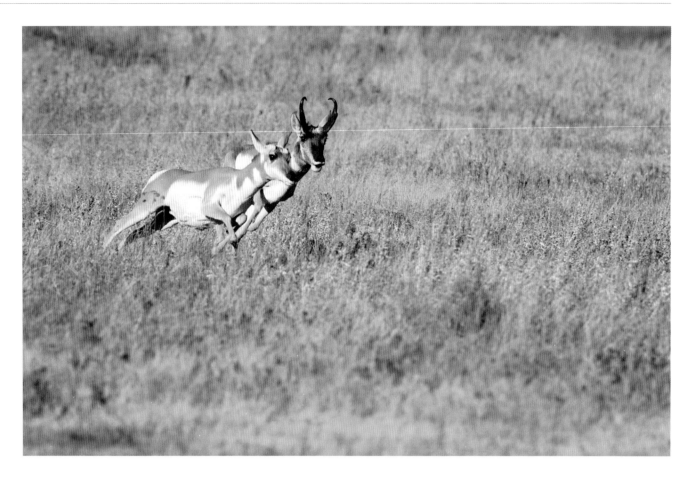

Pronghorn.
Photo captured by D1H,
400mm f/2.8D ED-IF AF-S,
on Lexar digital film.

film, any of that. Okay, so you can take more than 36 exposures at one time. Big deal, you might be thinking. It's true that, a vast majority of the time, having the ability to take more than 36 exposures without changing film won't make or break getting an image (unless you shoot action). But here's something you might not have thought of. Ever done any remote photography? One of the biggest drawbacks to remote photography is the 36-exposure limit. Typically, when shooting remotely, you're doing so because you can't get close physically to the subject any other way. By going up to the remote camera after every 36 exposures, you are probably scaring off the subject you're trying to stay away from in the first place. Imagine how nice it would be to have 440 captures rather than 36 (not to mention being able to instantly check if your remote is correctly set up, rather than waiting for the film to come back from the lab to find out).

Another HUGE benefit of this seemingly unlimited film is pocket space savings! I always mumbled about having bulging vest pockets that only held 25 rolls of film, sticking out from my body and making constant noise (not to mention always having to go back and reload my pockets once the 25 rolls were shot). This is not the case with digital. In a case smaller than your wallet, you can carry nine CompactFlash cards, the equivalent of 100-plus rolls of film. So in a case half the size of a checkbook, you can have 4,400 exposures riding around in your shirt pocket! This is one of the main reasons why I don't shoot wearing a vest anymore, since I don't need the vest to hold unexposed and shot film. Unlimited film taking up the space of a cigarette box. What a huge advantage!

Have you ever thought about the expense of shooting film? Of course you have, how could you not think about the cost of a roll of film and processing?

Say's Phoebe.
Photo captured by D1H,
400mm f/2.8D ED-IF AF-S,
on Lexar digital film.

FIELD TIP

For the photographer flying in these days of heightened security, digital is a blessing! With fewer and fewer airport security personnel available to do hand checks of film, digital can make for hassle-free flights. You see, digital film can go through X-rays without any ill effects. Not only does it take up less space and weight than film in your bag when flying, it won't give you one more thing to deal with when you're taking your shoes off at the security gate.

One thing I always dreaded about going shooting was the lab-processing bill when I got back home. Having to spend all that money to see my efforts always grated on me. This is not the case with digital film. The initial cost of digital media is about equal these days to buying and processing 30 rolls of film. Once digital film media is full, you upload the images into a computer and then reshoot (doing this on site and not having to wait until you get home to see your images). With conventional, after you buy the film and pay for processing you have to buy film and pay for processing all over again. Not spending money on film and processing means more money for time in the field and equipment!

FIELD TIP

Thinking about buying a longer lens, but just can't break loose with the bucks? Think about buying a digital camera instead! You can take your 400mm lens and make it a 600mm lens for less than it costs to buy a 600mm and take advantage of all the other aspects of digital photography.

There are other advantages to digital film besides having more than 36 exposures. One is the variable ISO. (ISO is the measure of film's sensitivity to light and therefore its speed. The higher the number, the more sensitive the film.) You can shoot digitally and literally change the ISO rating from capture to capture. You could be shooting at ISO 200 when a dark cloud covers the sun during some great action. To maintain a fast shutter speed, you could simply change the ISO to 400, 640, or whatever you need to keep on shooting, then return to 200 once the sun comes out. You might encounter more "noise" when you crank up the ISO (something like grain) but at least you have the option at your fingertip compared to having to change rolls of film. (I won't go into the ease of switching from color, to black and white, to infrared black and white, and then back to color from frame to frame.)

And while not a giant selling point for digital, you can send digital film through the clothes washer. What, you say? Well, I know of a couple of shooters who accidentally left CompactFlash cards in their clothes and washed them. The cool thing was, when they found them later, they simply dried them off, got the images off the cards, and went back to shooting. I've personally dropped a Lexar (my preferred brand) CompactFlash card into a stream, blew it out, and kept on shooting. You can't do that with a roll of film!

You're probably at this point saying something like, "This is all well and good, but what about the quality of digital?" Beauty is in the eye of the beholder! I say this because of an informal survey I've done for a couple of years. I put up three 20 x 30-inch (50.8 x 76.2 cm) prints and asked folks, about 500 total, which were captured by digital and which by conventional. It was great fun to hear everyone's theories why one print had to be digital and one was conventional. The reasoning understandably went along personal biases. The faces of folks were priceless when I revealed which was which. What's my point about digital image quality?

The vast majority of the images in this book (about 95 percent) are original digital captures. The vast majority of the images I've sold over the last couple of years and those in my last two exhibits have all originated as digital captures. The quality of digital is such that I can still sell my images, communicate my message, and make a living. All of this from original digital files barely 1MB in size. Digital photography is still photography and, if you get it right, right from the start, then the quality will be there just like conventional!

Longer Lenses

Digital gives you longer lenses! Simply put, you attach a 600mm lens to a Nikon digital camera and it becomes a 900mm lens (on a Canon EOS-1D, it's a 780mm)! This means that if you have a cool lens like the 80-400mm VR or 70-200mm VR, on a Nikon D1H it's equal to a 120-400mm or 105-300mm f/2.8 lens that you can handhold. To understand this better, refer to the "Digital Factor" on page 52.

A drawback to the digital focal length increase comes when shooting with ultra-wide and wide-angle lenses. A time when you want to get as much coverage as the lens can deliver is not the time when you need a 50% focal length increase. Of course, if you're shooting a landscape with digital, you can use a very old technique for getting wider shots that also works with digital: Move back! But since we're talking about wildlife photography more than landscape photography, this focal length increase is usually a good thing rather than a bad thing.

Faster Flash Sync and Learning Curve
Increased flash sync speed is a giant benefit of digital! Conventional 35mm cameras have a top, useable flash sync speed of 1/250; some have less. Digital tops out at 1/500! This one extra stop makes a BIG difference when it comes to fill flash. You'll read more about this in a moment.

The biggest benefit digital provides the wildlife photographer is an incredible learning curve! This point cannot be over-emphasized. In fact, let me say this again. The biggest benefit digital provides the wildlife photographer is incredible learning! I don't care what your level of expertise is, learning is a constant process if you're doing things right. Anything that promotes learning is a benefit, which is why digital is a good thing. This learning comes in many forms. Here are just a couple.

Take Blinkie Highlights, probably the best tool ever for learning light! Blinkie Highlights is a setting on nearly every digital camera. When you shoot a scene and then preview it on the camera's LCD monitor, select Blinkie Highlights (use Custom Setting 27 on the D1H/X and select Highlights) and the areas in the photo you have taken that are beyond the five-stop range of the sensor will blink at you! You see instantly where in the scene the light is beyond the latitude of the recording device. If you don't know light, this tool will teach you in a short time to see light.

This is something you cannot do with conventional film. Waiting until you get the film back from the lab is a painful way of learning what you did wrong. Not only can you not correct it to take the picture right, right from the start, you're dependent on remembering the lesson next time you go shooting. Remembering such lessons long after the fact is not our strongest suit, which puts digital way ahead!

On the flip side, some wildlife digital photographers use the LCD monitor as a crutch. That's not what I'm advocating here at all. All the lessons and techniques of wildlife photography over the ages apply to digital just as they do to conventional or even to George Shira's work a hundred years ago. Constant viewing of the monitor to see if you captured the image, especially at the expense of missing live action, is downright foolish! Use the tool for its intended use and you'll make the most of it—and you'll know it because your photography will improve.

One way of using the LCD monitor correctly is to check your composition. For example, most digital SLR cameras have only 96% viewing, which means what you see in your viewfinder is not what you're capturing. You're capturing more than you're seeing. For example, in the Nikon D1 family, the camera is capturing more of the subject on the right and top of the frame. If you compose your image to be perfect in the viewfinder not understanding this, when you look at your image you'll find a whole lot more space around the subject than you had planned. Using the LCD monitor to learn and then taking advantage of this knowledge is a good thing.

One of the best ways of learning is by experimenting. How many times have you thought of something and wanted to "play" but you were either low on rolls of film or simply couldn't afford to waste film experimenting? This is especially true when you know that more than likely your results are at best headed for the trash. That hurts!

Unlimited shooting without the cost when experimenting is a GIANT benefit of digital. One example I can think of is doing a technique I call blurs. This is when you photograph moving subjects while using really slow shutter speeds, down in the basement like 1/15! What are the odds of getting one great shot when you're shooting action with that shutter speed? For example, if you're shooting conventional, you can easily blow through ten rolls photographing

FIELD TIP

With digital, shooting vertical head shots can be a challenge when it comes to composition. Because the viewfinder only shows 96%, most photographers' vertical head shots turn out looking like poorly centered photos. This is really disappointing. Here's the trick. Turn your camera so the vertical firing button is at the top. Then compose so the subject's head is crammed right to the top of the frame. This will look wrong in the viewfinder, but remember, the viewfinder is only showing you 96%. The subject in the final image will have the proper compositional distance between it and the top of the frame.

Yellow-bellied Marmot. Photo captured by D1H, 600mm f/4D ED-IF AF-S with TC-14E, on Lexar digital film.

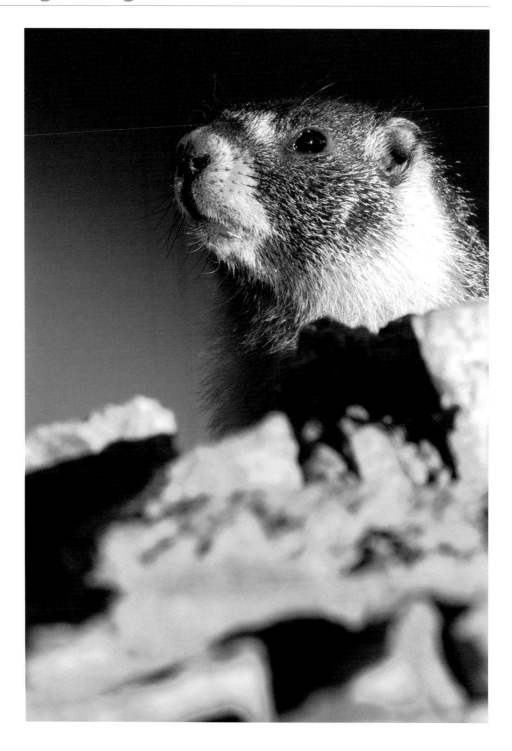

the sandhill cranes at Bosque del Apache, New Mexico and end up capturing only one great image. That's a lot of money for one shot! But with digital, you can blow through all the captures you want because you know it won't cost you a dime! If you don't like the shots or they didn't turn out, you just simply delete them and keep on shooting!

Experimenting with new techniques, tools, or ideas is how I personally come up with new ways of communicating photographically. With the financial restraints of this favorite pastime removed, I find myself experimenting more than ever. All of this experimenting is learning, something that shooting digital promotes!

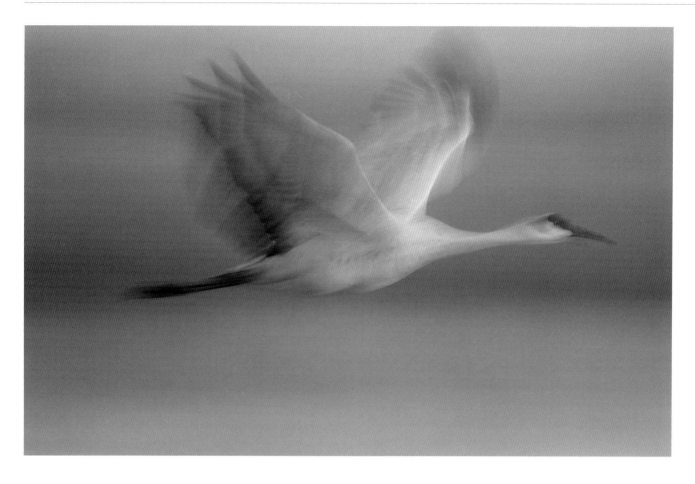

The biggest learning, though, from digital comes at night after you've been shooting all day. When I call up DigitalPro image management software on my computer and see the day's images appear, the wheels in my head start turning. I look at the images I captured and look for the weaknesses and strengths, I look at the experiments that worked or didn't work, I look at what I captured and what I need to go back and reshoot. Honestly looking at my photographs almost right after I've captured them has radically improved my own photography. Let me repeat that so there is no mistake in what I'm saying. Digital has radically improved my photography!

As I've said many times, I don't have all the answers, I'm learning something new everyday. Digital promotes this in every way. A big reason why I must shoot everyday is because I can't wait to see what I'm going to learn. The learning process excites me to no end so it's only natural that a medium that promotes learning excites me as well.

You don't have to shoot digital to be a successful digital photographer, that's not what I'm saying here. What I'm trying to communicate is why I switched to digital and no longer shoot conventional. It is as simple as: digital provides me more tools to solve the problems I face in my own wildlife photography. It will help you to look at these factors in your own photography, to make the most of the gear you use and the imagination that drives that gear!

The Megapixel Question
I'm bringing this up just to put my two cents' worth in on the topic. Camera manufacturers' marketing departments and some writers are working overtime

Greater Sandhill Crane. Photo captured by D1H, 600mm f/4D ED-IF AF-S, on Lexar digital film.

in the megapixel (MP) wars. The old American adage that more must be better is alive and well in digital camera marketing. Are more megapixels better, are they required for better image quality?

At the time of the writing of this text, 11MP cameras had just been announced. I was flooded with e-mails asking if I was going to buy them. Most were really disappointed when I said I was sticking with my 2.4MP D1H for now. Why would I do that when more is supposedly better, why?

In a very technical and mathematical sense, more is better but for the wildlife photographer, this is irrelevant. I can say this because I know what I've captured in images both conventionally and digitally over twenty years and have compared them. Even at 2.4MP I'm not "giving up" or "sacrificing" anything. In the barest of terms, if I were sacrificing quality I would simply be out of business. And nothing could be further from the truth.

I'm shooting with the Nikon D1H for the very simple reason it shoots 5fps. Frames per second (fps) is a huge consideration in camera bodies for me. While this is not up to the 8fps of the Nikon F5 or the Canon EOS 1D, it's the fastest Nikon offers at this time so that's what I've gone with. My consideration about camera bodies wasn't pixels but fps!

The "Digital Factor"

It is wrongly stated that digital "magnifies" the image. The digital factor for most digital cameras is a mere cropping of the image. This is because the CCD or CMOS recording sensor that converts light into data in digital cameras is smaller than the format of 35mm film. Nikon digital camera bodies have a digital factor of 50% while Canon has either 30% or no digital factor. When shooting with a camera with a digital factor of 50%, the effective focal length of the lens in use is increased by 50%. If you attach a 600mm lens to such a

digital camera, you have the effective focal length of a 900mm lens while maintaining the f/stop of the 600mm. It doesn't take rocket science to understand how this is a huge boost to the wildlife photographer!

What's occurring is that we have lenses designed to project an image that basically fills the 35mm film format. The problem is that the majority of digital recording sensors are smaller in size than a 35mm frame. This smaller size means that only the "center" portion of the projected image is being recorded. This is where the 50% focal length increase comes from, the sensor is cropping the 35mm image. This cropping is just like if you were to crop an image in an enlarger or in PhotoShop. This is why the f/stop doesn't change nor the depth or field, just the effective focal length.

I sure hope you weren't expecting to learn everything there is to learn on digital photography here. That requires at least a whole book to begin to cover that topic which is why I wrote *The D1 Generation* (Moose Press, 2001). My goal in this part of the text is to make you aware of the problem-solving abilities that digital can bring to the wildlife photographer. Perhaps you haven't given digital a thought (keep in mind the majority of the images in this book were taken digitally) or you have digital but hadn't connected all the dots yet. In either case, hopefully this section has been beneficial to you!

What's Up with Conventional Film?

No, conventional's days are not numbered, far from it! You should take comfort (perhaps) in knowing that I'm the only pro wildlife photographer using digital for 100 percent of his shooting (at the time of this writing, though some are starting to make a move). There are a lot of reasons for this; the biggest is simply that conventional is a

Parakeet Auklet.
Photo captured by F5,
600mm f/4D ED-IF AF-I
with TC-14E, on Agfa RSX 100.

known entity with the majority of the bugs worked out of the system. So you're not alone if you're still shooting conventional film, not by any stretch of the imagination. Conventional still rules the roost of wildlife photographers.

Four Advantages of Conventional Over Digital

There are some important features in your conventional camera body you need to have and take advantage of to be the most successful. These are actual advantages of conventional over digital. Don't take these lightly because they are big advantages! The four conventional features you need to take advantage of

are film advance speed, film rewind speed, viewfinder, and TTL flash.

Film Advance Speed

The one thing I miss more than anything else with digital is the sound of the motordrive ripping at 8fps! There is no more satisfying sound in photography than an F5 blasting away. The reason, that sound indicates that action is happening, images are being made and that when the film gets to the light table, great action photos and sequences are sure to appear. A fast motordrive is a must in wildlife photography!

The minimum for success is 5fps with 8fps or 10fps being preferred. Why is that? It really has to do with human response time. We don't need a fast firing rate for the portrait or the scenic, we need it for the action shot. To capture the action shot, we kind of need luck on our side, luck we create! In theory, you can see the action shot, squeeze off a frame and you've captured it. In reality though, we can't work that way. By the time we recognize the action shot, squeeze off a frame and the camera takes the photo, the shot is long gone. Capturing that perfect action shot requires anticipating the action, firing a hair before it starts, and then letting the motordrive do the rest!

The typical scenario is we see the action begin to unfold so we frame it in the viewfinder. If it does unfold we depress the shutter release and pan with the action to get a tack-sharp image. We concentrate on focus and composition to the point where we're not actually looking at the movement of the action, just the action as a subject. We rip the film from the beginning to the end of the action and it's not until the film hits the light table do we know if we captured the shot. What we're doing is taking advantage of techniques such as panning and features like autofocus and combining them with that fast film advance to create the luck we need to capture the action shot. While there is a lot of skill involved in making the shot happen, it's still luck that in the sequence of film we ripped off, we captured the shot. The faster your camera body can advance the film, the better the luck you'll have capturing that shot!

Fast Film Rewind

Just as fast film advance is important, so is lightning-fast film rewind! This incredibly important feature is often not even considered by conventional users. Fast film rewind along with film changing is essential when the action is happening. There are so many examples I can think of where the F5's rapid film rewind made the difference in getting the shot or not. Just like what I was just talking about, the need to create our own luck in capturing the action shot with a fast film advance, we're building on or enhancing it with a rapid film rewind. What's fast? I always pushed myself to have a six-second film rewind/reload speed when shooting conventional. That's six seconds to rewind, remove and reload with a new roll of film. And those six seconds seemed sometimes to last forever (especially if I was wearing gloves)!

A famous nature photographer was quoted as saying, "I never look when I'm reloading film, I don't want to see what I'm missing." That's really the point of the fast film rewind, minimize the great images we miss while we are reloading the camera!

Viewfinder

Composition is such an important tool for communicating successfully that the viewfinder becomes extremely important. Obviously we have to have one; that's not my point. It's the kind you have that's important. Conventional bodies have it over digital because conventional offers viewfinders with virtually 100% accuracy. This means we can compose right in the viewfinder without any post-processing thinking and get the right image right from the start. With a 100% viewfinder, you see exactly what

you're going to capture right from the start. Now, as a person who can't chew gum and walk down the street at the same time, this is important to me. When our goal is to remove as many variables as possible so all we do is concentrate on the subject, a 100% viewfinder is a biggie!

TTL Flash Plus Two More Advantages of Conventional

Flash is a critical tool to the wildlife photographer and TTL flash is the essential tool for making that all work. TTL (through the lens) flash means the flash exposure is measured through the lens. Digital simply doesn't compare to conventional when it comes to TTL flash. I will explain flash and fill flash in a moment. I just wanted to point out that when it comes to conventional camera bodies, TTL flash (especially in the Nikon conventional system) is a giant advantage that you need to be aware of and take advantage of in your wildlife photography!

There are two other advantages to conventional over digital but they aren't really wildlife-oriented. The "digital effect" makes using ultra-wides a little more challenging. This of course is not the case when shooting conventional. Not only do you get the complete coverage, the angle of view the lens was designed to deliver shooting conventional, but you have a 100% viewfinder in which to compose. When it comes to taking down-and-dirty, fast scenics, this is an advantage.

The other big advantage of conventional is long exposures. Since switching to digital, I've had to stop taking star trails. That's because digital does not lend itself easily to exposures longer than 30 seconds. Since star trails only start getting good around two hours, and are even better the longer the exposure, digital star trails are out.

Three Camera Body Features you Want in Digital or Conventional

There are many features in camera bodies today that conventional and digital share. Some of these features not only make your photographic life a heck of a lot simpler and more fun, but make your photography more successful more of the time. The three I feel are essential to have (and you must take full advantage of) are Autofocus, Matrix Metering, and TTL Flash. (Although, as I said above, TTL in conventional cameras is superior to digital TTL.)

Autofocus

Autofocus was such a hot topic a decade ago when it was just being introduced. Today it's almost ignored, both the fact that it's a feature and how to make the most of it. With both Nikon's and Canon's superior AF systems, it amazes me that many wildlife photographers fail to take full advantage of this feature. Yeah, they have it turned on but they've not taken the time to fine-tune both the user interface and operation to maximize this very powerful tool!

I need to emphasize this point: our quest is to eliminate as many variables from our photography as possible! Variables such as focus and metering can be handled by our cameras these days, so all we have to do is concentrate on the subject. When your attention is devoted to the subject and not the mechanics of making a photo, your photograph will jump in quality and content. How can I say this? Because I've seen it happen in my own photographs as well as others! You should reread this paragraph over and over until you understand this fact. I'm very tempted to cut and paste it three or four times just to make my point. You want to remove as many variables as you can from your photography so all you're concentrating on is your subject!

Today, modern autofocus has evolved to where it can track your moving subject

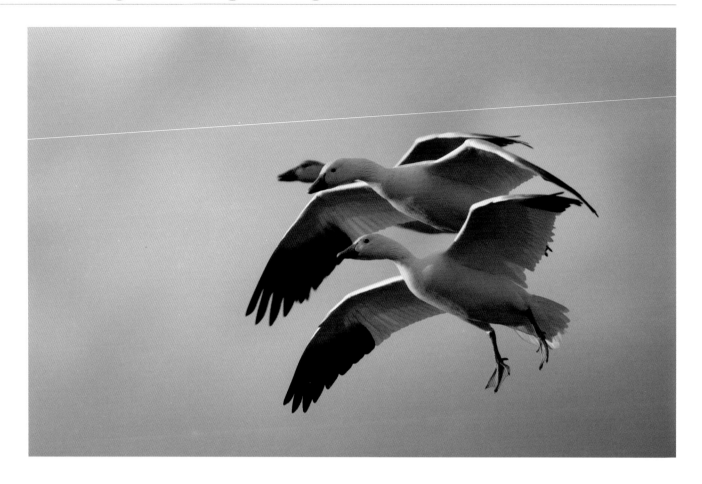

Snow Geese.
Photo captured by D1H,
600mm f/4D ED-IF AF-S,
on Lexar digital film.

while you're moving. Nikon calls this Dynamic Mode and it's engaged when you see five + signs in the camera's LCD inside the focus brackets. If you don't see, this then you're not using Dynamic Mode and you're making yourself work harder and focusing a giant chore!

No matter whether we're talking Nikon or Canon, their autofocus systems permit the camera to do much of the focusing work for you. The key is maximizing this technology! Let's use a flying bird as an example. You have a snow goose flying from left to right. You bring your camera up to your eye and you place any AF sensor on the subject's eye (in this case, I personally would place the center sensor on the eye). You then pan with the goose as it flies left to right (using proper panning, which I'll discuss in a moment). As you pan, if you change the composition of the bird in the frame or it gets ahead or behind in your pan, the camera will automatically, without telling you, switch

the AF sensor so the sensor tracks the subject and the eye is kept in focus. This is the beauty of Dynamic focus!

If, while you're photographing this snow goose, the lens starts searching, this is not a problem with the camera system. This is what we politely call pilot error. A lens searching for focus is an indication of very bad panning technique. You weren't successfully keeping the AF sensor on the subject and, once you break that connection, the camera starts searching to find it again. Most of the time the photo will be lost because we simply don't have the time to reconnect with moving subjects in the small window of time we have.

Another key component to making Dynamic Mode work is, you must move the camera with the subject! You cannot lock the camera down and expect the AF sensors to track the subject for you. It won't work that way! You must be

panning with the subject for the Dynamic Mode to be activated. Anything short of that and it won't engage. The cameras do not tell you that Dynamic is engaged either. There is no special light, AF sensor brackets don't light up, it just works. And to be honest with you, that's a good thing, because it would just be one more thing to distract you from the subject if it were there.

Autofocus permits you to rapidly lock focus on the subject, and this is a huge benefit! The vast majority of the time, the element of the subject we're focusing on is the eye. This is the one thing in our wildlife photographs that must be in focus. This is just the way it is; there's no way around it. What if the eye doesn't naturally fall within one of the AF brackets in your composition, but you want to take advantage of autofocus? Not a problem, just don't focus on the eye itself but on some other body part that is the same distance from the film plane as the eye. What am I talking about now?!

Let's use that snow goose as an example again. It's standing there, all teed up for the perfect vertical portrait. The eye, though, is nowhere near an AF sensor. In this case, you could use the center AF sensor and focus on the bottom portion of the breast, where it starts to curve down towards the legs. This lower portion of the breast is the same distance from the focal plane (digital or conventional) as the eye, so when you focus on it you'll see the eye come into focus. You could also think of the bottom of the breast as being on the same plane as the eye. What if this method of getting the eye sharp still doesn't work, what next?

Not to fear, Nikon is here! As I mentioned in the lens section, I have Nikon AF-S lenses just for their M/A (Manual/Autofocus) feature. The M/A feature permits you to manually focus even when in the AF mode. All you have to do to take advantage of this is to depress the shutter release partially to activate the system and then manually

focus normally. The camera will focus and hold the focus point you have obtained as long as you depress the shutter release. Once you have taken your photo and you no longer want to manually focus, simply let up on the shutter release and then depress it again. This brings you back to AF operation. This is the ultimate in maximizing AF as far as I am concerned. I can't live without this feature!

Whether shooting with Canon or Nikon, the principle for selecting the correct AF sensor for capturing action is the same. Your first thought should be of composition and communication of movement. This requires analyzing and planning the photograph before it happens. What do I mean by this? Capturing action requires having some idea of where the action is going to occur, which direction the subject will come from and go to. It also requires knowing how you want to capture that action and communicate it photographically. The flight photo of the Ross' gull on page 58 is a good example of what I'm talking about.

On a safari to Churchill, Canada, I had set up at the confluence of a creek and the Churchill River where I'd just photographed the Ross' gull, which I had observed for an hour the prior evening. I noticed that it would leave the riverfront at the confluence of the creek, fly up the creek and forage, and return back to the river front in a short while to restart the process. So I stood there, set up, figuring it would do the same thing this next day.

Knowing the direction of the wind, I figured the gull would fly in from my left to take advantage of it. Based on this instinct, I selected the left AF sensor. When the gull came back, I just put the left sensor on the gull and panned with it as it flew from left to right, right in front of me. The left sensor permitted me to keep the bird on the left side of the frame as it flew in. This helped to communicate the movement of the gull flying through the frame, the gull on the left and space on the right. Then as the

FIELD TIP

It is VERY important that you understand something about the relationship of AF sensor placement and metering in the Nikon system! In Matrix metering, the metering will bias its determination of exposure based on the active AF sensor. This is totally logical because the computer is saying to itself, "This is the subject because this is what I'm focusing on, so this is what I need to expose correctly." When you select an AF sensor, you're telling the camera that that's your subject and that's what it should meter on. But if you're focusing on a breast to get an eye sharp, the AF sensor is not on your subject and therefore might expose incorrectly for the eye. You must understand this because this can affect your images!

Ross' Gull.
Photo captured by F5,
600mm f/4D ED-IF AF-S,
on Agfa RSX 100.

gull got closer and filled more of the frame, the dynamic focus of the F5 took over to produce the image you see. You can see that taking advantage of the AF technology required an understanding of basic biology!

The subject's size in relation to the total picture area has a lot to do with which sensor to activate as well. (Like everything in photography, there are still choices to be made, compromises.) Here again, the main consideration is placement of the subject in the frame, especially the animal's eye. What do I mean by this? For a subject that's traveling left to right and is small in the frame, say it fills less than one-fourth of the entire frame, the left sensor would be the sensor to select. If the subject fills half or more of the entire frame, you might want to select the center sensor. Does this mean a bigger subject will be more centered in the final photo than the smaller subject?

The subject's eye might be centered if it's a horizontal format, but not the entire subject. Remember that above all else, the subject's eye must be in focus. And if the subject's eye is in the center of the frame, more than likely the rest of the body will be to one side of the frame, leaving space in the direction the subject is traveling through the frame to communicate movement. That's a win-win shot! What if it's a vertical subject? Well, I've found this also applies to verticals, as there is less space in front of the subject because of the vertical format. But the eye won't be centered in this instance, which really brings me to my next point.

Realizing when to turn off the AF is important because AF is not for every photograph. First of all, you'll make your batteries last longer if you're not using the AF all the time. This can be critical if you're doing a lot of shooting during a day's time. Next, for shooting static

scenes or subjects such as landscapes or grazing bison, there is little chance you'll need the quick response time of the AF system to capture action. But there is still another instance when I typically turn off my AF.

Photographing nesting birds, especially when they're incubating eggs, is a prime example of when I turn off the AF. The reason is simple: I want the eye sharp. Typically, the bird will be sitting on its nest, watching every movement I make. It will also move its head, peering left to right, right to left, scanning for other possible predators. In this scenario if I were using AF, there would be a really good possibility that the head and/or eye would move from the AF sensor, sending it searching for a focus point. Typically when you're this close, placing the active AF sensor on the breast or another focus point is not a viable technique to keep the eye sharp. So, I manually focus on the eye and let the head turn as it may, knowing the eye focus point will remain basically the same.

Interfering twigs are another reason why I turn off the AF. Working in a forested area, or perhaps at a marsh where there is a lot of grass, I tend to turn off the AF because of my mistakes. In the process of following the subject through the lens, not shooting but waiting for the shot, I can easily lose the subject for a moment in the viewfinder. If I do this and then reactivate the AF system and it finds a twig to lock onto, I've lost valuable time to relocate the subject and refocus. Now the F5's Lock-On system works great at not seeing twigs and the like when you're locked on a subject, but I'm talking about pilot error here, not camera.

And what about those situations where subjects are coming into a predetermined point like birds flying into a nest site or when you're using a WaveSensor (a remote triggering device)? In these instances when I've pre-focused on a particular point, waiting for the subject to come to that point to capture the image, AF doesn't assist in getting the image. More than likely, when you're in this situation and in AF, if you activate the AF a fraction too soon, it will focus past the predetermined point and you'll miss the photo.

Speed is one thing everyone is seeking with AF lenses and bodies. I'm here to tell you, folks, that to obtain the speed you're looking for, you need to be on top of your photography game. Speed takes more than just buying Nikon AF-S lenses. Some photographers measure AF speed by focusing a lens from its minimum to maximum focusing distance and seeing how long that takes. That's not how I've ever focused, manually or with AF. Pre-focusing, in my opinion, is essential in capturing action in focus the majority of the time.

As I mentioned above, capturing action is a lot easier and more successful when you have an idea of where the action will be coming from. You should also have an idea of the image size of the subject you want to capture. In this process, you should prefocus the lens to the approximate distance to achieve your goals. It's simple, just focus on a point the approximate distance you expect or want the subject to be. What are the advantages of this?

First and foremost is speed. Speed in that the lens will have to travel less and the camera searches less to get the subject in focus. Speed in that you can see the subject from semi-focus to in-focus, enabling you to be able to follow the subject and get the AF sensor on the subject where needed. Speed in that you can find the subject in the viewfinder to start with.

Maximizing AF technology takes more than just owning it. It requires knowing and using the fundamentals of photography. It requires knowing and applying basic biology to know where, when, and how the subject is going to move. It requires you be the best photographer you can be in combining all these things. Maximizing AF technology is really no more than applying basic techniques to

White Ibis.
Photo captured by D1,
600mm f/4D ED-IF AF-S
with TC-14E,
on Lexar digital film.

new technology. I guarantee you'll capture more sharply focused images while having a heck of a lot more fun.

Matrix or Evaluative Metering

I don't care if we're talking the F5, 1V, D1H, or 1D, the Matrix/Evaluative metering system inherent in these bodies is killer! Are they perfect? Well, in my humble opinion that really depends on the photographer and not the camera bodies. Can they be fooled? One example of this can be found in my previous tip (page 57). But then, you're the one actually causing the fooling. I can honestly say I've shot with all four bodies I've listed and only in their respective "overall" metering modes and had nothing but great results! As far as I'm concerned, all other metering options can be removed from the cameras and the

remaining memory space used instead for something more useful.

Keep in mind that, in this process of not having any metering problems and getting the perfect exposure time and time again, I was able to achieve these results because I understand the most important element in exposure. Light!

I'm sure you've heard, read, or been taught in a workshop that a gray card is a must, or some really complicated spot/center-weighted system. You've seen beautiful results by using these systems, which lead you to believe they are the only way. Well, obviously these methods do work, you've seen it. But on the other hand, if you look at all the images in this book, they were all taken using Matrix metering. Nothing complicated, no mental hoops to jump through, just select it on the camera. The choice is really yours. You can adopt the difficult or the easy way of getting the right exposure. They all bring you to the same exposure, they just have different routes. One difficult and one easy.

Let me mess up your mind a little more on metering by giving you this additional thought (with all the conflicting articles on metering, you have good reason to be confused). If our goal is to eliminate as many variables as possible so we can concentrate on the subject, which one of these metering systems does that the best for you? How many photographs have you missed because you were busy trying to work through gray card/spot/center-weighted metering computations? More to the point, are you having fun doing all of it? Please note, exposure is not a four-letter word!

Okay, if I have all the metering answers, where is my magic formula? I've given all of it to you already but you might have missed it, so here it is again. Matrix/Evaluative metering and light, that's it! Matrix/Evaluative metering takes no more than dialing in the metering mode. Light, well, that's a whole different matter and you'll read about light in the next

chapter. But since light is what photography is all about, once you learn it, not only will you have no metering problems, you'll have the best photographs you can possibly capture! But I think you'll agree that the gray card/spot/center-weighted metering mumbo jumbo that folks have been writing about for twenty-plus years just isn't working. If it were, folks wouldn't have to keep writing about it. I'm here to tell you that if I can make my very simple, non-calculating system work, you can too!

Flash

One of the most essential tools for the wildlife photographer is flash. One of the most complicated and least effectively used tools in wildlife photography is flash. The first and foremost rule for successfully using flash is knowing, seeing, and understanding light. Let's face it, the odds are stacked against you big-time when it comes to successfully using flash. For that reason, I highly recommend you reread this section many times until it all sinks in. It literally took me two years before it all sank in to my thick skull!

The cornerstone for flash work for the wildlife photographer is TTL flash. If your camera body doesn't have TTL flash, sell it now and buy one that does! One of the main reasons I have always shot Nikon is because I feel their flash system is the easiest to use on the fly. It requires very little brain power which for me is a big boost! But whatever brand you shoot, learning to use flash and fill flash is a must!

Being good with flash requires that you understand light. You can't get away from knowing light in photography and this is especially true for flash! Why is this? You must understand the deficiencies in the available light in order to know when and how to apply flash. When you have been given the gift of great light, you don't want to even mess with it. When you've been cursed with horrible light and a great subject, you

FIELD TIP

One of the best ways to learn flash these days is to shoot digital. Being able to instantly see the effects of your flash is a giant boost to learning flash. Even better is the ability to take before and after shots and then instantly compare the two before moving on.

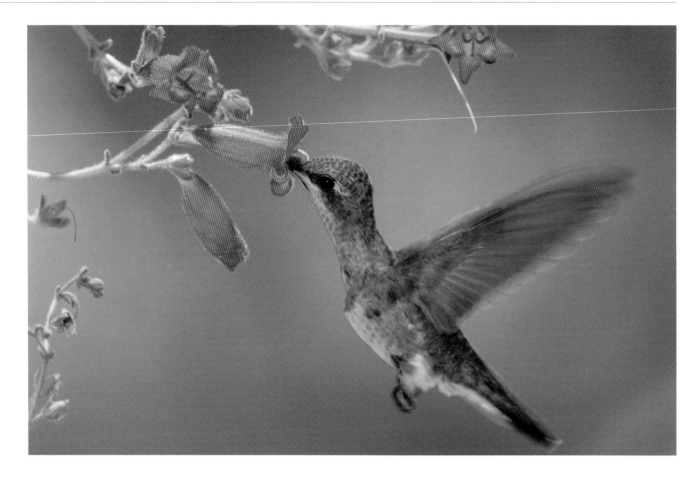

Black-chinned Hummingbird.
Photo captured by D1H,
600mm f/4D ED-IF AF-S
with TC-14E, on Lexar digital film.

must know how to use flash. Flash is a portable light source and its sole purpose is to fill in when natural light stinks! You first need to understand how the system works to make the most of it.

More about TTL Flash
TTL Flash is a really cool system originally invented by Olympus. It works this way. There are two computers, one in the camera body and one in the flash. The two talk to each other about the light being emitted by the flash, doing this instantaneously. Truly amazing technology! When you take a photo using TTL flash, the shutter opens and the flash fires. The light from the flash races towards the subject, lights it up, and then that light bounces off the subject and races back to the camera. The light enters the lens, bounces off the actual film, and hits a metering sensor in the bottom of the mirror box. At this point, the computers

go to work. The light that is striking the metering sensor builds up (not the same metering sensor as the ambient light meter), and once enough light has been received for a proper exposure, the flash is turned off. Boom, you have the perfect flash exposure.

Compared to the old days when we were restricted to aperture and flash-to-subject-distance for proper exposure, TTL flash is killer! TTL flash permits us to use a flash like a light bulb, turning it on and off as we see fit. TTL flash gives us control over depth of field that we never had before. And most importantly, TTL makes flash a no-brainer to use!

This is all 100 percent true for conventional but it's not for the digital shooter. Digital photographers don't have film for the light to bounce off, and that's a biggie. Because of that, we have to work with an OTL (outside the lens) system and not a TTL system. Because of this,

some older digital bodies make flash work nearly impossible. The best thing to do is simply take some test photos if you don't know about your digital system and see for yourself what's working best for you. (If you're a Nikon D1 family shooter, I highly recommend you read the lengthy flash section in my book, *The D1 Generation* to get the most out of your camera's flash system).

Because of TTL, we can use flash at its full effectiveness when we see exposure and color deficiencies in the ambient light. In a perfect world, we would be able to shoot in the fall in Alaska, where the sun never gets very far above the horizon for the entire day and gorgeous light covers every subject. Needless to say, this is the exception and not the rule. This is why we must know how to use fill flash and the first step in making this happen is knowing light. When ambient light is beyond the range of our film's latitude, we use flash to fill in the shadows. This is why it's called fill flash, it's filling in shadows.

Filling in shadows can be a tricky business. The amount and direction of the flash must be such that no one can tell you used flash. This means, of course, that you must understand light, ambient as well as flash. The most common solution for fill flash is flash directly over the lens. This option puts the shadow created by the flash behind the subject and out of sight while the flash lights up the subject. While this lighting pattern works cleanly the majority of the time, it is the least sophisticated and so creates the least amount of drama. But placing the flash over the lens is ideal for the most common use for fill flash, bird photography.

Fill flash in wildlife photography is used the majority of the time in photographing birds. And since the majority of the time birds don't hold still long enough to use any other lighting pattern, the flash is held directly over the lens. To physically accomplish this, I recommend the Wimberley Flash Arm. The beauty of

this flash arm is that you can rotate your camera/lens to either horizontal or vertical and the lens remains directly over the lens.

The big question always is, "How much flash fill do I use?" There is no one correct answer. You'll know you've got the perfect amount when nobody can tell you used flash in the final photograph. Getting there takes time because flash is the hardest of all photographic techniques to master. A good beginning point is -1/3 to -2/3 compensation. At the same time, if you're using the Nikon system, you must be sure you're in control of the flash exposure. This means you must be in what Nikon calls Standard mode. (Depending on the body/flash combo, this is achieved in different ways. Consult your instruction book for the exact combo for you).

What if you're shooting digital? Using fill flash with digital all depends on the body you're using. With the D1, you need to set the flash to A and not use the TTL settings at all. If you're shooting with the D1X/H, you can use the TTL setting, but because you're using an OTL system rather then TTL, you don't want to be in Standard mode. It's at this point you should be getting confused.

If you want the answer for fill flash, you must find it for yourself! Because we all have different ways we shoot and want to communicate, we're all going to have different preferences for fill flash. At the same time, we all use different cameras, bodies, films, and film processing, or we use different digital bodies. We need to test to find the right answers for ourselves. I know of no better way than the Teddy Bear Exercise.

Teddy Bear Exercise for Flash
In many instances, using just one flash isn't enough, requiring the use of multiple flashes. Understanding the effect of multiple flash on a subject is key to successfully applying it in a variety of situations. This means you need to have a

FIELD TIP
The last place you want to place your flash for wildlife flash fill is in the camera's flash shoe. While this sort of works when shooting horizontally, it doesn't work at all when shooting vertically. When you rotate the camera vertically with the flash in the shoe, the flash goes to the side of the lens barrel rather than remaining above it. This means the shadow created by the flash will fall to the opposite side of the subject (from the flash) and will be seen. So you'll create as much contrast as you eliminate!

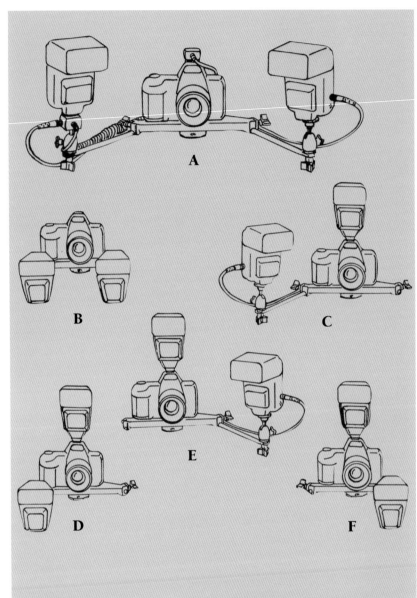

A. Two flashes out 45 degrees
1. ABFF
2. ST
3. ST, flash -1/3 stop
4. ST, flash -2/3 stop
5. ST, flash -1/3 stop, ambient light -1 stop
6. ST, flash -2/3 stop, ambient light -2 stops

B. Two flashes next to lens
1. ABFF
2. ST
3. ST, flash -1/3 stop
4. ST, flash -2/3 stop
5. ST, flash -1/3 stop, ambient light -1 stop
6. ST, flash -2/3 stop, ambient light -2 stops

C. One flash on top, one out 45 degrees
1. ABFF
2. ST
3. ST, flash -1/3 stop
4. ST, flash -2/3 stop
5. ST, flash -1/3 stop, ambient light -1 stop
6. ST, flash -2/3 stop, ambient light -2 stops

D. One flash on top, one next to the lens
1. ABFF
2. ST
3. ST, flash -1/3 stop
4. ST, flash -2/3 stop
5. ST, flash -1/3 stop, ambient light -1 stop
6. ST, flash -2/3 stop, ambient light -2 stops

E. One flash on top, one out 45 degrees
1. ABFF
2. ST
3. ST, flash -1/3 stop
4. ST, flash -2/3 stop
5. ST, flash -1/3 stop, ambient light -1 stop
6. ST, flash -2/3 stop, ambient light -2 stops

F. One flash on top, one next to the lens
1. ABFF
2. ST
3. ST, flash -1/3 stop
4. ST, flash -2/3 stop
5. ST, flash -1/3 stop, ambient -1 stop
6. ST, flash -2/3 stop, ambient light -2 stops

working knowledge of flash functions and their effects on a subject.

This exercise is designed for either the Nikon or Canon system. You'll need an appropriate bracket (I use the Wimberley system) and connecting cords so the gear can communicate with each other. The only other thing you need are subjects, the best being a small black and a small white teddy bear with glass eyes (which will reflect the highlights of the flashes).

Set up your subjects approximately 5 feet (1.5 m) away in an area where the background is neither in full sun nor in deep shadow. Photograph the teddy bears, using the lighting patterns as illustrated.

All of these are to be shot in the TTL mode. The flash units are to be set in either the Automatic Balanced Fill-Flash (ABFF) or Standard TTL (ST) as described above. Flash compensation is also set in the manner previously described. All exposures are to be made with camera set in aperture priority mode, except when the ambient light is underexposed; in this case, the camera should be set in manual mode.

Using Flash for Color
A very important use for flash, which most wildlife photographers do not take advantage of, is for color. Here again, bird photography is the main application of this. Birds' feathers are designed to reflect light and as such, reflect color. When there is no direct light to do this, there is no color. This is when you need to apply fill flash for color. When ambient light is deficient in this way, it's difficult for photographers to recognize. But when we don't, we have flat-looking images.

What in the heck am I talking about, right? This is something that doesn't take many words to communicate because it is as simple as bringing color to the photo. This is something that is better understood by just looking at the before and after photos.

Mountain Bluebird.
Captured By D1H,
600mm f/4D ED-IF AF-S,
on Lexar digital film.
The top photo was
exposed with existing light;
photo on left was captured
using flash fill.

What setting do you need to make to use flash for color? You can use flash with your normal fill-flash compensation, but you don't really need that much light. If I'm using flash just for color, I personally knock down the compensation by one whole stop less than normal fill-flash setting. It takes real little direct light to bring out the color in a subject, so I save

batteries and increase recycle time by simply knocking down the light.

Are there times when fill flash is needed but I don't use it? For me, you bet! I personally never use fill flash when photographing big game. Elk, sheep, moose, and other big critters look horrible when photographed with fill flash.

**Santa Cruz Kangaroo Rat.
Captured by D1H,
60mm f/2.8D AF,
on Lexar digital film.
The top photo was exposed
using on-camera flash;
photo on right was captured
using off-camera flash.**

Besides worrying about such things as "red eye," you have to deal with the critters' fur. These big critters have two types of fur. One is designed to absorb light. In order to be effective with fill flash, we need tons of flash just to get past this fur that is sucking up the light. But the biggest problem is the fact that the second type of fur creates hideous specu-lar highlights. The outcome to me looks just plain bad, so I don't use fill flash with big mammals.

Flash Attachments and Accessories

Light from flash is not perfect, far from it a lot of the time. Because of this, there many flash accessories you should know

about. The one biggie that bird photographers should know about is the Better Beamer (that's the product name). The Better Beamer is a Fresnel lens that attaches to the front of the flash. There are many units like this on the market; they all incorporate the same identical Fresnel lens but they all have different holders that hold the Fresnel. This is the big difference and why I use the Better Beamer. The Better Beamer folds flat when not in use, which is a big plus when traveling!

These "project-a-flash" units are not meant to light up a subject a mile away. They are designed to increase our depth of field! The vast majority of the time, we're 60 feet (18 m) or closer to our subject so we can get the desired image size we're after. When photographing small dickie birds, we're often 20 feet (6 m) or closer. Your basic flash can light a subject this close, no problem at f/5.6, maybe even f/8. But if we want more depth of field and close the lens down to f/8, f/11, or f/16, the flash cannot put out that much light by itself. With the Better Beamer attached, though, we can utilize these f/stops and so achieve the depth of field we desire.

Another example of a great flash attachment is the Sto-Fen Omni-Bounce. The Omni-Bounce is almost an exact opposite of the Better Beamer, you use the Omni-Bounce when you're really close to a subject. The Better Beamer increases light where the Omni-Bounce reduces light. The Omni-Bounce's role in flash photography is to mellow out the light from the flash. It's called "Bounce" because the light from the flash bounces around inside the Omni-Bounce before lighting the subject. In doing this, the light is mellowed as well as reduced. You lose two stops of light using the Omni-Bounce but you have an incredibly beautiful light source!

Flash units need power, lots of power! There are many ways of getting power to flash units, the most common is simply inserting 1800ah NiMH rechargeables into the flash itself. I personally love the PowerEx batteries. They last and last! But that's not enough power, though, to permit the flash to recycle fast enough to keep up with the motordrive of the camera. In order for recycle time to keep up with the camera, I use the Nikon SD-8a powered with more PowerEx 1800ah batteries. Being two-thirds the size, weight, and price of other auxiliary power sources, the SD-8a battery pack is a slam dunk!

Supporting All of this Gear

Supporting your camera gear is essential. I'm not talking about financial support, even though that's a biggie, I'm talking about physical support. Proper handholding and proper long lens technique are essential tools you must not only know, but also have as second nature! We've talked about getting the subject sharp a number of times already. But your technique in holding the camera still when you're actually squeezing off the shutter release is essential in finishing everything you've started.

Proper Handholding
Proper handholding is not something I've made up, it's a simple technique commonly used. We're going to turn ourselves into a steady platform for the camera. This is done by first bringing our elbows into our side. We next make sure we cup the lens with our left hand so gravity forces it down into our hand (rather than grabbing the lens by the top and having gravity pulling it away). Lastly, we have an eyecup attached and we press the camera against our forehead. This gives us three points of contact and with practice, a stable platform for our camera.

Proper Long Lens Technique
Proper long lens technique came about when the very first telephotos, which were Nikon two-part units, were used in stadium stands. The vibration was killer

Semipalmated Sandpiper.
Photo captured by D1,
600mm f/4D ED-IF AF-S
with TC-14E, 18mm extension tube,
on Lexar digital film.

FIELD TIP

Many photographers don't use an eyecup because they think it's just for keeping extraneous light from entering the viewfinder. But the eyecup acts like a shock absorber between you and the camera. This little, inexpensive accessory can make a million-dollar difference in your images!

so this very simple technique was developed to stop vibration. Vibration can be created in many ways but the most common source is the photographer (the second most common is wind which, when strong, can stop photography completely). Proper long lens technique is no more than resting your hand on your lens barrel just as you would rest your hand in your lap. The one small but important detail is that you want to rest your hand on the lens barrel directly above the head of the tripod. Lastly, you want to press you eye/forehead against the eyecup. That's it!

With either technique, it is essential that you not start camera movement when

you actually take the photo. Most vibration is caused from the very act of depressing the shutter release. A lot of folks depress the shutter release the same way they push a stamp on a envelope. They come down on it really hard and push down. This almost always kills the tack-sharp qualities we're looking to capture.

You need to learn to roll your finger across the shutter release. Yes, this sounds goofy but it is essential. You rest your firing finger on the outer edge of the shutter release. You then roll it backward slightly to activate the camera. A slight bit more pressure from the finger fires the camera. This very subtle technique prevents unwanted movement and so helps capture sharp images.

A very common comment I receive from photographers is that the images they take on Sunday are better than the ones they capture on Saturday. The question is why is this? It's because on Saturday we're reacquainting ourselves with our gear and on Sunday it's an old friend again. It is essential that we practice these techniques all the time. How serious am I about this practice thing? Every day, whether I'm actually out shooting or not, I pick up a camera and practice proper handholding. I fire off frames and practice rolling my finger. I practice, practice, and practice so it remains second nature.

Tripods and Heads

You might be wondering about tripods and heads. I've kind of given up talking to wildlife photographers about tripods and heads because they don't seem to listen. I'm is constantly amazed how many lenses worth thousands of dollars are out there being held up by cheap tripods! Why do wildlife photographers insist on putting cheap tripods under their very expensive lenses? It drives me nuts!

I use only the Gitzo Carbon Fiber tripods, the 1548 and 1348. I went to carbon fiber for the very simple reason it weighs less while providing the same stability as metal. With the 30 percent weight loss (and face it, any weight I can lose is a good thing), the obvious gain in buying carbon fiber wasn't lost on me. The other giant advantage of carbon fiber is it can go into any environment! Mud, snow, sand, salt water, whatever it is, the carbon fiber can take it with no ill effect.

I have the two models of tripod for two different uses. The 1548 is for lenses with their own tripod collar: the 600mm, 400mm, and 300mm. The 1348 is for all other applications, when I'm shooting with the camera body itself attached to the tripod. The 1348 can easily hold the 600mm lens when the tripod is on solid ground; the problem is, there's not much solid ground in wildlife photography. Mud, sand, snow, and the like are very unstable and, in those instances, one needs the stability of the 1534 for the big lenses.

I've come to rely on two tripod heads for all of my work, the Wimberley and the Gitzo 1377. The Wimberley is a gimbal-style head that's the perfect platform for the 600mm and 400mm lens. The complete flexibility of the head along with its stupendous stability makes it the perfect head for photographing action and portraits. The Gitzo 1377 is an ultra-light magnesium ball head that provides maximum flexibility and support in a non-jamming ball head.

I wish I could bulk up the tripod head section with a whole bunch of trivia, but I'm afraid the excellence of these two units precludes much text. But these two heads are essential in panning, a technique that must be second nature to the wildlife photographer.

Panning Technique

Success in photographing flying birds comes in large part from properly using the technique of panning. This is a technique many have heard of but few use

FIELD TIP

When working in watery, mushy worlds, you need to do the following. Extend the last legs of your tripod all the way. By doing this, you keep water and gunk out of the leg coupler. When setting up in such situations, push the front tripod leg into the muck. This breaks the surface tension of the muck, providing your tripod a more stable platform on which to rest.

Rough-legged Hawk.
Photo captured D1H,
300mm f/2.8D ED-IF AF-S II,
on Lexar digital film, handheld.

effectively. There are really a couple of aspects of panning, which are essential for success: the combination of mechanical technique and aesthetic desires.

The goal of panning is to obtain sharp images of moving subjects. In this process, the movement of the subject is communicated by the blurring of the background. This combination makes panning an essential technique for wildlife photographers. The ability to obtain sharp images that communicate should be the goal for all of us!

I'm sure you can all quote this as you read along. Panning is accomplished by moving the camera/lens to track the subject, firing the camera while continuing to track the subject until after the shutter has finished firing. Well, at best, those are the beginning basics because the technique of panning needs to go farther than that to be successful.

Establish a "kill zone." The kill zone is a predetermined zone where we actually fire the shutter and take the picture. This is only a small portion of the actual area we physically travel through during panning when focusing on the subject. Lost yet? Let me explain this in another way.

You want to photograph the bird when the bird is heading towards or beside you, not going away from you (avoiding the butt shot). When setting up your pan (taking into account background and lighting), try to set up knowing the direction the bird will come from and where it will head to.

Let's say, in this example, that's going to be from left to right. The kill zone would be the area from where your left arm is held out nearly straight from your side to the area covered as you swing your arm until it's basically straight in front of you. This is nearly a 90° arc. This would

be the kill zone for birds flying left to right; the same would apply to the right arm for birds flying right to left. Whether shooting hand-held or with the lens on a tripod, this is the zone where you pan and fire. Once the subject is basically in front of you, you stop shooting (this is a generalization and not a rule carved in stone).

Setting and knowing your kill zone must take into account the background and direction of the sun. True, some great bird flight shots happen off the cuff, what we like to call a "surprise attack." But the great ones are also planned for, where the background and lighting not only isolate the subject but also bring drama to the final image.

You must look at the background differently than if you were taking a typical static image. You must remember when panning that the background will be a blur and you'll capture more background in the image than if you were taking a static scene. When setting up your kill zone, if at all possible, look at the entire background in your kill zone for colors or shapes out of the ordinary. Look for elements that, when blurred and combined with the other elements of the background, would stick out like a sore thumb. You have no idea as you pan when exactly you're going to press the shutter. So you want as much useable background as you can muster.

Now, many shooters prefer a blue-sky background. That's cool and something we can all relate to. But if you look at the really incredible flight shots, you'll more often than not find these photographs to have a blurred background from panning. There is always something special about them, as if they are almost the colors of a watercolor painting that have melded together. This mood-setting element is what brings drama to your flight photography.

The sun or lighting is really the easy part of the equation. The best situation is when the light is on your back and the subject is flying either towards you or parallel to you so it's front-lit. Any drama the light might have from a sunrise, sunset, or storm is even better.

Go out and practice, have fun with it, and make panning a technique you can rely on. If you're not comfortable with selecting backgrounds for panning, just go out and shoot some backgrounds as if something were flying in front of them. Take one static shot and one panning, get back to the light table, and compare them. You can easily teach yourself what to look and watch out for. In the process, you'll become better at panning with the camera either hand-held or on a tripod.

The great masters of panning are masters because they understand and use all these techniques and elements to communicate motion. The fact that their subject is sharp is the icing on the cake.

Filters for Thought

Just like a lens, body, or accessory, filters are tools you can use to improve how you communicate. I use filters freely when I think they can improve what I'm trying to communicate. There are three filters I depend on: the 81a, the Moose Filter (warm polarizer), and the split-graduated neutral density filter.

The 81a

"Why do you use an 81a?" This is a question I'm often asked because of my insistence on always using an 81a warming filter. I have one on every lens all the time no matter what. I even have hounded filter manufacturers to incorporate a warming filter with polarizers. I've always given the same short, brief answer for a long time to the question, "Why a warming filter?" But I thought I would detail my thought process behind its use, so you can decide for yourself if you should use an 81a warming filter to give your images that warm feeling.

FIELD TIP

Filters work with digital just as they do with conventional. Filters mess with light no matter what's capturing that light. In the case of the 81a, to make use of all of its potential, you want to make sure your white balance is set to any setting other than Automatic.

The Technical Side

Our brain can amazingly interpret the message from our eyes and present us with information that really isn't there, at least concerning color. White light is made up of colors, colors that, no matter how the light might change, we perceive as remaining constant. To our minds, white remains white even though physics says it's not. Film does not have the advantages or ability to render colors as constants no matter the source, as our vision does. Film is stuck with physics. We must not only understand this but also be able to adjust for and take advantage of this fact.

We talk about the light spectrum and measure it in terms of color temperature on a scale known as Kelvin. Strictly speaking, the color temperature of light is defined in terms of a value on the Kelvin Scale. All light sources emit electromagnetic radiation, some of which is in the visible region between 400 and 700nm (nanometers) in wavelength. The amount of radiation emitted at each wavelength, and the total amount of radiation emitted, varies from source to source. When material or an object (called a "black body radiator") is heated in a vacuum, it will glow in different colors depending on how much it's heated. As heating increases and the object changes color, each different color of the spectrum is achieved and the temperatures can be measured in degrees Celsius. To express color temperature on the Kelvin scale, add 273 to the Celsius temperature. In turn, the color temperatures of different light sources are also expressed as Kelvin temperatures. The fact that light sources approximate a black body in their spectral energy distribution, however, provides for a simpler means of specifying, at least approximately, the output of a source. (In case you want some more Kelvin trivia, 0° Kelvin equals −273.16° Celsius, which is absolute zero.) This is not technical information you need to know, heck, I didn't have it memorized. I had to look up this "trivia" but thought I would throw it in, just in case someone asks you to define it.

On the calmer side of this discussion, our daylight slide film, no matter the ISO, is rated at 5500 K. This is the standard color temperature for all daylight film. This is the temperature of your basic noontime light on your basic clear day at your basic low altitude (originally set on a July day in Washington, D.C.). This is probably why this temperature was selected as the standard. But don't expect to find this exact color temperature in the majority of the situations where you find yourself shooting. For example, on overcast days, color temp can be in the range between 6500 to 7500 K, in open shade 9000 to 11000 K (might be more on overcast days), deep shade 11000 to 12000 K (or more on overcast days). Throw elevation into the color temp equation and you'll find yourself at 8,000 feet (2.4 km) with a temp of a minimum 9800 K. Add to this elevation some other variables, such as overcast skies, and it could skyrocket! On the other hand, a 75-watt bulb is a mere 2800 K and a basic sunrise/sunset, 3100 K. Every one of these factors can affect not only how the subject is rendered on film, but also the way folks perceive a subject shot in this light!

The problem is that we don't typically shoot in light that is the optimum color temperature for our film. For that reason, we have filters. The Kodak Wratten 81 series (81, 81a, 81b and 81c the most common) has been the standard for dealing with color temperature correction for daylight film. The 81 series absorbs blue/green color, the color prevalent at the higher color temperatures. Depending on the temperature of the light present, you would technically apply the correct 81 filter to bring that temperature back within "normal" Kelvin range for daylight film. For example, your basic 81 filter (which nobody uses) might work well at sea level on a slightly overcast day. In open shade or up to about 7,000-foot (2.12 km) elevation, your 81a brings the color temperature back to 5500 K. Over

the 7,000-foot (2.1 km) mark but closer to 9,000 feet (2.72 km), the 81b might be needed to bring the color temperature back to that 5500 K benchmark. (I live at 8,200 feet [2.48 km] and still use just the 81a.)

Where does all this technical discussion leave us? You might now better understand the technical reasoning for the 81a warming filter but its use, at least for me, goes a lot deeper.

The Psychological Side

The psychological side of communicating is by far the easiest to understand and explain when it comes to applying an 81a filter. I know that for my own photography, this is the reason why I use an 81a. Yes, all that technical stuff still holds true, but that is not the reason why I first started or continued to use an 81a. An old boss first turned me onto the 81a long ago. He used it to warm up skin tones when shooting portraits. This has always been one of the prime uses of this filter, giving the subject a warmer tone to its appearance.

From very early on, I was turned on to using the Nikon A2 filter, the Nikon equivalent of an 81a. I first started to use it just for portraits. But then I left it on when shooting scenics and noticed I liked what it was doing. No, I wasn't shooting during those times when I should technically be using the filter. Rather, I was adding warmth to the image for the sake of the warmth. I was and still am—hold on to your seats now—manipulating the image! There, I said it, it's out in the open now and I feel much better, I'm manipulating the image by using an 81a.

Let me explain what I mean by warmth and how it's psychological in its effect. When photographing a coyote (not that far removed in folks' minds from the big, bad wolf that chased Red Riding Hood through the woods), we can depict the coyote as either menacing or friendly. The difference between these two emo-tional responses to the same critter can be as simple as the use of an 81a filter.

No matter the light the coyote may be in, be it noon sun, open shade, or 9,000 feet (2.72 km) in altitude, it will have a slight blue tint to its pelt. The degree of blue in that pelt may vary, but it's there and it has an effect on how the viewer of the photograph perceives the coyote. It comes across psychologically as cold and menacing. Someone viewing the image isn't going to say to themselves, "Man, this looks cold, too much blue, must be menacing," they just won't have a positive response to the image.

Now take this same coyote with the blue tint and add an 81a to the lens. The filter removes the blue tint from the pelt, warming up the pelt and our mental perception of the coyote. We now have a warm and fuzzy coyote and we're a step closer to grabbing someone's heartstrings. Humans go for warm tones; we embrace them psychologically and accept them even though the subject might be traditionally associated with "evil."

Now why is all this mumbo-jumbo important to our wildlife photography? I mean, really, I didn't mention f/stop or shutter speed once, how can it relate?

Remember when I talked about the eight-second attention span of the average person riffling through a book or magazine? I depend on the 81a filter to break that eight-second barrier!

I depend on my photographs to grab not only folks' attention but also their heart-strings! I depend on the 81a to warm up the subject and the viewers' perception of that subject, to get them involved with the subject. Working with folks and educating them about endangered species, I need them to take an interest in them. But let's face it, when you have the choice between learning about a wolf or a delta smelt (a fish), which would you go for? The fish will lose out, but it's endangered and needs our help as much as the wolf does. Believe it or not, the 81a filter can

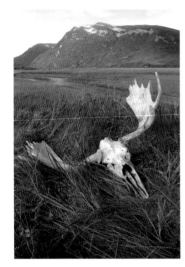

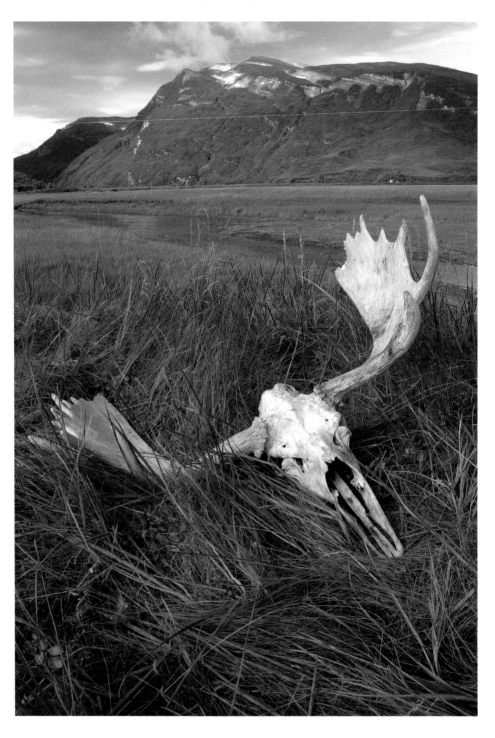

Moose Skull.
Captured by D1,
14mm f/2.8 AF,
on Lexar digital film.
The photo on right was
captured with a Moose Filter;
photo at top without.

make the difference between educating or not, grabbing one's attention or not!

So, there you have it, the reason why I have a Nikon A2 (an 81a) filter on every single one of my lenses for every single photograph. I use every single tool, technique, device, lens, angle, or anything else I can employ to get folks' attention with my photographs. Here's a simple and inexpensive tool you can apply to your photography that can make a big difference. I hope I've warmed you up to the idea of using a warming filter in your photography!

The Moose Filter (Warm Polarizer)

There is a tremendous amount of reflection when we're out in the wild shooting. You might have never have noticed it, but it's there. The vast majority of the time, the reflection has a blue cast to it, which literally influences the subject's color. This blue cast affects the color of all the elements in your image and if at the right angle to the film plane, gives them all a blue tinge. This reflection is coming from the sky, the blue sky!

Many attribute great color in a nature photo to the use of one film or another when, in actuality, the great color was a result of proper use of a polarizer. Proper use of a polarizer removes the reflection so the color we see with our eyes is seen and recorded by the film. It is essential you understand that the proper use of a polarizer is to remove reflections (glare) and not make the sky dark blue. There are times when a correctly used polarizer will also make the sky darker, but to see if you have proper polarization you look at the ground rather than the sky.

Using a polarizer correctly takes talent, just like using any other tool in photography! All you have to do is rotate the filter, right? That is correct, but when you're rotating the polarizer you need to look through the viewfinder and look for the blue to disappear. (This means you don't use the polarizer unless you have a bright blue sky overhead.) You don't look at the sky, you look at the ground. The way I do it, I rotate the polarizer while looking at dirt if possible until the ground appears a nice, warm, rich, chocolate-moose brown (get it, chocolate-moose, Moose's technique?). Normally, the ground will have a dead-brown color when viewed through an improperly rotated polarizer. You want that ground to appear a rich, chocolate-moose brown because then you know you've removed the reflection from the scene.

What if the ground is not your subject, does this technique work? Polarizing light is another one of those physics things photography is so wrapped around. Technically, only objects approximately 90° to the film plane are affected by a polarizer. That's the full effect of the polarizer (and if the sky is in the photo, it turns dark blue at 90° from the sun). In practice, you can see the effect of a polarizer even though the object might not be a true 90°. That's why you rotate the polarizer and take a look. I recommend first looking at the ground because dirt is pretty much dirt and it helps folks understand the polarizing effect more easily than by looking at a critter or tree bark. That's because polarizers are not a cure-all but just another tool.

They don't always help! If you're shooting in overcast light for example, a polarizer will do nothing for you. If you're shooting a backlit subject, the polarizer will do nothing for you. Shooting a backlit subject means you're shooting with the lens pointed towards the sun and at that angle, the physics are all against you.

In the same vein, polarizers are not just for photographing scenics! I use a polarizer quite often when photographing critters, especially big game. The incredible impact a properly used polarizer can make on an animal's pelt is mind-boggling! But this is a time when you have to think through the pros and cons of using that polarizer.

Polarizers have one major drawback. Polarizers may block up as much as two stops of light. When shooting in low-light situations or when you need lots of depth of field so you're at a slow shutter speed, you might not be able to afford this loss of light. As a very general rule of thumb (which I'm the first to break), I try to never photograph any action with a shutter speed less than 1/30. A good example of this is a grizzly bear eating grass (a common thing). When grizzly bears or any other critters are chewing, their jaw muscles affect the eye and, at slower shutter speeds, the eye might be out of focus when a critter is chewing. This is a time I don't want to be below 1/30 and won't attach a

FIELD TIP

I can't encourage you enough to take before and after photos when working with any new tool or technique in photography. Using a polarizer is a great example! Take one image polarized and one not polarized so you can not only see for yourself the different effects, but you can also learn what works and doesn't work for YOUR photography!

polarizer. I don't want to sacrifice the sharpness of the image for better color.

So what's with this Moose Filter? As one e-mailer asked, the Moose Filter does not put antlers on a cow moose. The Moose filter is the combination of an 81a filter and a circular polarizer in one mount. The reason for this combination is simple. You've read how I always use an 81a filter. You've read how useful a polarizer can be. The combination of the two filters is lethal (in a good way)!

When shooting with ultra-wides though, you cannot stack a polarizer on an 81a because the two stacked filters are "seen" by the film, causing vignetting. Vignetting is the darkening of the corners of a photo. This is not desired. By having an 81a filter and polarizer combined into one filter mount, you don't have vignetting. So, you can have the benefits of the two filters when using your ultra-wides. When I attach the Moose Filter, I do remove the 81a filter already attached to the lens. This is because the combining of two 81a filters produces an effect that's not really desired. The result is an over-warming of the image.

The Split-graduated Neutral Density Filter

I think of this filter as the Drama Filter! The split-graduated neutral density filter (SGND) is the filter that has a gradient that is about half dark and half clear. Its purpose is to burn and dodge the light when you take the photograph (one of those tools to help to get the photo right, right from the start). Its application is rather straightforward and the filter is most typically used when the sky is in the photo.

The SGND is used to compact the exposure in a scene so the film can see all the detail (refer to chapter two, page 83). The range of a sunset, for example, when reflecting that sunset in a body of water in the foreground, is normally 5+ stops. By applying a two-stop SGND filter, we

can bring the exposure range down to three stops and within range of the film. Have you ever taken a photo like I just described, a sunset that is being reflected in water and the exposure in the water is better than the real sunset? If you have, you have a perfect example of when you should have applied a SGND!

The one GIANT tip I can give you when using the SGND filter is, don't have the line of the split horizontal! The key to using these filters is to angle the split line (the line where the dark and light in the filter meet) so you enhance the direction of the light in the photo. We're using these filters to bring the light within the range of the film, not just darken a portion of the photo. This is why I think of the SGND filter as the drama filter. When applied to enhance the light, you bring greater drama to the light and so your photograph. This is a very important aspect of this or any photographic tool.

Do you have to use filters to be successful in wildlife photography? Hell no! These are tools that you can use if they fit your photography, to improve how you communicate. These are three filters I use on a daily basis for the same reasons. It's up to you whether they work for you!

Care for your Gear!

I cannot stress enough the importance of taking care of your camera gear! This is a no-brainer process, which most wildlife photographers completely ignore. I have a kit that I always take with me that has the basics of what I think I need to maintain my gear.

Here's my list (see page 188 for more information): Lens Clens lens cleaner; Eclipse Sensor Cleaner and swabs for the digital CCD; lens tissue; cotton swabs; spare Nikon eyepiece and rubber eyecup; Wiha screwdriver set; tweezers; spare terminal and PC caps; Krazy Glue; and half of a clean T-shirt.

FIELD TIP

If you shoot digital, you may be able to neutralize the two-stop light loss caused by the polarizer by simply cranking up the ISO by two stops. If you're already at a low ISO, this isn't a problem, but if you're shooting at a higher ISO, such as 800, this solution may not be possible.

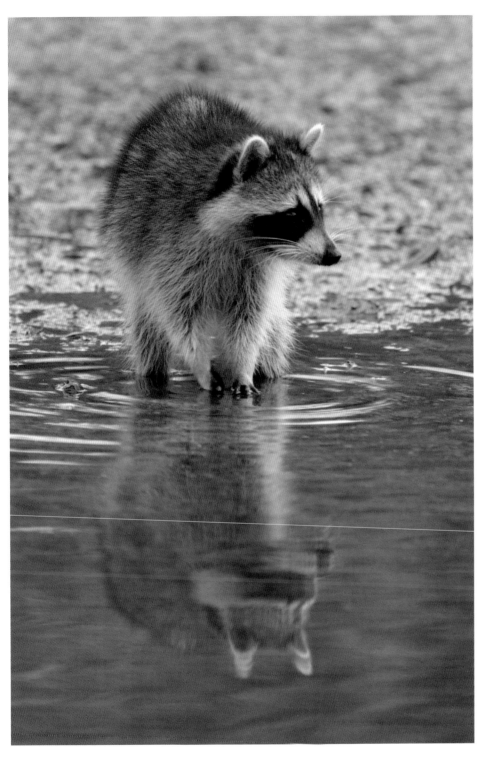

Raccoon.
Photo captured by D1,
600mm f/4D ED-IF AF-S
with TC-14E, on Lexar digital film.

I carry these items with me all the time. EVERY night, after I've used the camera that day, everything I used gets cleaned and inspected! I make sure all surfaces are cleaned, both the camera bodies and lens optics. I make sure all batteries are charged and everything is ready for the next day. And once a year, I send in ALL of my gear to Nikon for cleaning and inspection. Because of all of this TLC of my gear, I've never had ONE piece of equipment go down on me in the field! I take good care of my gear so it will take good care of me.

77

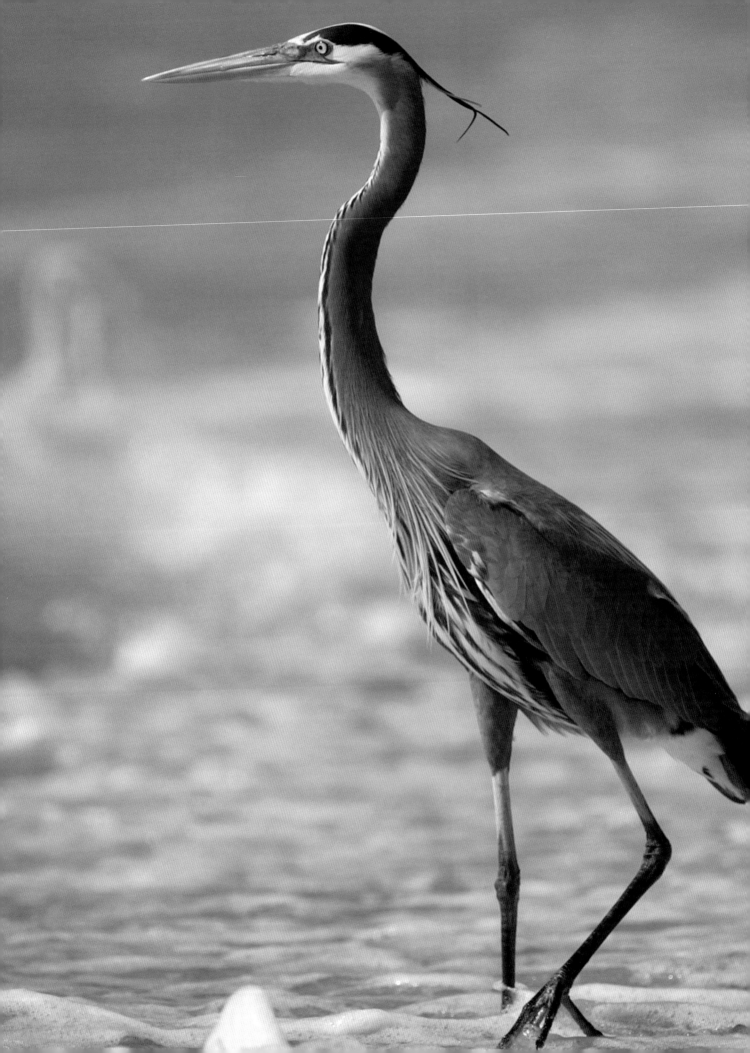

"Do I shoot in the rain?" This is a very common question and the answer is yes. "Do I cover my gear?" Nope! If I can deal with the rain, so can my gear. But it's important that you take care of your gear properly if it gets wet. This means you DO NOT wipe it dry! You must BLOT your camera gear dry, not wipe it dry. What's the difference? If you wipe your gear dry, you'll force the moisture into places it shouldn't go, causing problems. You need to blot the gear dry, letting the towel soak up the moisture. It's not rocket science, just common sense that can permit you to keep on shooting and not have your gear go down.

If I've been out shooting in the cold, I do have a certain routine I follow for cleaning my gear that night. I leave all my gear in the backpack when I come in, but I unzip the pack so the gear can warm up. I don't open the flap or take the gear out but I do let the warm air slowly filter in. I wait a minimum of an hour before I take the gear out to clean and inspect. I've never had a condensation problem doing this and, like I've said, I've never had my gear go down on me.

I've always likened the gear in my camera bag to what a carpenter takes on the site to build a house. In the toolbox will be an assortment of different saws, hammers, chisels, and the like. The tools are present so when a particular job requires a particular tool, it's available and the job can get done. Photography is no different!

You must decide for yourself which tools go with you into the field in your bag of confidence. You must decide which tool is going to do the job for you, permitting you to communicate the wonders you see to others. There is no right or wrong answer, you don't have to emulate my camera bag or any others to be successful. Use what I've provided here for you as a guide, a list of possibilities, and then make your own. I'm looking forward to seeing your images so I can learn more about the wonders I personally will never be able to witness, learning about them in your images!

Left:
Great Blue Heron.
Photo captured by D1H,
600mm f/4D ED-IF AF-S,
on Lexar digital film.

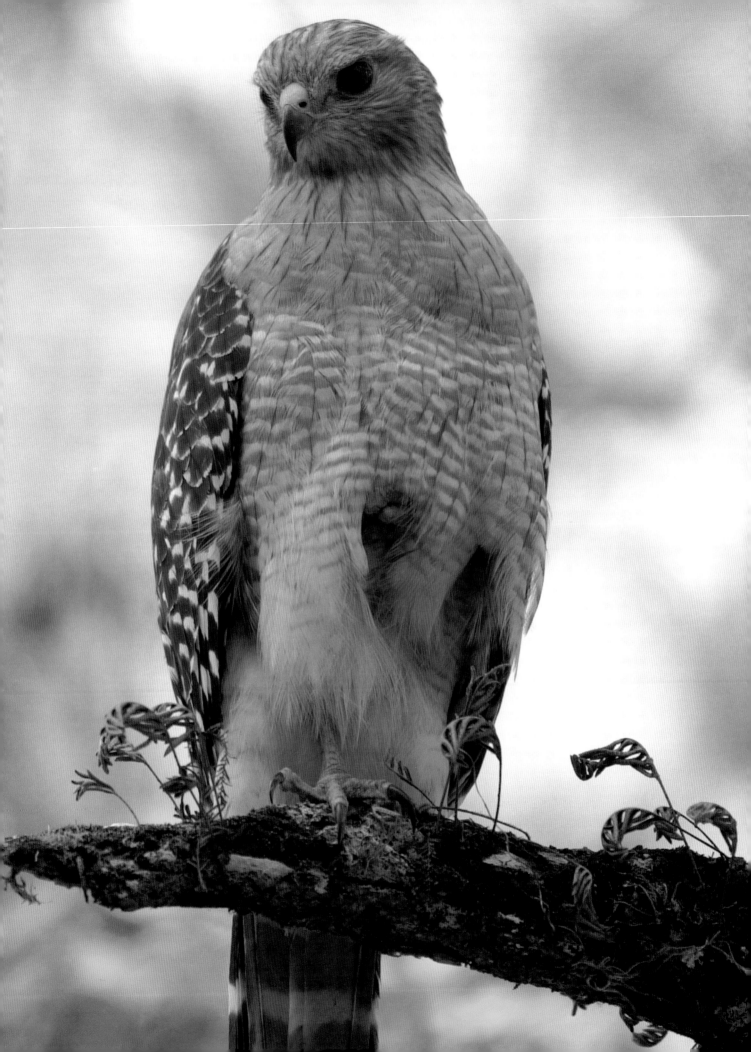

Chapter II

Making the Subject Pop

The morning air was damp. The smell of wet wood filled your senses. Light was barely filtering in through the spring leaves just appearing on the cypress overhead. We were making our way along the boardwalk, looking high and low for subjects. We noticed a pair of eyes staring at us from the black water below, an alligator observing our passing as we tiptoed by. All of a sudden the air filled with the scream of a raptor, then two, as they seemingly conversed about something, perhaps our presence. As we tried to get a view of the raptors through the dense tangle of the canopy, our glances went overhead and we began to suffer from "warbler neck."

We ventured further into the swamp, looking and listening. The swamp is a magical place early in the morning, when all its creatures begin to stir and start a new day. The sounds filled our imaginations, conjuring up some old black-and-white jungle movie. We made a turn on the boardwalk and there, perched in front of us, was one of the screamers. When we first spotted it, the red-shouldered hawk was hidden partially from view. We slowly moved to our right, and then I slowly lowered my tripod to reframe the subject and change the background. Finally, the shutter snapped, and the morning sights and sounds were recorded in a single frame!

Creating "Pop"

What is "pop?" I'm certainly not talking about a can of soda! Pop is the successful outcome of isolating the subject. Pop is making the subject the most dominant element in the photograph, even though it might not be the largest. Pop is using every photographic technique and piece of equipment to communicate to others what you see. Pop is what distinguishes the great wildlife photographs from the rest!

In the confusing, tangled world of nature, separating the subject from its surroundings while still portraying the world in which it lives is no easy task. In many instances, the light falling on the surroundings is the same as that illuminating the subject. Color is often of no help since wildlife tends to be hidden, blending in naturally with its surroundings. How, then, can we isolate the subject and make it pop within its natural setting?

Isolating the subject is by far one of the most difficult challenges facing the wildlife photographer. As if selecting the right camera, lens, and film weren't enough, technological knowledge also has to blend with aesthetics, composition, and style. We can't physically drop a white or black sweep behind the subject to make it pop, nor can we count on a cloud overhead to provide magical light to spotlight the subject. Isolate the subject and make it pop. In the beginning, writing and reading about these techniques are far easier than applying them in the field. It takes time to refine the eye and condition the mind to master these principles. Once they're part of your photographic instinct, you'll never be conscious that you're looking for ways of making the subject pop.

Left:
Red-shouldered Hawk. Photo captured by D1, 600mm f/4D ED-IF AF-S, on Lexar digital film.

Making the Subject Pop

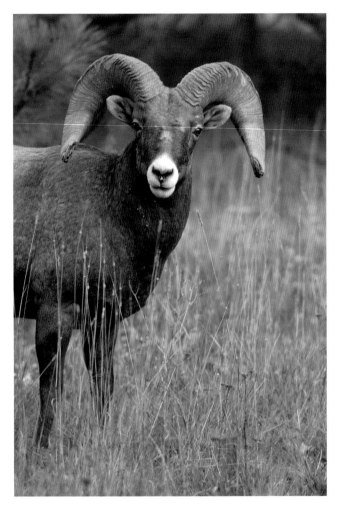 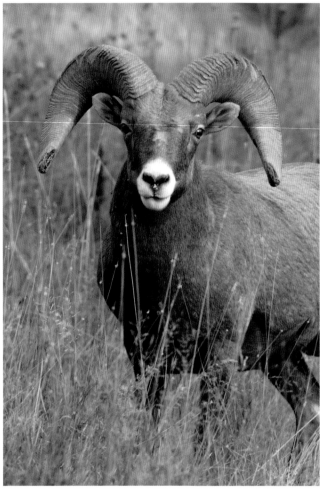

Both photos above:
**Rocky Mountain Bighorn Sheep.
Photo captured by D1H,
400mm f/2.8D ED-IF AF-S,
on Lexar digital film.**

Four Keys to Isolating the Subject

Isolating the subject requires the blending of four photographic elements: light, background, depth of field, and lens application. These four concepts, when used separately, will produce a clean photograph that will stand out from the rest. But when all four concepts are combined in one photograph, drama is brought to the one-dimensional plane of film and life is given to the image.

Light!

I'm sitting here at my light table, viewing images. They're not my own, but those of another photographer seeking help. The problem: exposure! The photographer had seen the bald eagle images in my BT Journal (http://www.moose395. net/journal/) and when he attempted to photograph black and white birds, either the white was burnt out or the black was as dark as sin. He didn't understand why I was able to capture detail in the black and white of the bald eagles when he couldn't with his subjects. The photographer's question was, "What's wrong with my F5, or what compensation did I need to dial in to capture the right exposure?" The answer to the problem is none of these; the answer begins and ends with THE LIGHT!

Photography is all about the capturing of light, as it has been since the very beginning. This quintessential element is what brings life to an image, communicates moods and emotions, and makes it possible for others to see your vision. Yet this key ingredient to photographic success is the least understood concern and one that is hardly ever taught. But make no mistake, without the right light,

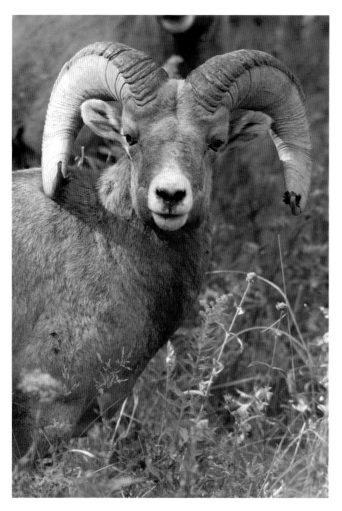 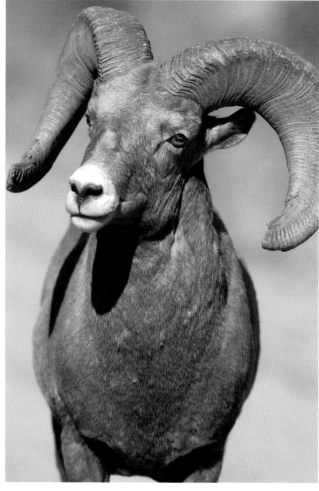

Both photos above:
**Rocky Mountain Bighorn Sheep.
Photo captured by D1H,
400mm f/2.8D ED-IF AF-S,
on Lexar digital film.**

you can't capture the perfect exposure, communicate and evoke emotions, or capture the drama present in our wildlife and wild places!

I have always felt that black-and-white photography is the perfect medium for learning light, because you don't have color confusing the mind into seeing light when there is no light, just different shades of gray. In an old "Tip of the Month" on my website, I recommended watching old black-and-white movies, because you can learn very quickly from the old masters about light. SO, I strongly suggest you read through this a few times until these concepts make sense and you can see what I'm seeing in the photographs.

Light and Exposure

As I've said many times, our brains and eyes are amazing tools! They can see light and color and communicate them to us to the point where we can almost see when there is no light or color. When it comes to photography though, we have to "reprogram" our brains and eyes to be able to see light as film sees light.

When it comes to light, what our mind sees and communicates to us is not what film sees and can communicate. You must tattoo this fact in your memory and never forget it! I was told once that the average person could see detail in a range of approximately 14 stops of light. It's hard for me to imagine that there are that many stops of light out there, but I know that, if we can see even half that many, that's four stops more than film can see. I've written many times that film can only see, record, hold, and show detail in a three-stop

Making the Subject Pop

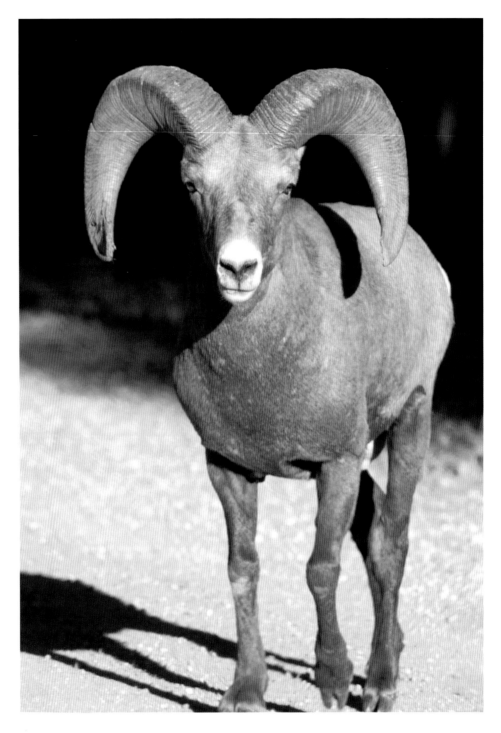

range of light! Film has a three-stop latitude for holding detail, that's it! It's true digital technology can hold detail in five stops. But as I've already mentioned, the photo-viewing public isn't mentally ready to see that much, so I even keep digital images contained within that three-stop range. Let me define what I mean by three stops so you can better understand that point before moving on.

When looking at a scene, any scene with any colors you might think of, a three-stop range means that to capture detail in the highlights and shadows, the lights and darks, the actual meter reading between those values must be only three stops apart. This means that, with a constant shutter speed, if you meter the highlights (with whatever metering system you'd like) and get an f/stop of f/16,

84

and you then meter the shadows and get f/5.6, you have a scene with a three-stop range. (This is just an example; you don't necessarily use these exact f/stops to measure the range of light in your scene.) This means that, if you were photographing a bald eagle in this scenario, you would see details in the feathers in both the white of the head and the black of the body. If you go past this three-stop range in either direction, you will start losing detail, the ability to see information, in the highlight or shadow areas. There are no ifs, ands, or buts about it! This holds true for every metering system, including the F5's RGB as well as any exposure compensation you want to dial in.

"The correct exposure for a photograph can be defined as an exposure that produces an image with the tonalities and colors the photographer desires," as defined in *The Focal Encyclopedia of Photography*, third edition. Sounds like what I've said, yet within this definition lies an acceptable range or standard of exposure that we, as a community of artists, regard as being pleasing. More important is the standard of acceptable exposure for the printing of images as established by the industry and buyers. To succeed in reaching any of these standards, light is where it all begins.

"Seeing" light the way our film registers light takes practice and, it takes an eye trained to evaluate light. Looking out my office window at the wildflower meadow in my front yard, I can see the range of light is about five or six stops. When I take a meter reading, I can see that I'm right on. How did I train my mind to see that? I'm telling you straight out, I'm a student of light! I constantly analyze light to see it, understand it, and be able to manipulate it to make my photographs work. One tool I use, which I carry with me all the time, is my hand. Obviously, I never leave home without it and it has helped me learn light.

Anyone ever watching me must think I'm nuts because I constantly stick my hand out and look at the light falling on it. I do this in every imaginable lighting situation I can find. What I look for is the detail in the highlights and shadows on my hand. Can I see the lines in the palm of my hand or the lines between my fingers that are in shade? With these questions answered, I look at the scene around me. Over the years, I've learned to see light the way my film sees it. I guess you could say I have a three-stop hand.

Another old trick to seeing light the way film sees it is to squint at the scene you want to photograph. When you partially squint, those highlights that are going to burn out and those shadows that are going to go jet black become apparent. Now you have to learn to start honestly seeing these areas where the light is deficient to make this work, but with practice, you can pick it up.

The bottom line, though, is simple: to start capturing the perfect exposure, you need to understand light. Gray cards, matrix metering, or variable-speed films can't make up for not seeing and understanding light when you want to capture the perfect exposure. When you can see light, your exposure problems disappear, totally and completely! There is no magic to it; it's simple physics that work in your favor. But photography is so much more than the perfect exposure!

That million-dollar piece of advice, "Shoot early in the morning or late in the afternoon for the best light," while widely practiced, is rarely understood. This is promoted as the best light because the range, latitude, or contrast of the light is so slight that film can capture detail in the highlights and shadows with little effort on your part. Any meter can take the right reading in this kind of light. These hours of shooting offer very little contrast and little in the way of dark shadows. For some reason, shadows have been made out as being bad and like anything in too great a quantity, shadows can be bad. But either the lack or the profusion of shadows is

FIELD TIP

Digital shooters, this is for YOU! Do not go by the exposure you see on your LCD monitor! The images on digital camera LCD monitors are not accurate representations of the actual image exposures. If you want to capture the right exposure as well as learn light, make sure you use Blinkie Highlights and Histograms!

Musk Ox.
Photo captured by D1H,
400mm f/2.8D ED-IF AF-S,
on Lexar digital film.

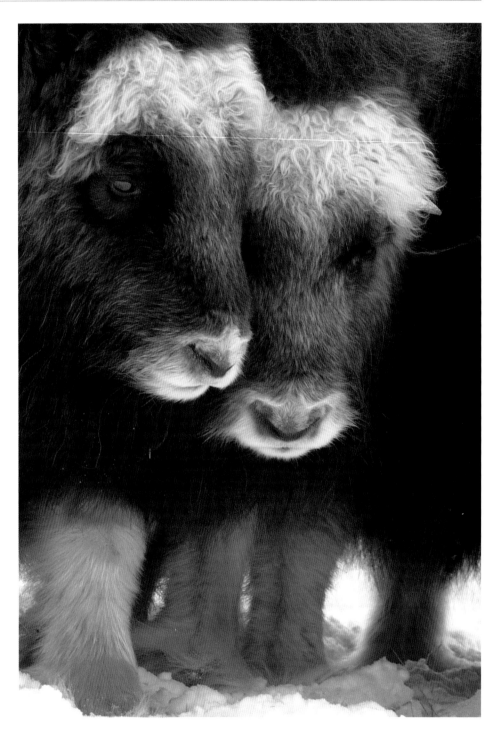

an essential element in my own photography. I urge you to look at those images you enjoy; shadow plays a big part in why you like them. It's all about communicating, isn't it?

Light and Communication

One of my favorite illustrations about understanding the use of light for communicating goes back to when I was a little dude in elementary school. For an art project, the teacher asked the class to draw a vase. With this done, we all looked in awe at our simple drawings, the simplistic outline of a vase. The teacher then said, "Let's give the vase some shape, depth, and dimension," and asked us to take our pencils and shade in one side of the vase. Like magic, our simple outline

turned into a three-dimensional piece of art! We had just learned about light and we didn't even know it!

The play of lights and darks, highlights and shadows in our images bring the subject to life and what it is about it we want to communicate. Most photographers don't realize it, but it's this play of lights and darks that originally grabs our attention to a scene and causes us to photograph it in the first place. Our minds really grab hold of these light values and in them we see potential. The lack or abundance of highlights and shadows directly determines the mood, emotion, or other quality we want to communicate in our images.

The total lack of shadow, say, early in the morning or on a very overcast day creates an almost monochromatic image even though color is present. This type of image easily evokes a very tranquil, serene, emotional response to an image. The light is so even that you can take this type of lighting as is or play with it, depending on what you want to communicate. Let's say we're photographing an early morning meadow in this type of light. As is, it's a beautiful scene. But if we frame the meadow with a bright red flower in the foreground, we can communicate something totally different, evoke a totally different emotion. The key to this flexibility is the light, permitting us to take photography beyond the perfect exposure into communication.

The other extreme is hard shadow. Shadows have so many different meanings and, depending on what you want to communicate, they can be manipulated to your desire. Take the same meadow we photographed in the early morning light. If we were to photograph that a little later in the morning, then the grasses (that previously blended together creating a beautiful carpet) now stick out as each is defined by a shadow. Shoot a little later in the day, and that early-morning, gorgeous scene is nothing but black lines and white lines, because the shadows are so dark. But what if there were a

tree on the edge of the meadow and you wanted to communicate the "late afternoon of summer?" You then would work the scene to incorporate the shadow of the tree, waiting until it was stretching across the meadow as far as possible. All of a sudden those shadows aren't so bad and in fact help us communicate. It all depends on what it is we want to say.

In that early morning light, communicating shape or texture is nearly impossible. We need shadow to do so, but how much shadow? Ah, the answer to that question is what makes your photography stand out from the next person's. How you deal with shadows , including them, excluding them, or flash-filling them a little or a lot all directly determines just what your final image will look like and say to others! But to make all of this work, you've got to see light the way your film sees it.

A note on exposure when it comes to communicating with light: the general rule of thumb is to expose for the highlights to maintain detail within them and let the shadows fall wherever they may. Do I therefore use a spot meter to accomplish this? NOPE! While that's a possibility, it's way too slow a metering method for me. This is the main reason I rely on the D1's and F5's RGB meter. Since it understands these things and I understand light and film, it delivers the correct exposure, every time!

While you will have a nice photo when you've captured the correct exposure and you'll have an even better photograph when you add light that communicates, you'll hit the top of your photographic potential when you use light to bring drama to your images.

Light and Drama
Dramatic lighting: the first thing I think of when I hear this term is a dark summer storm on the horizon with the colors and textures of Bryce Canyon, Utah in the foreground. Now that's dramatic lighting!

> **FIELD TIP**
>
> If you want to learn how light communicates, start looking at old black-and-white ads (even some new ones). There are many books and websites where you can see how the old masters—and some new ones—simply use light and the shades of gray it produces to make you see exactly what they want you to see.

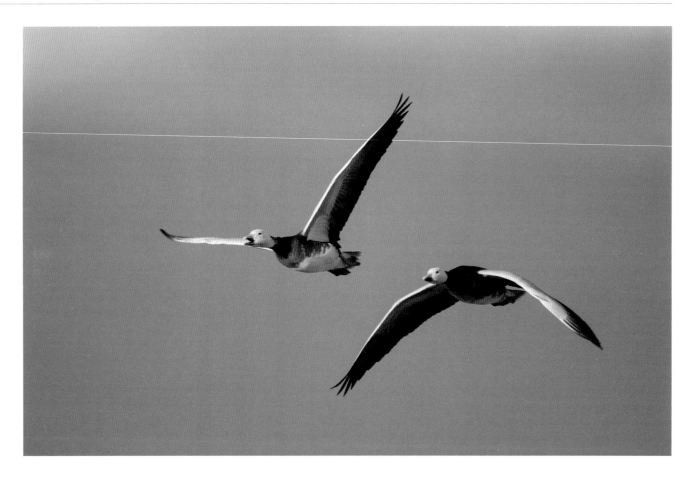

Snow Geese.
Photo captured by D1H,
300mm f/4 ED-IF AF-S,
on Lexar digital film.

When Mother Nature presents us with dramatic lighting, hopefully we recognize it when we see it. That's something that simply can't be taught. The subtleties of dramatic lighting, though, are something you can recognize even when it's not obvious and, at times, drama is something you can create. Dramatic lighting requires that you understand the first two points of this piece, exposure and communication. The best way I know of explaining this is by relating a story to you.

One May I was in Custer State Park, South Dakota with folks on a day shoot from my Walk Softly seminar. There were a bunch of baby bunnies bouncing about, and one came out in the beautiful, spring green grass and started to munch. It was sitting right in front of a bush and all of the branches made a tangled, horrible mess for a background. I instantly plopped down my tripod with 600mm f/4 and started to shoot. Now, the student standing beside me asked why I

would take such a shot with that horrible background. I said the film would never see the tangled background. The student gave me a queer look and said I was nuts since it was as plain as day in the viewfinder. I then said to look at the scene the way the film "sees" it, the bunny out in the light, the tangled background in the shadow; it was a four- to five-stop range. The film would never register the tangled mess.

Understanding light and how film sees it with regard to exposure and communication is how we bring drama to our images. The spectacular drama that light can bring on its own is rare, and when those events do occur, every photographer stops to marvel and record it. But it's in the everyday scheme of things that we need to seek or create drama in our photographs by using light. The bunny example above is just one way to achieve the drama, putting a lit subject in front of a dark background. There are lots more examples. By understanding light,

exposure, and communication, you can find them nearly at every turn.

Are you into photographing wildflowers? If you are, you might wonder how you could bring drama to them through light. Let's say you're out on a bright, sunny day, no wind and you have in front of you a killer blossom. The flower is great, but the light is hard and contrasty. Furthermore, the background is lit just like the blossom. This is a no-win scenario, or is it? First, can you do something about the background? Let's say you've tried all the traditional ways of changing your angle of approach, gone high and low, even switched lenses but with no luck. What if you created your own shadow on the background, either with a flat, a person, or even your camera bag? Does this take care of the background and bring a little drama to the image? But still the light falling on the blossom itself is burning hot, can it be diffused? I always carry a large Ziploc bag that I use to diffuse light in such a situation. And with little effort on a bright, sunny day, we've taken an otherwise unphotographable scene and made it possible, with drama!

Are you into birds? During the summer, especially in the Sierra Mountains of California, the small dickie birds are very active during the middle of the day when the big hatches of bugs are everywhere. This is not the best light, especially when you have natural highlights and shadows from the sun streaming through the forest canopy. The contrast range is quite high. What to do? The answer is simple: use flash, yet not simply by flash-filling but also by manipulating the flash to create drama.

Attach your flash to your camera or do it the way I do it, by using the Really Right Stuff Flash Arm. I dial in minus one stop on the camera body via its exposure compensation dial and then I dial in plus one on the flash. The camera's computer sets the meter in the body and on the flash to underexpose the whole scene by one stop. But by dialing in plus one on

the flash, it now exposes correctly, the plus one canceling out the minus one. This underexposes the ambient light by one stop, cutting down or neutralizing the highlights from the sun that are streaming through the canopy. The flash pumps up the shadows and properly exposes for the subject. In this very simple way, you've brought drama to the lighting where there was none before.

Are you into scenics? That dark storm cloud off on the horizon is a natural way to bring drama to any scenic, but you can't always find a storm when you need one. Many folks like to use a polarizer to darken the sky, but the problem with that is, often it mutes the rest of the colors in the scene because it doesn't polarize the right elements. There are other ways of bringing drama to a scenic when there are no clouds, such as a split-graduated neutral density filter. I like the two- and three-stop models, which I find are enough to darken a sky while still permitting detail to appear in any clouds that might be present. The filter performs a simple function: it holds back the light in the sky, effectively darkening it, creating drama.

There are so many ways to bring drama to your images through light that I should write a book on the topic. I don't, though, because understanding light and all of its complexities is best done out in nature, not by reading a book. Shooting, shooting, and more shooting, hunting light and then recording what you see is the best way to learn to really see light, to "see" light as your film does!

The cornerstone of what we capture is the light. If you want perfect exposures every time, learn light. If you want to always be successful in communicating through your photographs, learn light. If you want drama in your images so when folks see them, they can't help but "Ooh" and "Ah," learn light. Light comes in so many flavors, in so many forms, and at so many different times of the day, I don't think I'll ever learn them all. Some of my favorite light is when there is no "light" at

FIELD TIP

Want to learn dramatic lighting? Get cultured! Stage lighting can provide interesting examples of dramatic lighting designed to draw your attention to the subject. The play of light, the "follow spot" on the main character, and the lighting on the secondary characters and the backgrounds all play in concert. Seeing this play of light in a play can play on one's vision of light!

Making the Subject Pop

Right and Far Right:
**Horned Puffin.
Photo captured by D1H,
600mm f/4D ED-IF AF-S,
on Lexar digital film.**

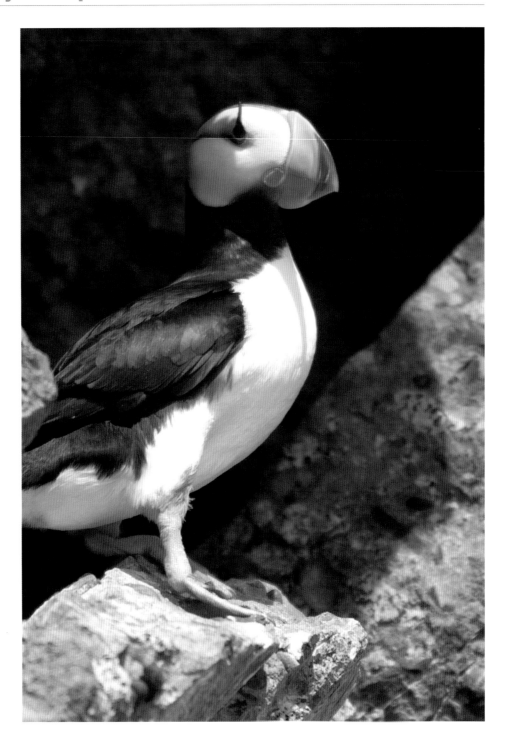

all during overcast and stormy days. One of the best investments you can ever make in photography is mastering light, seeing light as your film does, and then sharing that with the rest of us. Learn to see light, and you will become a master of your photography!

The Direction of Light

In its purest pursuit, photography is the art of capturing light: its highs and lows, its mysterious and revealing moods, its ballet over the rolling landscape. Light beckons the photographer out into the field to chase and capture its every ray. Light is what brings drama to wildlife photography.

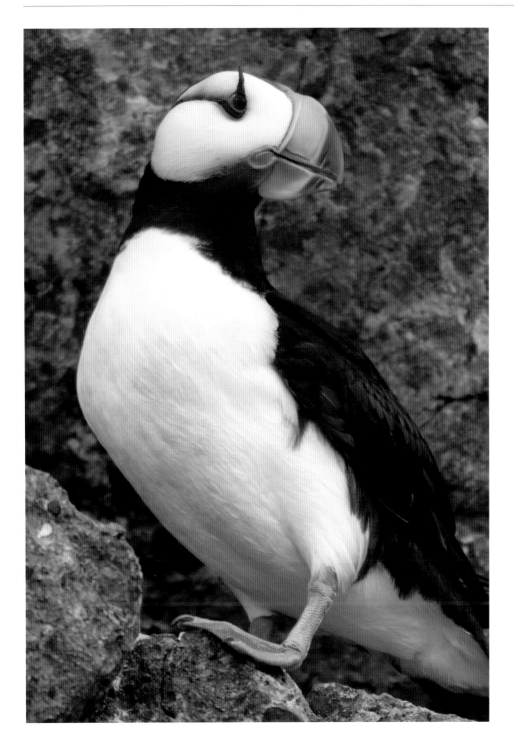

Light is the heavy hitter in making the subject pop!

More than any other discipline in photography, wildlife photography presents photographers with a genuine challenge in chasing light. Where a portrait, still-life, industrial, or fashion photographer can select when to shoot and where the subject should be to maximize light, the wildlife photographer contends with a roving subject and ever-changing light. Photographic opportunities present themselves whether the light is good or not. It's an incredible challenge in which there are no concrete answers, except to just be out and grab that shot when opportunity strikes.

There's a saying that success in wildlife photography comes from f/16 and being there (and f/16 is not really important). Mother Nature influences whether a subject will be out and about; and she is also the provider of that magical beam of sunlight for the photograph of a lifetime. But if you're not out in the wilds to see it, live it, and capture it, all the equipment and technique in the world really doesn't matter. This is the only thing separating "professionals" from "amateurs;" professionals are always out and by the law of averages are able to capture more of those magical moments.

Light has a variety of unique qualities, each defining a mood or shape. Understanding these and using them to communicate is what each one of us strives to accomplish. There are so many rules about when and where the sun must be for a successful photograph. Rules for shadow and highlight, mellow and harsh, flat and contrasty light, scare most photographers from ever exploring the realm of photographing light. Forget the rules, learn light, and make it work for you when and where you find it!

The quality of light sets the stage for the subject. We all recognize early morning, high noon, or late evening light in a photograph. But what about cold light, warm light, revealing or hiding light? When is high noon photography a no-no? Is its light really that bad? And what direction and quality of light defines the sharp nose of a fox or the thick coat of a grizzly bear?

We use light to communicate emotions in photography. Happy or sad, love or hate, good or bad, each feeling has its own special light quality which we all recognize. The goal is to see this quality of light in nature and capture it in our photographs, communicating it successfully to others.

And in this quest, light must serve the photographer in one last facet, making the subject pop. In this quest, photographers must make the light be at their beck and call and serve as a key element in the photograph. To this end, the pattern and quality of light is what separates the good from the bad, the disappointing from the magical. Light is what makes the images of dreams!

Light Quality

Early morning, late afternoon, before or after a storm, late fall and early spring, each and every day of the year has its own unique quality of light. I can't emphasis or repeat this enough (which is why I'm repeating). Seeing light, understanding it, and ultimately capturing it on film is the challenge confronting us every time we venture into the field. Do we only venture out when the light is just right? When we go out and find the light is harsh or nonexistent, do we go out to make it better? Understanding if the light is just right, do we need to relate it to the subject as much as to its own unique quality?

The quality of light must be related to its subject. The desert cottontail comes out in the early morning and late evening. The black-tailed jackrabbit, which lives alongside the cottontail, comes out during the bright midday hours. The cottontail will present itself during those magical hours of light but the jackrabbit appears during the taboo hours. Does this mean we'll never photograph the jackrabbit because the sun is at high noon with its harsh, contrasty light?

What are we trying to communicate? The cottontail is cute, soft, and cuddly, and early and late light portrays this feeling. The jackrabbit is a gawky, scraggly creature and high-noon light conveys this feeling, but the quality of light at this time is contrasty. But if the jackrabbit ducks under the shadow of a bush where the harsh noon sun is mellower, and we properly expose for the shadow, letting the highlights go where they may, what's the final result? What does the quality of light communicate about the subject, about the scene? More importantly, can we recognize and take advantage of it to communicate?

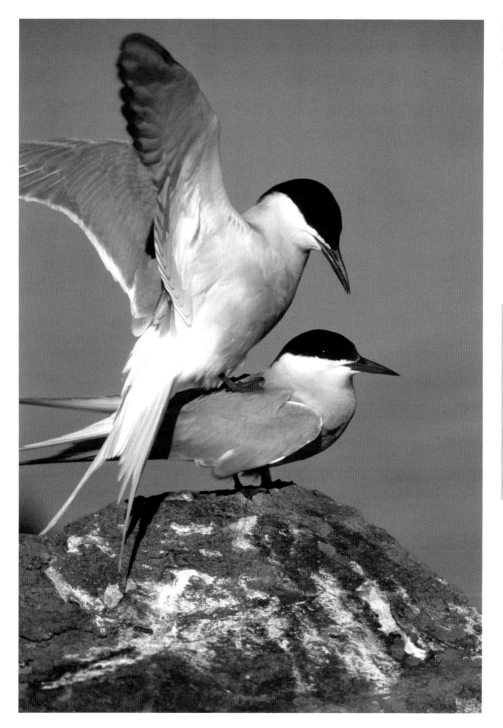

Arctic Tern.
Photo captured by F5,
600mm f/4D ED-IF AF-S,
on Agfa RSX 100.

FIELD TIP

Is there bad light? You bet! In fact, most bad photographs are ones that never should have been taken in the first place. One top pro's definition of a professional photographer is, "One who knows when not to take a photograph!"

There are times when I've just got to get out and shoot even though lighting and other conditions are anything but optimal. The pair of mating arctic terns is a great example of this. Arctic terns don't know to mate only in the good light. They, like most animals, do it when the urge strikes and in this case, that was at high noon. What was I to do if I wanted the photograph, since I had to shoot and make it work technically for what I wanted to communicate? Since the whites are what are so dramatic and the blacks only set off the whites, the exposure and final photograph were literally a snap. The biggest error, of course, would have been if I listened to the rules and never shot at noon in the first place!

Making the Subject Pop

If we follow the rules of when to shoot, photographers would be defined as crepuscular (or creatures of the twilight). But if we look at the quality of the light, the subject and its environment, and remember that we're communicators, the meaning of quality light is not as strictly defined as conventional rules might suggest.

Just what is quality light? Quality light, whether all-natural, combination of flash and natural light, or just flash alone, is light that gives definition, drama, and pop to the subject. As photographers, it's our quest to define quality light every time we snap the shutter. In this quest, we need to use light's many directions to create drama and make the subject pop. These are categorized in three ways: frontlight, sidelight, and backlight.

Frontlight

The most common lighting, called spotlighting or frontlight, depends heavily on those magical hours for quality light. Frontlighting has the least amount of unique character without special conditions (such as twilight hours) because it's generally a harsh light. It's light that emanates from over our shoulder, hitting us on the back and the subject square on the face. It can best be remembered as the lighting pattern also created by on-camera flash.

One of the greatest attributes of frontlighting is the catchlight that, in my experience, it's nearly guaranteed to create in the subject's eye. What some believe is a must for the perfect wildlife photograph, the catchlight is simply a reflection of the sun or flash in the subject's eye. This light gives the subject "life," unlike the "lifelessness" of a stuffed animal with marble eyes. It's quite psychological and, like many rules, the absence of catchlight doesn't mean the photograph should hit the trash. But with frontlight, there's no doubt that birds (with eyes on the side) or mammals (eyes looking forward) will have the spark of life shining in their eye.

In its natural form, equating frontlight with the harsh light emitted by flash is easy. Frontlighting makes shooting at high noon undesirable because of its harshness and extreme contrast. Frontlighting, for this reason, is the lighting direction of the magic hours. This is why it's also the most common lighting seen in photographs, since most are shot during those hours. It's only then that its mellowness has a dramatic influence on even the most common of subjects. Its lack of shadow, from the low light level and direction, requires that the subject or scene have built-in contrast.

This contrast comes from lights and darks in color and shading. The dark bison against the tan-colored grass or the great egret against the blue water are common examples of this. Color contrast has nothing to do with exposure range, but is a purer, unmanipulated form of contrast. Exploiting this color contrast is what makes early and late light so tantalizing!

As a defining light, frontlighting creates shadows not readily seen by the camera (during those magical hours). This three-stop light is marvelous for subjects such as bison. Their big, dark forms need no defining light, but rather light that's very low in contrast to properly expose for their mass as well as that of their surroundings. This also fits within the film's three-stop range. Here, color contrast is what makes the bison pop. That is a good thing since there's no shadow separating the subject from the background, because of frontlighting!

Since frontlighting creates no discernable shadows during those magic hours, flash isn't required the majority of the time for the exposure's sake. It's only when venturing out during the voodoo hours of frontlighting that fill flash is required. Here, matching the sun's power of 1:1 to a minus 2 stops flash compensation might be required to rescue the exposure (by filling in the shadows). In these situations, flash overcompensation is typical, destroying the feel of the photograph.

94

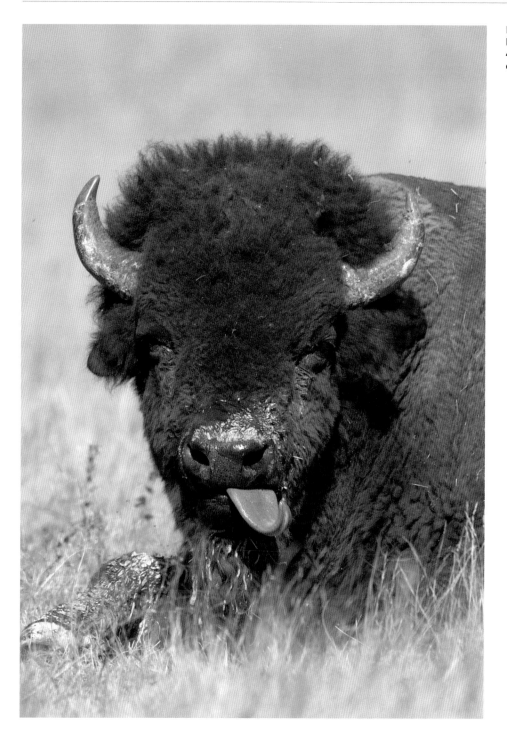

Bison.
Photo captured by D1,
400mm f/2.8 AF-S with TC-14E,
on Lexar digital film.

I've found for my taste that minus 2/3 stop, as a general rule of thumb, is the greatest amount of fill flash that should be used in these situations.

Filling in the frontlight contrast at high noon requires frontlighting from the flash. The flash must complement the existing lighting pattern by filling in shadows. It doesn't have the power to eliminate the shadow from the frontlight caused by the sun while creating a new lighting pattern. Placing the flash on the camera's hot shoe is not only the easiest option, it's really the only one.

Visual depth requires shadows, which create the illusion of depth in a two-dimensional photograph. With the bison, the illusion is present thanks to the color

contrast and our preconceived ideas of the bison's size. But what about other subjects, such as a fox or coyote? Their inquisitive ears and sharp noses are what give these creatures their character and instant recognition. Frontlight in its true form will blow all these characteristics out, its harsh light flattening out the features of these creatures.

Sidelight

The skimming light of sidelighting is what makes a grizzly bear a grizzly bear, as its naturally grizzled fur comes to life! It "skims" across its sharp contour, brightly lighting its lines and glancing over the rest of its softened features. The quality of sidelighting communicates the cunning of the coyote by defining its characteristic features while alluding to its soft and cuddly side. Sidelight can be a difficult pattern to use because of the built-in exposure contrast. By its very nature, it's a contrasty light source since it creates shadows which can be quite severe. Sidelight skims over the subject and, as with the coyote, lights only the sharp lines exposed to its rays. All the rest of the subject's features are washed in low or shadowy light.

Sidelight can at the same time make a subject in a monochrome scene magically pop. This is because brilliant highlight on the side visually makes the subject come alive. This can be a very powerful tool in communicating a small subject's size within a giant frame.

The photograph of the Dall sheep is a perfect example of what I'm talking about when it comes to sidelighting. The young ram climbing the ridge line was in perfect darkness until his very last step, when he stepped into a ray of light. This is when the magic of sidelighting came into play and the photograph became a reality. The single beam of light made the Dall sheep pop in the very even, monochromatic exposure of the predominantly white scene. This was the perfect light for a perfect photo!

Sidelighting can make capturing a catchlight in the subject's eye very difficult. If the subject has its head turned in any direction where the light cannot hit the eye, there will be no catchlight. When shooting the bird perched on the branch constantly scanning about or the coyote lying in the grass, capturing a catchlight can be an almost impossible task. Is this a problem worth our concern? That's a matter of individual taste.

This lighting pattern often requires the assistance of the flash for a catchlight. To put the catchlight in the eye or to fill in those shadows, frontlighting from the flash is a must. But here, the flash must only fill in and not dominate, or else the magic of the sidelighting will be lost. With the coyote, using flash would have created shadows on the coyote from the grasses between the flash and the subject. So the decision had to be made as to which was the worst evil, no catchlight or the shadows of the grass. You can see my choice, yours could have been as easily (and correctly) the other.

In the example of the Dall sheep, the camera was set to Matrix metering. Since the subject, like the background, is an overall shaded white color, the meter accurately exposed for the shadow. By doing so, the bright sidelight was technically overexposed and as such visually takes your eye right to the sheep. Generally speaking, exposing for the shadow detail overexposes the rim lighting, making the sidelit part of the subject more vibrant.

Fill flash can meld quite successfully with sidelighting. Of course, the flash should not have the same exposure value as the sidelighting or it would overpower the halo effect. Starting at minus 2/3 stop compensation on the flash and going down to a maximum of minus 2 stops will bring up detail in the shadow area and not destroy the magic of the sidelighting. The tonality of the subject and the photographer's preference are the deciding factors in how much flash exposure compensation to use.

FIELD TIP

Your meter can be fooled! We focus on the subject's eye using the AF system. This is the natural and correct thing to do as we must have the eye sharp. In the process, we've told the camera's computer that the eye is our subject so it bases its exposure accordingly on the eye. So, we need to think whether the exposure for the eye is what we want for the whole photograph.

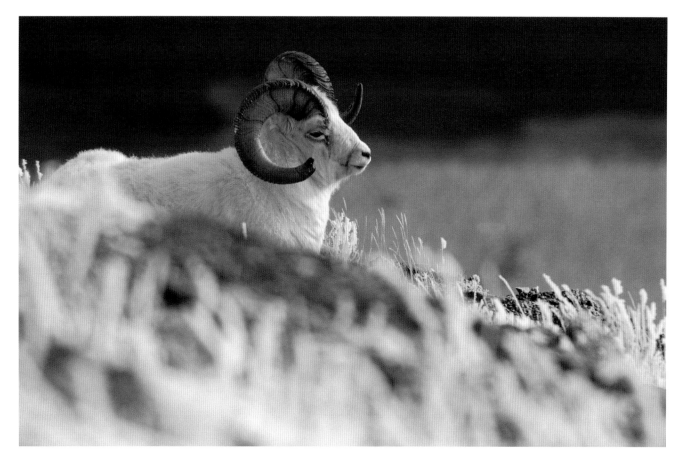

Sidelighting is unique because it can be utilized anytime of the day (as long as the subject is not in full sun). It's a light that skims down hillsides or through forests, outlining a deer or owl against its shadowy world. This is the light that finds the jackrabbit under the bush during high noon and gives the image character. For example, although the jackrabbit sits in shade cast by the bush, sidelighting illuminates the side of the jackrabbit that faces out more than the side next to the darker interior of the bush. Sidelighting is a light of isolation and drama that can be used to your advantage almost anytime!

Because of the technical difficulties in capturing sidelighting, it's often overlooked, ignored, or avoided as impossible. Mastering sidelighting takes more than just recognizing it and understanding how to use flash and exposure compensation to meld and capture it. This is a very powerful form of communicating, of defining and isolating the subject.

Mastering sidelighting will make your wildlife photography not only dramatic, but will bring life to even the most placid of scenes!

Backlight

Backlight, also called the outlining light, combines the challenges of frontlighting and sidelighting with its own special flare (pun intended). Backlight emanates from behind the subject and hits the photographer (and lens) square in the face. It's the most contrasty light source, as the subject facing the camera is nearly in complete shadow. For this reason, backlighting has the definition of sidelighting with the harsh contrast of high-noon frontlighting.

Backlighting can be very magical! Its golden light etches a fine line around the subject, following every graceful line and curve, defining shape, form, and character. This outlining halo is caused by the light shining through the hairs or

**Dall Sheep.
Photo captured by D1H,
400mm f/2.8D ED-IF AF-S
on Lexar digital film.**

Coastal Grizzly Bear.
Photo captured by D1H,
300mm f/2.8D ED-IF AF-S II,
on Lexar digital film.

FIELD TIP

There are times when I really want to capture a backlit subject but the light flooding into the front element makes it impossible. It's at these times I head for the trees! If there is a tree nearby, I'll use its shadow to shade the front element from the backlight so I can shoot.

feathers on the outermost edge of the subject. It's a phenomenon known as "wraparound." The light shines through the edges as well as "wrapping around" the object (usually thin feathers or hair), visually illuminating the shadow areas that otherwise would be present. Capturing this rimming effect requires solid exposure technique. Since it can vary with each subject, exposure compensation is critical to success.

Let's consider a worst-case scenario, a backlit great egret in a marsh. The bird is white, the water is dark but is reflecting the backlight into the meter. The light reflecting off the water is almost surely going to fool the meter into advising a setting at least one stop under the actual daylight exposure value (underexposing the egret, making it grayish). Shooting the basic daylight exposure will make the bird white all right, but that marvelous backlighting would then be burnt out (overexposed) and lost rather than magical. What to do?

First, remember what attracted you to photograph the backlit egret. In this case, the cameras meter's advice will be correct, as the reflected light's exposure value will be correct to overexpose the rimming backlight. If detail in the bird and not the rimlight is desired, either change the exposure or walk around to the other side of the egret and use frontlighting. Exposing for the magnificence of the rimming backlight isn't tricky; the trick is deciding where you want detail (in another words, deciding what's the subject).

Backlit subjects require careful attention. Though the entire subject may be in shadow, if it turns its head, the head will be sidelit. This is a unique moment that can transform even the worst situation into magic. Be aware of this possibility and be ready to quickly take advantage of the situation. Have the correct exposure already predetermined. The sunlit part of the subject will be basic daylight, while the shadow

(the main portion of the subject) will be two or three stops down.

Fill flash can be introduced to help diminish the severe contrast of a backlit scene. Be forewarned, though, that if there is much distance between the subject and the flash, it will have little effect. Its effect is also dependent on the subject itself. White subjects require less flash and are easier to meld with flash. The flash compensation needs to be set to a maximum of minus one stop, to increase information in the shadow area of a white subject. Dark subjects are the nightmare. They can absorb as much as three stops of fill flash without any effect on the shadow. There is no easy cure for black subjects, but if the only hope of getting the photograph is a flash you'd best use it. What have you got to lose?

Be cognizant of the exposure compensation required by different color subjects so that the fill flash melds in. Most viewers will realize that the sun is coming from behind the subject; thus, they might unconsciously question why the front of the subject is lit. (That's if the fill flash is overexposed.) They won't know exactly why, but the resulting image will feel "wrong." The melding of flash with backlit subjects is difficult, very difficult. Practicing with the backlit black and white teddy bears (see page 109) can simplify handling this situation in nature and avoid anxiety.

The real problem when shooting with backlight is flare. Since we're dealing with telephotos, flare manifests itself as a loss of contrast and color. This is one of the best reasons to extend the lens shade to its fullest when shooting (no matter what lens). There are certain situations where nothing can be done to eliminate flare. Other times, finding a natural object to shade the front element can help. Many times, I put my wife or kids to work holding a large reflector (really a car window shade) to block the sun; that's if there's time and the subject allows it. Unless flare can be eliminated, don't expect much of your resulting photograph.

Even with all its drawbacks of contrast and flare, backlighting can perform magic in making the subject pop. Like so many techniques and skills in photography, this is just one more that requires practice in order to make it a part of your photography. In the drive to take that once-in-a-lifetime photograph, this is one technique that can put you out in front.

Overcast

Overcast is a lighting pattern? Well, not directly, but it's a common and potentially magnificent light source. Overcast is well-known to all of us as those dreary times when the sun is directly blocked by low clouds (especially if you shoot in Alaska a lot). Overcast can cause the loss of as much as four stops of light from reaching the subject, making photography nearly impossible. But its shadowless, unidirectional light extends shooting past the normal magic hours, making it possible to photograph otherwise unobtainable subjects.

Overcast begins with just a mere hint of cloud cover that's barely enough to knock down basic daylight by one stop. It makes even the worst frontlight magical. Even at high noon the overcast acts like a gigantic diffuser. It reduces the overall contrast range to fit within the film's three-stop latitude so shadow detail at high noon is not a problem. This is the best kind of overcast, making photography a cinch all day.

Determining exposure based on basic daylight can be difficult. One rule of thumb, if the sun can be seen through the overcast, is that the overcast is knocking down basic daylight by one stop. Past this point, basic daylight exposure calculation becomes difficult as there is no absolute method of determining light loss due to the overcast. Yes, we could meter off a grey card, count back the amount of light lost and proceed, but

FIELD TIP

If all you're after is a catchlight, you need very little flash. The magic of sidelighting can be ruined by too much fill flash. You'd be surprised how minus 2 or minus 3 stops can put a catchlight in the eye while not affecting the magic of the sidelighting.

Making the Subject Pop

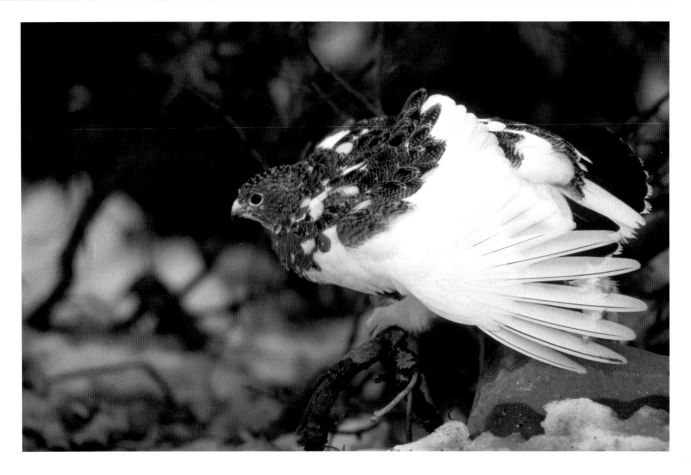

Willow Ptarmigan.
Photo captured by F5,
Tokina 300mm f/2.8,
on Agfa RSX 100.

what wildlife is going to wait for all that? Nor can we use the same value we start the day out with and continue using this same value, since overcast is constantly changing the light values.

When the overcast gets to this point, photography becomes a challenge. Shadow detail is everywhere while highlights are nonexistent. This makes for a "flat" scene lacking any exposure contrast. There is a loss of shape, definition, and depth! Flash can remedy this, but it must be at exposure values less than the ambient light (-2/3 maximum compensation). The lack of contrast is not just in exposure but also in color. Except for really bright colors, which will be muted, overcast sucks the color right out of a scene. Worse yet, overcast raises the color temperature (remember, the color temp of blue is actually higher than yellows or reds), causing a gradual color shift with heavier overcast. Warming filters (or flash) in many instances won't even sufficiently warm up an overcast's cold colors.

So why even venture out when photographic conditions are so miserable?

Some of the best wildlife photography occurs when the weather is at its worst. In overcast, rainy, or snowy conditions when the sun is not available, wildlife tends to take advantage of the all-day low light, just as if it were the early morning or late evening. The overall lack of contrast also means that shadow detail can be photographed with fewer exposure concerns. But returning visual depth to the subject will require photographic tools, especially flash, just as if the sun were out.

Flash is not used for correct light exposure, but rather correct color exposure. Flash's daylight color temperature brings color back to the lackluster overcast light. However, the flash exposure must not overpower that of the ambient light, but instead should add color temperature to the scene. This is done by setting the flash at a minus 2/3 stop

compensation. Any more flash over-powers the ambient light and any less yields little color improvement. By using the flash on-camera, since it's being used subtly, it won't create its own lighting pattern shadows.

If the subject is obliging, try using the flash to simulate one of the other lighting patterns. Sidelighting or backlighting can be accomplished with off-camera TTL connecting cords and the help of an assistant. Shadow detail is not a worry since there are no shadows. The flash will just add character. Remember to position the flash so that its light imitates the general direction of the sun.

Psychology of Color

In wildlife photography, I think the psychology of color plays an overwhelming role in how successfully an image communicates. Advertising sells products by grabbing the attention of the buyer. In a sense, that's exactly what we're attempting to do with our photographs. To be successful, we should be doing it with color in mind, just like Madison Avenue! We might not be selling a "product" with our images, but we are most definitely aspiring to grab our viewer's attention and communicate our vision.

For example, there's an age-old adage that, when photographing birds, if you don't have a good background you should find something green to put behind them. Why is the color green so important or so pliable that it's a universal cure-all for the backgrounds for birds? What is it about color that grabs our attention in a scene to photograph it in the first place? What are we doing technically right or wrong in our photography to exploit people's natural attraction to color? Unlock these answers for yourself and your photography will span the rainbow!

With the human brain able to differentiate among two hundred shades of white and able to see the same color no matter the light source, saying color is essential to our perception is no slight exaggeration. Viewing a black-and-white scenic full of all the shades of gray that a good paper and photographer can bring to light, the emotions that just those shades of gray can evoke are tremendous! But that's just a small sampling of the potential a full palette of colors can bring to a photograph. I'm not going to pass myself off as a scholarly master of psychology or try to convince you that you must have one color over the other for a photograph to be successful. A sunset is going to be in a red band of light no matter what psychological message we might want to communicate. What I want to bring to the forefront of your consciousness is how color communicates photographically and how you can make use of that.

When photographing wildlife, you'd be surprised by the emotional response color can evoke and how color, especially the color of the background, can emphasize and enhance that emotional response. We can't change the color of a subject to any great degree, but we can definitely alter the colors of the world around the subject to some degree, using various technical tools at our disposal. (If nothing else, this will help you understand what images to send and not to send to editors.) But which colors communicate what? Let me give you some very basic descriptions of colors and how we subconsciously perceive them. (It's very important to realize that we are talking about psychology of colors here; folks don't see certain colors then rationally think about their emotional response to them.)

Yellow is the most visible color and is the first color the human eye notices. It leaves a warm and satisfying impression, lively and stimulating. Yellow birds, flowers, and skies are sure to be eye-catchers just because of the way the mind and eye work!

Red is a bold color that commands attention and promotes excitement and

Wood Stork.
Photo captured by D1,
600mm f/4D ED-IF AF-S
with TC-14E,
on Lexar digital film.

action. Using red should be done with caution because of its domineering qualities. Pink, on the other hand, is associated with femininity and has a gentle nature. Purple can represent coolness, mist, and shadows and is considered mysterious and mystic in some cultures.

Blue represents sky, water, and ice, coolness, mist, and shadows. It can represent peacefulness, calm, and contemplation but is also associated with somber emotions. It also represents masculinity. Green is the most restful color for the human eye. It's the universal color of nature and usually represents fertility, rebirth, and freedom. Brown is also associated with nature, trees, and wood. It is one of the most neutral of the colors and useful for balancing out stronger colors.

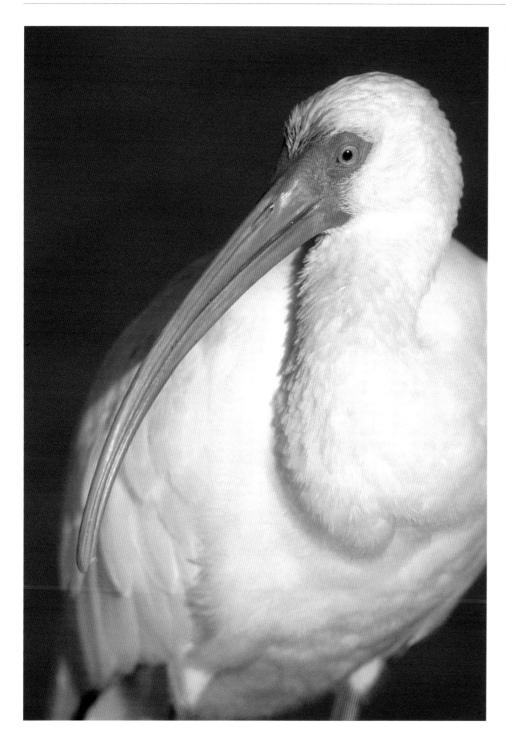

White Ibis.
Photo captured by F5,
600mm f/4D ED-IF AF-S
with 16mm extension tube,
on Agfa RSX 100.

Gray is a neutral which enhances and intensifies any color it surrounds. Black is associated with elegance and class but is also the traditional color of fear, death, and mourning in the West. Despite its negative connotations, it is useful as a design element since it contrasts with most colors quite well. White symbolizes purity and innocence and is closely associated with winter. Its simplicity and subtle quality make it an ideal color for establishing clarity and contrast in your images.

If you're like most folks, you've probably never thought about color in this way. That's partly why it's called the psychology of color. You're probably saying, this is all well and good, but what does it really have to do with your photography?

Well, why not use the same principles to help sell your message or your photography? I bet that, if you look at your favorite photographs and their colors and then read the above definitions, you'll soon discover just how important color really is.

My photo of the male San Joaquin kit fox (page 115) is a prime example One of my signature images, it has a huge publication history and has been used to help protect and preserve this endangered species for nearly fifteen years. It grabs the viewer's attention instantly. The dark background in concert with the fox's posture brings out a feeling of elegance and class. The brown coat is a color of familiarity and nature and, with the slight orange tinge to the coat, brings warmth to the image. While these things are obvious in the photograph, the effects on the mind and emotions are not. It simply just grabs your heartstrings and doesn't let go! Color is a big reason why.

Critters and their poses are the heart of my images, but it's the colors that make them stand out! Could I have put a differently colored background behind my photos? Was there an option? My point is not that we can radically change background colors or even those of the subject to any degree, just that really memorable images have color combinations like those in the kit fox photo mentioned above that play on the psychology of the mind. We need to recognize this and exploit it, for lack of a better term, whenever it's possible! It's part of that eight-second clock I've talked about before, that clock that starts when someone first looks at an image and the time we have to grab their attention before it goes elsewhere. Color psychology is a big part of beating that clock!

Tools for Color Psychology

Being aware, really aware of these colors and how they affect our perception and the responses they evoke in us is important. Understanding how you can affect these colors with the tools we use every day is even more important. I'm not talking about Photoshop or some bizarre filter, but basic tools you should have in your camera bag or vest at all times.

The film you use most definitely makes an overwhelming difference in your photography when it comes to the psychology of color! The bias of your film has the most obvious affect on the psychology of color. Everything, from the qualities of its white to the richness of its greens and every shade in between, makes film choice the basis on which you build your vision! The contrast level of your film can make or break your communication efforts all by itself. Black is an amazingly important part of color, a separator, definer, and enhancer unparalleled! This critical fact was driven home to me when I learned to do color separations for my *BT Journal*. All of this starts and ends with your film, so don't take it lightly!

The very exposure you select for your photograph greatly influences its color and its mental effect. A mere plus or minus of just 1/3 stop can radically change everything! This effect on the subject and the background and surrounding colors, making them darker or lighter in tonality, all play such an important role in your ability to communicate. You thought quality of light had to do with just exposure, but it greatly influences colors and the mental reach of their communicating powers.

The psychology of color is the main reason why I always use an 81a filter. You can always have this very simple tool with you, making a world of difference in your success as a communicator and as a photographer!

Flash is another critical tool in the psychology of color. Flash brings the light closer to the film's 5500 K so the true color of the subject can be captured. There are times when, depending on the light source, this can be a critical part of making an image happen!

Even simple tools like a regular polarizer can greatly affect the colors of your image.

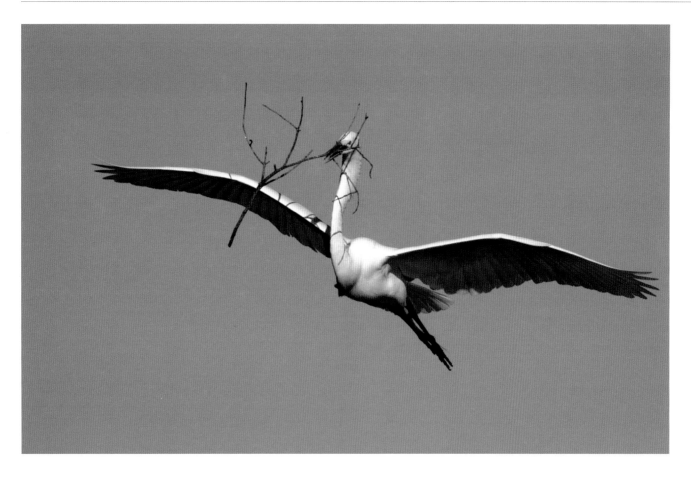

Great Egret.
Photo captured by D1,
600mm f/4D ED-IF AF-S,
on Lexar digital film.

But the importance of removing the blue, cold tint of the sky from a scene or subject can't be overstated! That blue reflection emanating from the sky can be an image killer! By combining the 81a and a polarizer (see Moose Polarizer, page 75), you can radically change the mental perception of your photograph. Instead of repelling viewers, you can suck them right in. It's all in the psychology of color.

Photography seems so much easier when all you worry about are f/stops and shutter speeds, but it's one heck of a lot more fun when you consider thoughts way beyond those basics. Photography is a whole lot more rewarding when you take it to a higher plane, leaving behind the day-to-day drudgery and make it into a quest. And when you go beyond that and start taking into consideration such subtleties as the psychology of color, well, the joy it brings to you and the viewer of your images cannot be expressed in words. When all the elements that make a great image come together, including the psychology of color, you'll know it because the viewer of your image will simply smile, a smile that comes from deep within and radiates out, a reflection of your photography!

Exposure Is Not a Four-Letter Word!

How many books on exposure do you own? How many classes on exposure have you taken? How many gray cards have you sat on? Is exposure a four-letter word for you? Are your prized images those with the best exposure or are they the best photographs? It seems to me that for the vast majority of wildlife photographers, exposure is still the biggest stumbling block when it comes to photography. This gray card and 18% gray stuff has been around for over forty years, and yet there still is this giant void of uncertainty, if not downright paranoia, when it comes to exposure.

Don't get your hopes up that I'm going to lay down the golden rule of exposure, because I'm not. Those who know me know I don't deal in rules anyway. What I am going to do is explain how I view exposure and how I deal with exposure in the field not only in the technical sense but in the aesthetic sense as well. Those who came to our Walk Softly seminars saw for themselves how just 1/3 stop in exposure value can dramatically and completely change an image. It can change the technical merits of the image, but more importantly, it can change what is being communicated. And that's how I view exposure, as a tool to communicate!

Moose's Meter

Yes, I use the F5 and now the D1H and depend on their RGB Matrix metering to make my life a whole lot simpler. Yes, these meters haven't been fooled in years; I trust them completely. Yes, I have the proof, my images. But with that said, there was photography before (and after) the F5, which required metering and exposure decisions. And even with the D1H, sometimes what I want to communicate might not be "technically" the correct exposure and so I must make a change in the exposure.

But there lies the problem, doesn't it? What is technically correct, and how can I manipulate it and still have an acceptable exposure? As I explain in my seminars, you must know your meter, your film, your style, and, most importantly, double emphasis on this, you must know light! Photography is all about the recording of light, no ifs, ands or buts about it! If you take the best zone system, finest gray card, or any other fancy metering philosophy and apply it to a scene where you have five stops or more latitude in the light, no matter what you do, how you meter or stand on your head, you're going to have either jet blacks or burnt-out whites! It's not the fault of the metering system; it's your fault for not understanding light and your film's capabilities.

The vast majority of the images shown to me with the subheading, "something wrong with my meter," in actuality were photographs that should never have been taken in the first place. The light, that oh so important element, was too much for the film! Film can only hold detail, definition in the whites and blacks and all points in between, when there is a three-stop range between the darkest black and brightest white. When you start going beyond that range, then you start losing detail. That's a fact of life in the relationship between light and film. Even the worst meter can provide you with the correct exposure in a three-stop range of light. Those times when we're outside that range is when metering gets tricky, isn't it?!

How do I cope, then, with those times when some of the opportunities for the best photography occur in the worst light? I'm just plain old pig-headed, I guess. I just learned and memorized my meter and how it would react in those situations, what I wanted out of those situations and how to get it. Now I know I'm not the only one doing this, my good friend Artie Morris does it as well. I hear him talking to himself about what compensation he needs or doesn't need, depending on what he is seeing through the viewfinder, and more importantly, what he wants to communicate to others. This is not just a Moose thing; I have peers who do the same thing.

There are many ways you can learn to understand your meter; one way, of course, is the 18% gray card. But in all honesty, folks who go that route spend their whole lives trying to understand which color or shade of color constitutes 18% gray in a world of color. When you have a grizzly bear fishing in a river, is that what you want to be thinking about?

That's why I devised the Teddy Bear Exercise long ago. I didn't make it up to get rich, because I give that exercise away; you can download it from our website. I came up with that standardized system of testing to solve my own

metering problems and increase my understanding of these issues. Once the test was shot, I simply memorized (for lack of better terms) the conditions or light under which my meter was fooled and what I wanted to do to make it right for me.

You must understand light, film, and how your meter relays information about these two key elements to you, for creating the proper exposure. It's just like when we were in school, learning our multiplication tables; we just had to memorize them. And once that was done, we could manipulate numbers for the rest of our lives. Exposure is the same way. Once you memorize it, you can use it for the rest of your life!

Moose's Personal Metering Method for Communication

Once you have metering down pat (and I know you will), you go beyond the technically perfect exposure. I can't emphasis enough the importance of having your own taste or style when it comes to exposure and using it to its fullest to communicate the way you want.

Another good friend, John Herbst, just loves to shoot backlit subjects. I personally don't see it and it goes against the norm, but he does it very well. He has had to master exposure not just in the conventional sense but in the unconventional sense as well. He's pushing the envelope of film and light every time he depresses the shutter release. But his skill at making it work, and the artistry he brings to photography, make his images very powerful communicators!

Ever look at the images in a National Geographic magazine, I mean really look at them? How about Frans Lanting's beautiful images about biodiversity? (What a great job! Search the website at www.nationalgeographic.com) Look at the light, exposure, and communication going on in each image! He's not just snapping the technically correct exposure, he's snapping to grab your

heartstrings with every ounce of light he can capture. Look at the cave shot with the scientist looking at a fossil. Look at the ceiling of the cave and the shadow of the dinosaur, a shadow Lanting created by using a flash. This is lighting, light, and exposure at their communicating best! I'll bet my bottom dollar that Frans did not pull out an 18% gray card to figure out the exposure!

Knowing that conventional film can hold detail in about a three-stop range (Agfa RSX II pushes that to four), changing your exposure by just 1/3 stop plus or minus, can make a huge impact on your image! Digital can hold five stops, so you need to use 1/2-stop increments to make discernible differences. What do I mean?

Let's say you're photographing a moose that's grown a new set of antlers for the year, the velvet glistening in the afternoon sun. If you want that velvet to really shine and that's your subject, then dialing exposure compensation of just 1/3 of a stop can make it glisten and pop in the image. But in this equation of metering to communicate, you must understand not only light and film, but also what is the true subject. In this example, many go for the entire moose as the subject. But in reality, it's the glistening velvet, most likely backlit against a dark background, which caught your attention originally and is the true subject of the photograph. Metering to communicate means using your mind and heart to single out the true subject and exposing to make it become visible to the viewer of your image.

So do I dial in compensation with the D1H? You bet, but not because the meter is being fooled! For the vast majority of images, the D1H meter works perfectly without my having to get involved. But what about photographing western sandpipers flying into the ponds of Palo Alto Baylands, New Mexico ten minutes after sunset? What about photographing two mule deer does in the grasses of Lava Beds National Monument, California thirty

Making the Subject Pop

**Sanderlings.
Photo captured by D1H,
600mm f/4D ED-IF AF-S,
on Lexar digital film.**

minutes after the sun has set? What about photographing roseate spoonbills at high noon at Ding Darling, Florida? You wouldn't pass up any of these opportunities, especially if you're dead on top of them! But the light is beyond conventional wisdom about light. You probably don't want a technically correct exposure, not after the sun has set or at high noon, not even with a D1H!

What do I do when there's no direct sun but there's a subject? Take the sandhill crane example above; in that case I dial in just +1/3 stop. In the deer example, I might dial in as much as + 1-1/3 compensation. For the spoonbills, I might dial in −1/3 stop. But that's what I would do, knowing my meter, film, light, and how I want to communicate what it is I see.

These are just a couple of examples of when I dial in exposure compensation with the D1H. Let's look at that example of the moose with glistening velvet

antlers. The D1H would deliver the correct exposure for the moose, no question. It's more than likely that the AF sensor would be on the eye or near it, so that's what the D1H would think I want to expose correctly, or thereabouts. The D1H would have no way of knowing that, in reality, my subject is the glistening velvet, nor would it know how I want it to pop, so I would have to dial in compensation. Some folks might see this as a shortcoming in the D1H; that's hardly the truth though. The photographer still has the final say regarding what the subject is and how to communicate that subject to others. That's why I said that you must be honest with yourself in determining what's really the subject in order to meter and expose for the subject.

18% Gray Conclusion

Why haven't I even talked about dialing in plus for this or minus for that? Why haven't I even given you one little morsel

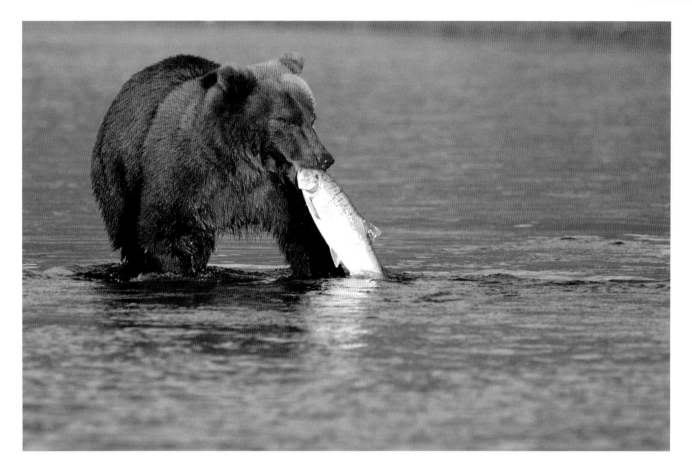

to chomp on, to assist you in learning exposure? Because too many folks will take that info, apply it, then find it doesn't work, doesn't work for them, their camera, film, light, or what they want to communicate. Exposure is a personal, creative thing; you need to learn it for yourself, what it is you want and need to capture by controlling exposure. If you want to learn about exposure, first learn light, how you see it and how your film records it. Then learn how your meter sees it and relates it to the film. Start looking at other photographs in print that you like and see what's going on with these elements. That way, when you see it in your viewfinder, you'll know how to handle it. Start enjoying the incredible world of color around you. You do this and I guarantee that you'll soon find out that exposure is not a four-letter word!

Teddy Bear Exercise (for Learning Ambient Exposure Compensation)

My kid's teddy bears see as much of our backyard as I do since I'm out there photographing them quite often (sure does get my neighbors staring). I have three that I use, one black, one tan and one white, each 12 inches (30.5 cm) tall. They have taught me much, and they can help you quickly learn how and when to use exposure compensation. The goal of this exercise is to provide you with a set of images in which you can visually see the effect of exposure compensation on a variety of tones in a variety of situations, that you can then set in your mind for real life situations.

You'll need to have a black and a white subject for the test (I add a tan one to certain shots). I recommend stuffed animals which have glass eyes (able to reflect catchlights). You'll also need to have a number of locations where you can photograph the subject, paper and pencil for notes on each frame, and a

Coastal Grizzly Bear.
Photo captured by D1H,
400mm f/2.8D ED-IF AF-S,
on Lexar digital film.

For each exercise below, photograph a white teddy bear and black teddy bear in the same exact setting. Adding a tan teddy bear is optional. Light and expose each bear individually, as indicated:

A: Full shadow on subject and background. Photograph each bear as follows:
Underexpose by 1, 2/3, and 1/3 stop
Expose as the meter suggests
Overexpose by 1/3, 2/3, and 1 stop

B: 50/50 shadow on subject, full shadow on background. Photograph each bear as follows:
Underexpose by 1, 2/3, and 1/3 stop
Expose as the meter suggests
Overexpose by 1/3, 2/3, and 1 stop

C: Full sun on subject, full shadow on background. Photograph each bear as follows:
Underexpose by 1, 2/3, and 1/3 stop
Expose as the meter suggests
Overexpose by 1/3, 2/3, and 1 stop

D: Full shadow on subject, 50/50 sun on background. Photograph each bear as follows:
Underexpose by 1, 2/3, and 1/3 stop
Expose as the meter suggests
Overexpose by 1/3, 2/3, and 1 stop

E: 50/50 shadow on subject and background. Photograph each bear as follows:
Underexpose by 1, 2/3, and 1/3 stop
Expose as the meter suggests
Overexpose by 1/3, 2/3, and 1 stop

F: Full sun on subject, 50/50 sun on background. Photograph each bear as follows:
Underexpose by 1, 2/3, and 1/3 stop
Expose as the meter suggests
Overexpose by 1/3, 2/3, and 1 stop

G: Full shadow on subject, full sun on background. Photograph each bear as follows:
Underexpose by 1, 2/3, and 1/3 stop
Expose as the meter suggests
Overexpose by 1/3, 2/3, and 1 stop

H: 50/50 shadow on subject, full sun on background. Photograph each bear as follows:
Underexpose by 1, 2/3, and 1/3 stop
Expose as the meter suggests
Overexpose by 1/3, 2/3, and 1 stop

I: Full sun on subject and background. Photograph each bear as follows:
Underexpose by 1, 2/3, and 1/3 stop
Expose as the meter suggests
Overexpose by 1/3, 2/3, and 1 stop

zoom lens in the 75-300mm range, though 80-200mm will do.

Dialing in the compensation can be done in a variety of ways, which vary slightly with each camera body. I use D1H and use the exposure compensation dial to adjust compensation because I can see these adjustments in my viewfinder. Others like to change their ISO setting to over- or underexpose. A method I use when I know I'm just compensating one photograph is to move my lens off the subject and watch my shutter speed until it changes to the desired value, at which time I hold in the memory lock and reframe for the photo. Whatever method you use, employ it in the test and get into a routine of doing it the same way all the time.

Make sure you write down the frame number, situation, subject, base exposure, and most importantly, the amount of exposure compensation used for each exposure. DON'T trust it to memory!

This test, when done in its entirety, will take a minimum of 54 frames of film. This is assuming you're shooting everything at just one distance; three different distances would be optimum, but would require five rolls of film. If you opt for one distance, make the subject fill approximately one-half to two-thirds of the frame. If you opt for three distances, choose them so the subject fills one-third, one-half, and two-thirds of the frame.

The values below are for conventional shooters. When I do this exercise for digital, I use 1/3 increments. This reflects the exposure latitude of the two respective mediums and the degree to which I like to change exposure accordingly.

A helpful hint: Shadows on the subject and background can be made by using a towel or sheet of cardboard. Place them to block light where and when needed. This can make the test go faster if you leave the camera and subject in the same place and just change the lighting patterns to fit your needs.

Backgrounds and More

The background and its tonality are the final and most critical concepts for making the subject pop. This is by far the one component that can save a photograph if the other three elements of lighting, lens application, and depth of field are missing or not the best. A photograph cannot survive with a bad background! When using a telephoto, selecting the right background is really quite simple since the telephoto has such a narrow angle of view. It's just knowing where to point the telephoto to get the right background that is difficult.

Background requirements can be condensed to a minimum of two basic ideas: light subjects in front of dark backgrounds and dark subjects in front of light backgrounds. This is by far the most simplistic method to make a subject pop. For quick in-and-out photos where all that's needed is to document something, this is a great way to get a clean image. But those once-in-a-lifetime images require taking this simple concept even further.

Photographing a dark subject against a dark background or white against white is possible when a lighting pattern makes the subject pop. This can be further enhanced by controlling depth of field. Once you are combining all four elements of background, lighting, lens application, and depth of field, getting the photograph of a lifetime can be as simple as moving the lens to take advantage of the right background for the subject.

One of the biggest killers of otherwise great photographs of waterfowl and shorebirds resting on water is the background. Naturally, the background is the same as the foreground and middle ground, an even, steel-blue water. How can the subject be made to pop and a sense of depth added to the photograph? Water is by nature a large reflector normally bouncing back the blue sky,

Making the Subject Pop

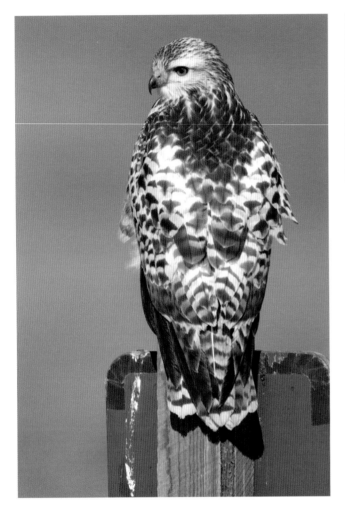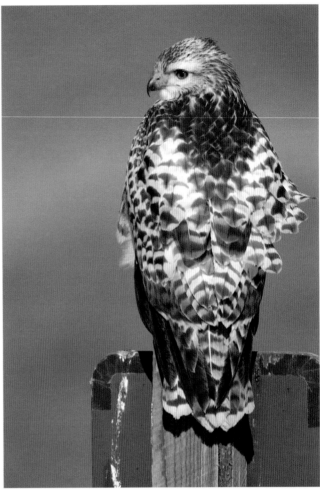

Photos above:
Swainson's Hawk.
Photos captured by D1H,
600mm f/4D ED-IF AF-S
with TC-14E,
on Lexar digital film.

creating one big, blue slate. Close observation may reveal a background reflection of whatever is immediately behind the water, which could be dark shrubs, trees, a bank, and even clouds. This changes the reflection, giving depth and tonality to the water. Moving in the necessary direction can incorporate these reflections, giving the water character and depth. Most importantly, it makes the subject pop.

This can be taken even further. Dead space or spatial designs can be created and manipulated by background reflections. Shrubs and trees usually are circular or spherical in shape. Their lines can be used to create unique backgrounds. Water rippling while reflecting a dark object becomes a design element when used with waterfowl or shorebirds, creating magnificent photographs!

The contrary is true as well. The background can squelch a great waterfowl or shorebird photograph. The busy patterns of reflected reeds, tangles of cordgrass, or intertwined tree branches can interfere with a subject as effectively as the real things. Reducing the depth of field, moving laterally, or waiting until the subject itself moves, are your only real options to change the background unless you have a flash. In that case, you could underexpose the ambient exposure of the background and properly expose the subject with the flash.

With something as large as a bison, finding a background large enough to make it pop is a challenge. As a matter of conversation, do we even need to make such a large subject pop? If we want the ultimate bison photograph, yes we do! Early morning, the bison might be backlit as it munches away on the open prairie.

The sun is outlining its form, casting a golden light. Against the open prairie, this rim light is lost; something dark must be in the background. Move laterally and see if the shadow of another bison or the herd makes the background dark. Lower the camera so that a stand of trees in the distance makes the background dark. Combine lighting, depth of field, lens, and background and that plain old bison can be a photograph of a lifetime.

What about those situations when the subject and background are the same color, both lit by the same sky? This is very common since wildlife tends to hide in an environment that is its same color, commonly referred to as camouflage. The most common solution is, again, finding a darker background. This is a situation where a busy background can be a blessing because the simple lines of the subject will pop from the confusion. In these situations, there's a tendency to rely on the other three concepts to make the subject pop, making the best of the background.

This is a perfect example of why all four concepts are vital to isolating the subject! In situations where you have to deal with camouflage, combining lighting, depth of field, and lens application with the best background will make the subject pop. The importance of the background is visible in each and every photograph taken. Make the background the dominant element, don't let it dominate the subject!

There are times when there is no light or dark background to make the subject pop. These are cases when using complimentary colors can do the same job. A perfect example is the Anna's hummingbird. The male's bright red gorget contrasts against the green of its body and that of the background. With overcast light making the entire gorget light up (in illustration photography, this phenomenon is referred to as "the angle of incidence equalling the angle of reflection"), the bird pops from the background even though it's a green-on-green situation.

In sizing up a situation that lacks a good background, be open to any possible solution. The key is to remember that the background must not only make the subject pop but also communicate something about its world. When you combine all four concepts in any one photograph, you will have achieved this goal. You might think that, with your bag of confidence and ability to isolate the subject, you've got wildlife photography all wrapped up, but there are still some other very important concepts to be learned in order to say that. You still have to get close physically to allow the optics to isolate!

Depth of Field (DOF)

Here's my dilemma. Should I buy the 85mm f/1.4 AF or the new 70-200mm f/2.8 VR for an upcoming project to photograph moose? When working in the dark cover of the Alaskan forest while stalking my "cousin," speed is an issue because there's little available light and flash is out of the question (and I don't like using faster film). I'm in need of a faster lens to capture what it is I have in mind. But with that speed comes the compromise in reduced depth of field.

So the question for me to answer is, do I buy the 85mm f/1.4, a short, bright, fast, sexy f/1.4 lens, or the more versatile 70-200mm f/2.8 VR with lightning-fast focus but slightly slower optics?" Put into terms that might relate to your own photography, do you buy a lens with 300mm f/2.8 or 400mm f/2.8 specs, or along the lines of 300mm f/4 or 400mm f/5.6? Ignoring price, size, or weight (I know, hard to do) and strictly looking at depth of field, which is the best option and how do you and I determine that? Here's how I found the answer for myself.

First, I want to explain what it is I look for in depth of field (DOF). DOF can be a broader concept than how much of the subject itself is in focus. It also can include how much of the world around the subject is in focus. Compounding this issue is the subject I'm intending to

photograph. Birds, for example, are physically small and the distance from the eye to the tip of the bill typically is not that great (there are exceptions to this, of course). In comparison, even the smallest rodent has a nose-to-eye distance greater than a warbler. Start getting into big game and, in my particular quest, the nose-to-eye distance of a moose, you're talking quite a distance for you to grab and render in focus, taking advantage of depth of field.

Keep in mind with wildlife that we're always focusing on the eye, as it has to be sharp, so that's our starting point for depth of field. Now with a bird, if you want to get more of the bird's body in focus, you don't have to go that far to get more in focus given the bird's physical size (generally speaking). But if you want to get more of the moose's body in focus, you've got to go a great deal further to get the nose and hindquarters in focus. And as you increase your DOF, you increase how much of the world around the subject comes into focus, which can be a good thing or a bad thing depending on what you want to communicate. With that in mind, let's proceed.

Testing for Depth of Field

Well you know me, my testing is as unscientific but as accurate as I need. It's really quite simple: I photograph the critter I have in mind and shoot from wide open to closed down and then look at my slides to see if what I need is present. The problem is, as in this case, I don't have a moose in my backyard to photograph to test for the DOF needed. I do have a moose head though, hanging in my living room. So guess what I did? You betcha, I photographed it.

I know very few photographers who have a big game head or a small bird mounted in their home to test as I did. So what do you do, if that's the case? Ah, the answer is simple, head for your local natural history museum! I'd call ahead to make sure you can shoot inside the facility, but I've never had my request turned down. Even if you don't have film that's balanced for the lights used in the exhibits, don't worry. You're not after correct color balance, but to see depth of field. Don't use flash, though, as it will make looking for the DOF in the final image difficult because of the light falloff from the flash. Also, the museum more than likely will not permit the use of flash.

What if there's no natural history museum around you? The next best thing is a stuffed animal. You need to go to the books and determine the actual size of the critter you're testing for. Find a stuffed animal approximately the same size and test with it. If you're testing for a grizzly bear, I doubt you'll either find or want a life-size, stuffed–animal griz. The thing to do is use two stuffed animals and place them far enough apart to approximate the size of the real griz.

With this kind of test, reading the final results can be the biggest challenge of all. I'm always surprised at how difficult it is for some folks to determine whether an image is tack-sharp. Determining DOF is even more difficult! Whether looking at a small bird or big moose, seeing what's really sharp and where that sharpness ends is a real challenge. This has to do with contrast, from the light, the film, and the nature of the critter itself. Contrast can easily increase apparent focus and depth of field when in reality it's not there. Well, going back a few decades, let me tell you about an old school exercise of mine, which might help you to see actual depth of field in your images.

Six-Pack Test

Being able to see where depth of field ends and out of focus begins is important when you get your tests back. Not being fooled by contrast is also important, an aspect of film, light, and lens that increases apparent focus, not actual focus. To deal with this, some wise teacher before the dark ages came up with the six-pack test, to help students understand and grasp DOF. (The test was originally

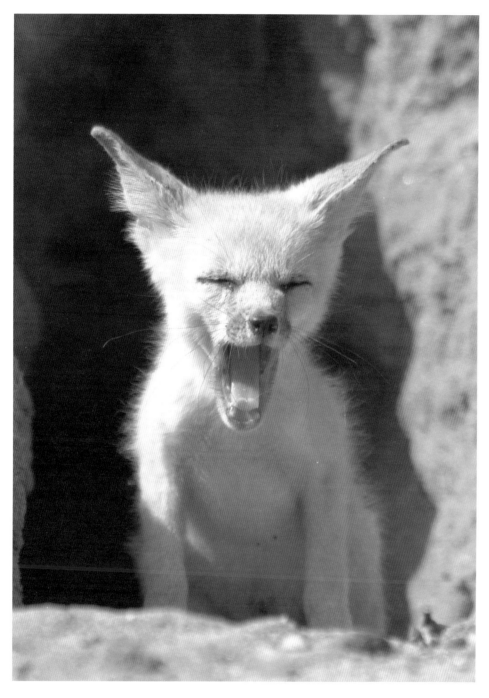

San Joaquin Kit Fox.
Photo captured by D1,
400mm f/2.8D ED-IF AF-S,
on Lexar digital film.

created to be used with the swings and tilts of a large-format camera.)

As the title suggests, it requires a six-pack. Now, back in school days, you can imagine the six-pack of choice, but you can use any you would like to drink after the test. We use cans in the first place because cans have fine print on their labels, typically contrasty, as in black type on white background, so select your six-pack accordingly. This makes it very easy to read, when you get your test back, whether the type is in focus and when it's clearly not. It's critical with this test to see what's out of focus!

Now, you want to arrange your six-pack so that the cans are at distances that make sense for the subject you might eventually be photographing. For example, I want to test for moose. I set up the six-pack so the cans are about four inches (10.2 cm) apart and focus on the second to the last

Making the Subject Pop

Moose.
Photo captured by D1H,
400mm f/2.8D ED-IF AF-S,
on Lexar digital film.

in the line, making that my "eye" point (as if it's an animal's eye). With that done, I start shooting with available light, shooting wide open and closing down one stop with each exposure (with the F5, I do it in 1/3 stop increments). If you want to see how much behind the "eye" comes into focus, you can set up more cans, or lay a yardstick flat on the same plane as the cans.

Now you might want to arrange the six-pack in any one of a number of different ways. The original assignment back in school days had us arranging the six-pack in twelve ways, but you don't need to go that far. If you're going to do this test for small birds, arranging a couple of cans is all it takes. In the case of the moose, I set them up two (vertically) high and four deep, requiring more than

a six-pack. But the vertical height helped me when I looked at the slides on the light table, to see how much depth of field I was really going to pull for the full muzzle of the moose.

Finally, when you shoot your test, you want to shoot the test at varying distances, getting physically further away from the cans. You want to shoot at distances that are your ideal distances for the image size for the subject at hand. For example, with the moose test, I selected 10, 15, 20, 25, 30, and 40 feet (3, 4.5, 6, 7.5, 9, and 12 m). You should understand that DOF increases as the distance from the camera body to the subject increases. The amount of the increase is a function of the focal length and the f/stop combination. Using a shorter-focal-length lens provides greater depth of field than a longer lens at a given f/stop and distance. There is a dramatic difference, for example, between a 400mm f/2.8 and 600mm f/4, one that can make all the difference in the world in how you visually communicate. This is what is called style, and your style is determined by the lenses you use.

Depth of Field and Teleconverters

There's a lot of confusion when it comes to teleconverters and depth of field. I've had many a conversation with some over this topic. When you attach a teleconverter to your lens, the effective f/stop changes. Using a 1.4x, your effective f/stop changes by one stop. With a 2x, it changes by two stops. What's happening is that the teleconverter is eating up light, sucking it up and preventing it from reaching the film (the result of light squeezing through more glass).

The teleconverter has not directly changed the aperture; the aperture remains the same size as it was before you attached the teleconverter. For example, if you place a TC-14E 1.4x teleconverter on the new 80-200mm f/2.8 AFS (a real big fad at the moment that's beyond me) and the lens' aperture is set to f/2.8, your effective f/stop will be f/4.

The key to this definition is focal length divided by aperture. While the focal length of the lens changes by the amount or strength of the teleconverter, the aperture does not. This function of optical physics is why you do not retain the full depth of field of the effective f/stop. A piece of trivia I picked up long ago was that with a 1.4x, you retain 40% of the depth of field of the effective f/stop. A Nikon lens book states that, with a 2x teleconverter, you retain 1/2 of the depth of field of the lens in use and with the 1.4x, you retain 1/4 of the depth of field of the lens in use. What this means is you have half of the DOF of the effective f/stop for a 2x and 1/4 of the effective f/stop for a 1.4x.

But if you want to see for yourself what you're losing or gaining, do the six-pack test with your teleconverter and see for yourself. I personally like the loss of depth of field when I use the TC-14E with the 600mm f/4, as it really helps make the subject pop. But if you're battling to gain depth of field, a teleconverter might not be the best solution. Getting a bigger lens to start with or getting closer might be what it takes to capture the depth of field you require.

So what lens did I decide on buying after doing my test for the project? I found that for my own personal taste, the f/1.4 was too shallow to pull the depth of field I wanted to see. Closing down just one stop to f/2 was close, but f/2.8 was the smallest opening I could use and pull the depth of field I wanted around the eye of the moose. So I went with the 80-200mm f/2.8 AF-S for my project. This is the simple way I go about determining if a lens' fastest f/stop, its maximum opening, will solve the problems I need solved to capture what I want to communicate on film. I hope it aids you in better understanding the use of depth of field, as it can dramatically change your photography!

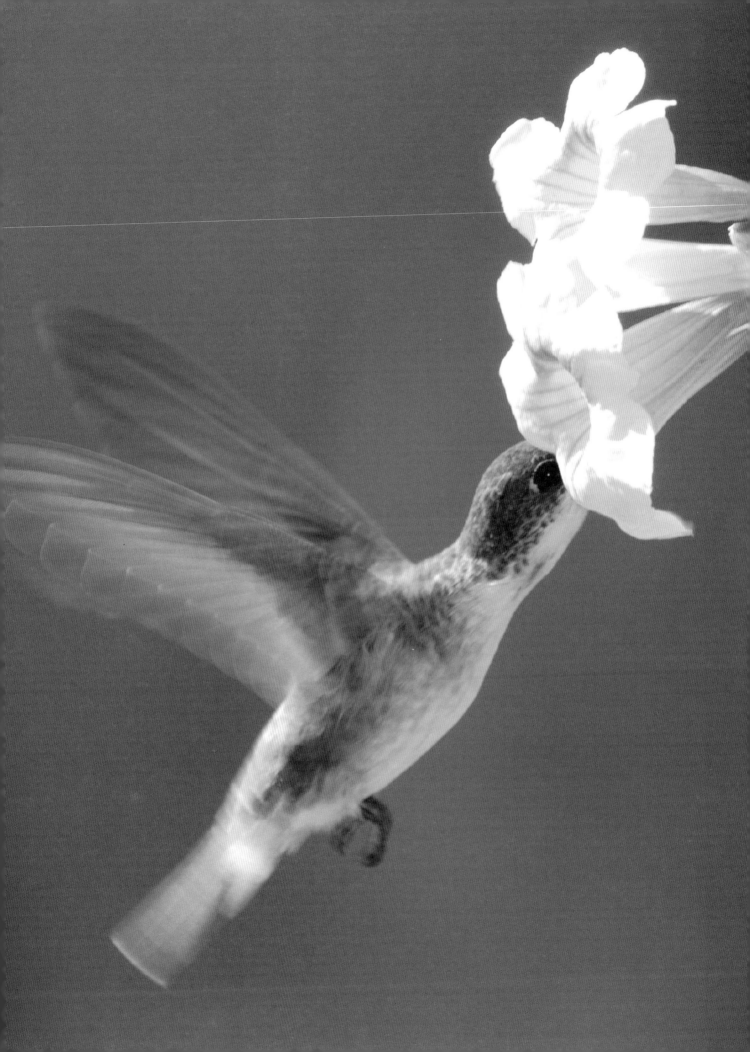

Chapter III

Getting Close Physically

With a key in hand, I looked in all directions as I unlocked the gate to the sump. I didn't want anyone to see me enter and I didn't want the curious public to disturb my subjects in my absence. Sneaking around a housing tract with a 400mm f/2.8 lens was not easy, especially when I needed to enter around the same time school was getting out. I got in and locked the gate behind me. I wove my way around the rim of the sump, avoiding stepping on the garbage that had been heaved into it. I got to the corner where I could safely walk down to the bottom. Waiting for me there were a couple of inches of smelly, old, standing water. I slowly and very quietly walked to the other side, where I set down my chair, set up my tripod, and began to wait. An hour went by, then two, when I heard what sounded like whimpering. As I stared through my lens at the hole in the bank 14 feet away, dark brown eyes returned my gaze. At first the vixen appeared, and then, slowly, four four-week-old San Joaquin kit fox pups emerged!

I was the first to ever photograph such young kit fox pups, members of an endangered species. Sitting in a smelly sump, though, definitely dispels any idea of wildlife photographers leading glamorous lives. My point is not to dispel a myth (though it is, isn't it?), but to tell you that the whole experience came about because I got close physically to the subject! Since day one, all of my photography has been based on this simple concept. Get close physically and use optics to isolate the subject.

You might have noticed as you've paged through the book that there are a quite few images of grizzly bears. You might like to know that I'm typing using all ten fingers. Folks are always awed by my grizzly stories and how they were only an arm's length from me at times. If you were standing beside me (Some of you are saying to yourselves, "No way!"), you wouldn't be as amazed. My point is, getting close physically should not put you or your subject in harm's way. I repeat many times in this book a phrase I've been repeating for twenty years: *No photograph is worth sacrificing the welfare of the subject!*

You've completed that bag of confidence; you've mastered exposure and exposure compensation, flash, and isolating the subject. You think you're ready to capture the wilds of the world on film. NOT! The biggest challenge still lies before you, getting physically close to the subject. Personally, this is the most enjoyable challenge that I know of in wildlife photography.

Getting close physically requires understanding basic biology. I'm not about to suggest you get a PhD degree in wildlife biology. I am asserting that, for the welfare of the subject (which always comes first) and for the best photographs, basic biology must be just as much a part of your thinking as aperture and shutter speed. In the process of this

**Violet-crowned Hummingbird.
Photo captured by D100,
600mm f/4D ED-IF AF-S
with TC-14E,
on Lexar digital film.**

understanding, you almost guarantee the great image while not harming your subject. They go hand in hand! Basic biology is no more than a general understanding of our natural world. This knowledge of what the wildlife is communicating to us about themselves can be used to get in close physically while safeguarding the subject.

I should preface all this by telling you that I've never taken one class in biology. What I learned over 20 years comes from being in the field, most of the time from biologists who have been very gracious in sharing their expertise. My achievements as an environmental educator are a matter of far greater pride to me than anything I have achieved in photography (which is why I was honored with the John Muir Conservation award in 1998).

This is something that all photographers can accomplish. Experience comes from watching and observing. One thing you must keep in mind: Basic biology is a generalization of animal behavior. Individual wildlife have had different encounters with humans and, based on those encounters, will react accordingly toward you, the photographer. The wildlife of national parks, habituated to us, react differently to our presence than those found in the wilds of Alaska. What you read or see is, at best, one reference for a particular species. By knowing basic biology, you can make assumptions which will generally get you in close physically, get the photograph, and protect the welfare of the subject.

Getting close physically is the marriage of basic biology and technology. We've gone through equipment and lighting in preparation for the moment of firing the shutter. Now, we need to get in close physically to put that long lens and marvelous light to work. I hope you're not disappointed in just how easy it is to get in close physically. It's no more than common sense (which makes up all aspects of wildlife photography)! Once you have basic biology under your belt, the equipment and technique

will all fall right into place and the magic of wildlife photography will fill your CompactFlash cards!

Knowing Basic Biology

Where to start absorbing basic biology? From that favorite armchair, of course. Learning basic biology can be done by simply watching television. This day and age, there are really lots of great programs (and some that really stink, especially the ones on grizzly bears). They can aid you in your quest for knowledge. Though many nature programs are staged, the actions of the wildlife are nonetheless genuine. The learning that can be acquired from watching and observing is amazing! I still watch and learn from these programs.

There are many examples of great programming. There are many excellent programs on hummingbirds, one of my favorite subjects. By watching them on television, we can see how they approach and retreat from a flower when feeding. We can also get a feel for how long they spend feeding on one flower. We can take this knowledge into the field and prefocus and preframe on a flower in preparation for the bird's arrival. By understanding that they come in low to a flower and hover, we've increased our opportunities to successfully photograph them!

One area of photography most wildlife photographers don't venture into is nocturnal. If you want to see what you're missing, get ideas of where and when to go and what you might find, just watch any one of the many great programs on nocturnal wildlife. I have taped many of these programs strictly for the great information they contain. It has saved me years of painful trial and error working with a truly unseen subject!

There is still more learning to be gleaned from watching television. The moving images on television provide insight into the animal's behavior and how it uses its

FIELD TIP

Family vacations are a great time to learn about basic biology. There are many times when photography just isn't possible, but learning about wildlife is an anytime activity with the family. Kids just soak up the subject. Make it a family adventure, stopping at visitor centers and roadside kiosks and learn together the wonders of nature. Your photography and family will thank you!

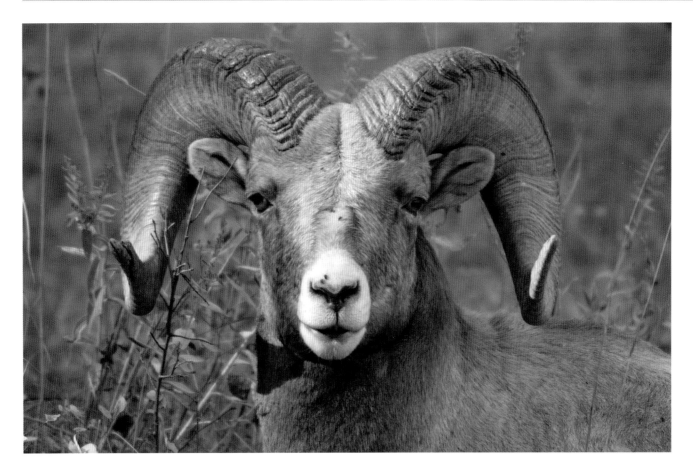

habitat. It gives hints as to the time of day the species is active and possible problems associated with photographing during that time of day. The observant TV watcher can see how the species communicates its actions prior to executing them. This is something which all wildlife does, which we can use to our advantage! It can even provide possible clues where to go to photograph that particular species.

You need to start filling the shelves of your mental library (and office library as well) with what I term nature trivia. Reading is the best way to do this. There are, for example, many excellent magazines on birding. *Birder's World* and *Bird Watcher's Digest* are two excellent magazines that discuss the world of birds, where to find them, their habits, and, in many cases, how others have gotten close to them. (Unfortunately, comparable magazines devoted to mammals aren't available, but you might try *Nature*, *Smithsonian*,

or *Natural History* for their occasional look at mammals.)

These are great beginning references, but there are even more specialized magazines called journals which provide a wealth of information. *The Auk*, *The Condor*, *Journal of Mammalogy*, and the *Conservation Biology* journal, plus tons more, are written by the scientific community for peer review. It isn't necessary to be a rocket scientist to understand what's written. The methods sections of the papers in the journals are particularly useful.

In this day and age, the Web can be a killer locale to find biological material. So do a search on the species name and birds or mammals in general, as well as the state game department where you live. The real trick to get the most out of these pages is to READ them carefully and explore the links they provide. Too many folks want instant answers from a website and do not take the time to read

Rocky Mountain Bighorn Sheep. Photo captured by D1H, 400mm f/2.8D ED-IF AF-S, on Lexar digital film.

Getting Close Physically

**Northern Flying Squirrel.
Photo captured by D1H,
300mm f/4 ED-IF AF-S,
multiple flash,
on Lexar digital film.**

and explore it. I can guarantee you that the Web is an incredible wealth of biological information you can find and trust. I know I do on a nearly daily basis!

For example, supposing you want to photograph the nocturnal habits of a kangaroo rat. Look up kangaroo rat in general or the specific species in the indexes of journals and find the papers that deal with that topic. Next, the method sections in the papers will outline how the kangaroo rats are found, what is used to lure them, what time at night they come out, what time of the year is best to see them, and if there are any special precautions needed to protect their welfare. A further reading might reveal such added insight as key behavior to anticipate and photograph. In fact,

if you run a search for this particular subject on the Web, the majority of the time you'll find the articles illustrated with my kangaroo rat photos. The information you need is out there in book, magazine, journal, and Web form. You've just got to do a little homework!

Reading specific books on a species to be photographed will further open doors to its biology. One of the wildlife photographer's greatest resources is the library of the local natural history museum. I was very fortunate to have one of the best in Santa Barbara where I spent hundreds of hours reading. Librarians in specialized libraries can point out the most current books on the species you're researching and in many instances know of current articles and other resources available to aid you.

Many state wildlife departments (such as California Department of Fish and Game in my home state) and the U.S. Fish and Wildlife Service publish reports on a wide variety of topics covering our natural heritage. Many of these free publications can add a great deal to your understanding of basic biology. This is one of the greatest untapped resources available to everyone. They also have huge websites with many of their own journals and biological descriptions.

One note of caution: These sources are usually dated by the time you read them. Check the publication date of the books and the dates of the research in the journals. Even though the information was extremely accurate when it was done, don't think of it as the final word on the subject. I can't remind you enough, this is a constant learning process, no one has all the answers!

I personally have a huge library of reference books in my office (and with Internet booksellers making it so easy, I'm constantly adding new releases). There are a number of publications that only a crazed soul like myself would want, but others are basics which all wildlife photographers should have on their shelves.

The first is a bird identification book such as The Sibley Guide to Birds or National Geographic Society Field Guide to the Birds of North America. Your library should also include volumes on mammals, reptiles, or insects if that's your interest. Not only do these books tell how to identify a particular species, but they provide general biological information.

Those who are interested in birds must have A Field Guide to Nests, Eggs and Nestlings of North American Birds. This book provides critical information on the nesting biology of the birds in North America. It gives nest location and season, incubation, nestling and fledging times, parenting behavior, and much more. This is a must in every wildlife photographer's library!

Reading Sign

Before you even leave the house, become a general expert on the species. Once you leave the house, you can compare what you've read with what you're seeing and fill in the holes not covered in your research. One thing most rarely gotten from book learning is generally termed "reading sign."

Reading sign is really no more than observing and understanding what wildlife are communicating. A good example involves raptors and their defecation. Just before a raptor (hawk, eagle, or owl) is about to leave its perch and take flight, it will get rid of a little extra weight by defecating. So, when approaching a raptor and it defecates, be aware it's about to take flight and take the appropriate action.

On that same note are the clues that birds' white wash leaves behind. You find a locale with lots of white wash, what does that tell you? You know it's a place where a raptor often perches. You want to get the shot, you just need to wait. What about white wash and little pieces of bone or skull, what does that tell you? It tells you that it's a perch for an owl,

Sawhet Owl.
Photo captured by F5,
600mm f/4D ED-IF AF-S,
on Agfa RSX 100.

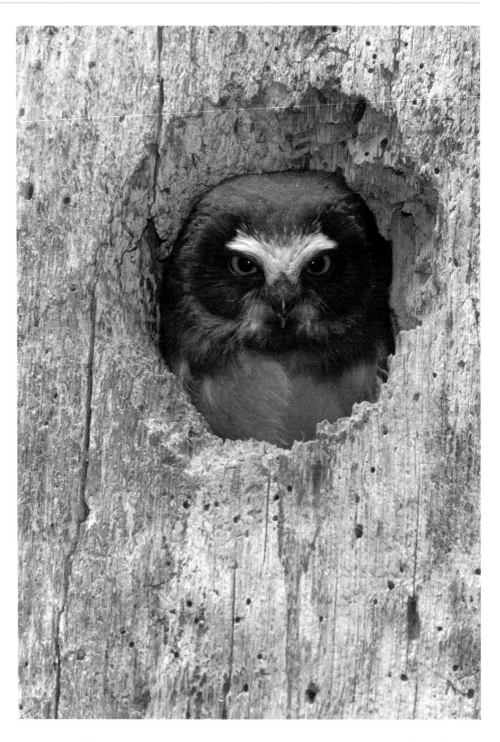

FIELD TIP

Don't be in a hurry to get nothing! I shoot with a lot of wildlife photographers and one bad habit they seem to have in common is to be in a hurry! Instead of going slow, stopping when needed, and watching the subject like they should, they just rush right up to it. Slow and easy wins the race. If you've found that great subject, work it slowly to capture the great shot. The worst feeling is when you've rushed a subject forcing it to move or move off completely. Don't be in a hurry to get nothing.

more than likely. What about finding a lot of white wash on the ground at the base of a tree? If you look up the tree to find the source of the white wash and you find a nesting cavity, you've found an active nest. This is how I found a nesting northern sawhet owl's nest one year.

Reading sign doesn't require putting on a coonskin cap and becoming Davy Crockett.

Listening to the call of a bird, tracking its origin, and retaining the information is lots of fun. Learning calls can also be key in knowing if an owl is in the area and if jays are mobbing the owl. This is just one example of how easily detected and useful sign can be in photography.

Reading sign also comes in direct forms. When approaching a wild animal, it

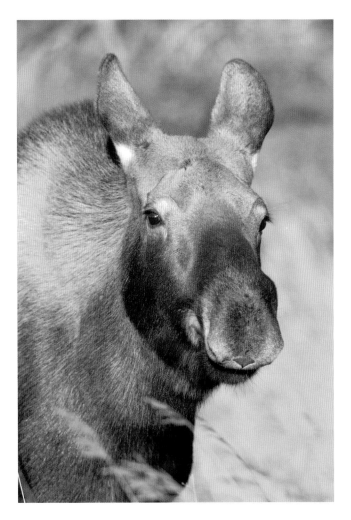
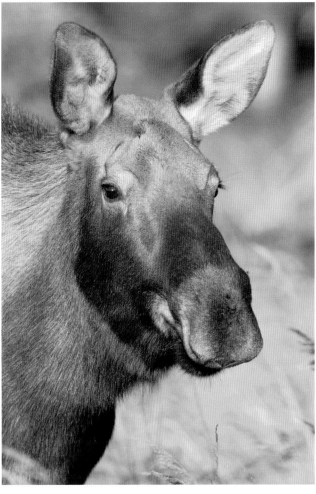

communicates in no uncertain terms what it's feeling about your encroachment. The thing we hope to see and have communicated to us is the one-time glance by the critter and then its return to activity. It is only by careful study of and watching the subject that we can safely and successfully get close to the subject! Getting close requires that you always, always, always watch the subject! They will tell you, I guarantee, always just what they're thinking. The trick as it were is to be able to read that sign!

I've already mentioned how raptors defecate before taking flight. Many birds will fluff up their feathers when they're uncomfortable. Some birds will change which foot they are standing on prior to leaving. That's if they don't just start moving away. Many times, birds do what is called displaced aggression. When a bird is feeling stressed by an outside

presence, it will act very nervously and take out its frustration on a mate, another bird, or a twig or leaf.

Mammals have various ways of showing their discomfort, most being comunicated through the eyes and ears. If you're working with a cow moose and she lowers her ears, you'd best know she is not just disturbed but is probably pissed off! You can see in the two photos above exactly what I'm talking about. In the image on the left, you can see the ears are back and on the right, they're in the "happy" position. In this case, the ears were back because the cow was listening to a bull and was not actually mad, but you need to know the difference when you're out in the field.

No Photograph Is Worth Risking the Welfare of Any Subject!

Knowing basic biology enables you to understand the signs I've just mentioned

Ear position is often a clue to an animal's comfort level as seen in the above photos of a moose. Captured by D1H, 400mm f/2.8D ED-IF AF-S, on Lexar digital film.

Greater Sage Grouse.
Photo captured by D1H,
600mm f/4D ED-IF AF-S
with TC-14E, on Lexar digital film.

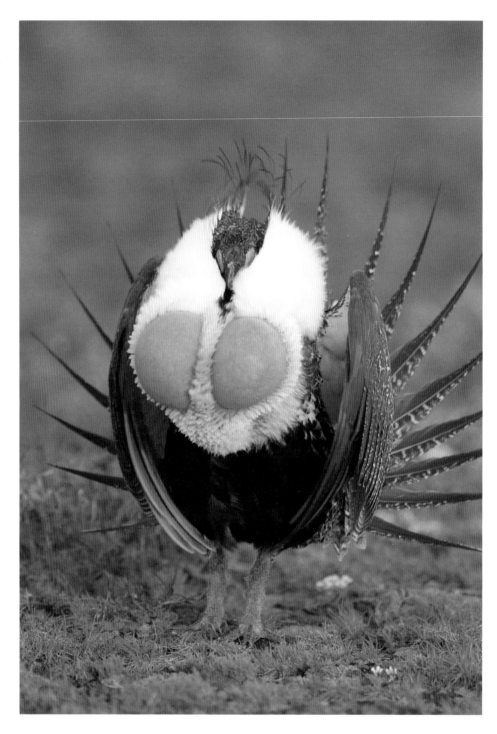

plus the hundreds of others that let us know we're doing something right or wrong. This prevents careless accidents and injury to wildlife. As I said, knowing basic biology is just understanding what wildlife is communicating.

The biggest photographic benefit in knowing basic biology is getting close physically. Knowing what a critter might

be communicating, you can act accordingly, which includes knowing which direction to head or not, as well as how close you can get. You still might be wondering just how this all falls into place, basic biology and getting close physically, so let's discuss a couple of scenarios.

During the spring, wildlife does what comes naturally, the bird and bee thing.

No Photograph Is Worth Risking the Welfare of Any Subject!

During this time of courtship, males especially are interested in finding a mate. (Sex is one of the best things for your subject to have on its mind when you're trying to get close physically) During this time of, let's call it preoccupation, males throw caution to the wind and, for photographers, this means getting in close physically is a whole lot simpler.

Understanding the different bird species' styles in attracting mates is of enormous value. Each species has a different methodology of attracting a mate. If it's drumming from a particular log, then you have an idea where to set up. If it requires singing from atop a perch, once you find that perch, you know the male will constantly return to it. Males establish territories quite often and defend them against other males. They constantly traverse their territory, singing from chosen perches. Knowing this, you can find the best perch for photography and set up on it instead of chasing the bird.

During the nesting season, knowing basic biology permits you to sleep in. Males tend to sing when there's sun and it's not windy or breezy. When that alarm clock goes off and you look out your window and you don't see the sun and it is breezy, you can go back to sleep, knowing that the males won't be out singing. Just be sure that the weather at your house is the same as that where the birds live and you'll be okay. This doesn't hold true though, at other times of the year, nor is it true for mammals.

Certain species only display their special ornamentation during the breeding season. The male greater sage grouse only fans his tail and inflates his air sacs for a brief period during the spring. The male red-winged blackbird only flashes his red shoulder patches during the spring. If the goal is to capture these seasonal shows, you'd better understand when and how these species display to attract their mates.

Mammals are a little more difficult. Males don't tend to flash bright colors or sing from atop a perch. For many mammals, mating also takes place in late fall rather than in spring as with birds. Elk bugle for mates and have their shoving matches in late fall. The mighty clashes of bighorn sheep ring through the mountains in late fall, as do the sounds of tangled mule deer antlers. Be aware that mammals with antlers (deer, elk, moose) shed their antlers in late winter to early spring. Photographs of a bull moose with a large rack are best shot in late fall once they have shed their velvet and are in their prime. A bull without its rack at first glance by the public looks like a cow. If you want a bull photo, you need to be at the right place at the right time to capture the rack!

You won't miss events if you keep in mind you live on a round planet. In Alaska, in the northern latitudes for example, the breeding season for birds runs typically from June to July, whereas in southern California and Florida, it's more likely to be in early April. Doing research on the nesting or mating biology of a species will reveal such information, thereby preventing the mistake of traveling to a region for events which are past or have yet to occur.

One of the greatest benefits of understanding basic biology is knowing when an event is going to happen. One of the biggest reasons I work with biologists is because their knowledge aids me in capturing those unique moments on film (as well as safeguarding the species' welfare). Let's face it, only so many wildlife portraits can be taken. The most exciting photographs and challenges in wildlife photography come from capturing the wildlife in action. If, through basic biology, you understand that the subject is communicating its next action, capturing that action on film is not such an challenge. You can have yourself and your gear ready in a heartbeat to capture it. You'll find that learning basic biology not only benefits your photography, but it's fun!

This next point seems so obvious, yet it's still one of the greatest untapped principles

FIELD TIP

Photographing the bighorn sheep clashing or moose pushing during rut is best in state or national parks. Unhabituated big game tend to do their thing in secretive places where we aren't meant to go. Whereas big game that are habituated to people, such as wildlife in parks, do it right out in the open for all to see. This is the best opportunity you have to capture this highly charged action on film.

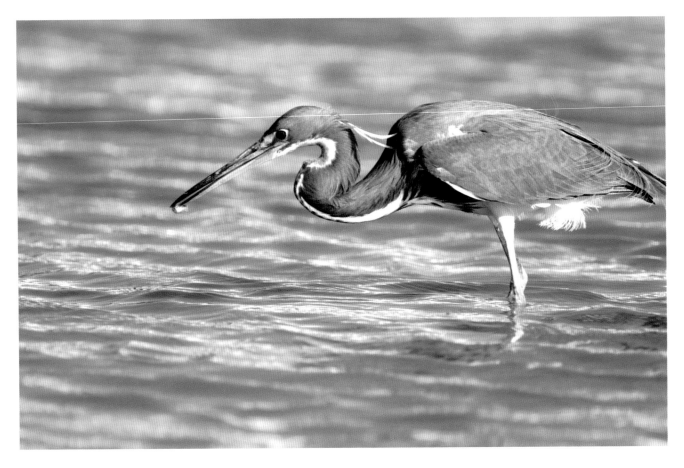

Tricolored Heron.
Photo captured by D1,
600mm f/4D ED-IF AF-S
with TC-14E, on Lexar digital film.

in wildlife photography. Set your camera's motordrive to Continuous!

A heron in the Everglades is standing perfectly still in the water, its gaze piercing the surface. You'd better have that motordrive set to astro blast and the metering set, because at any second that heron is going to stab into the water to catch a fish. This means you need to be prepared! You need the fastest shutter speed available and enough room in the composition for the neck of the heron to grab the fish and not be out of the frame. Knowing basic biology has you prepared to capture the event!

A coyote prowls a meadow. Suddenly it stops and cocks its ears straight forward. Slowly it looks down, pointing its nose like an arrow. Once again, have the camera's motordrive set to astro blast, metering set, and room in the frame for the coyote to first jump up and then out. The coyote by its movements is telling you it's heard a vole and is zeroing in on

the noise. Homework done, you know coyotes pounce on prey like a cat, up and then out. Know your basic biology so this marvelous event goes home on film and not just as a memory!

You'll get better photographs by knowing basic biology and selecting equipment accordingly. You should only travel into the field with the equipment needed for that particular shoot. For example, you probably wouldn't use a 600mm lens to photograph a hummingbird's nest or try to use a 200mm to photograph an eagle's nest. Likewise, if you are going to photograph kangaroo rats, you wouldn't go without a flash. Understanding the basic biology of the subject lets you prepare for any possible problems that might arise when photographing it. This in turn allows you to travel light, carrying exactly the equipment you need. The moral is, take all your gear with you to the locale but only take that equipment into the field that solves the immediate problems of getting the particular photograph.

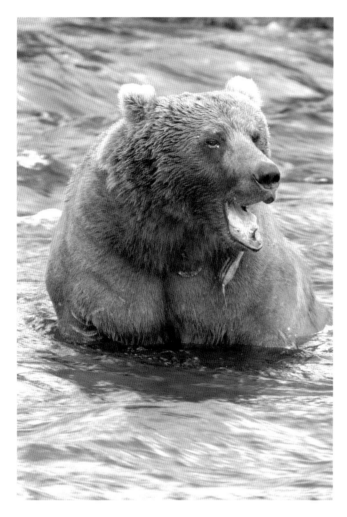

The welfare of the species is the biggest reward in understanding basic biology. Ethics in wildlife photography is a gray area where there are no written guidelines for every possible situation. But the gray area never has to be a problem if you understand basic biology. You'll never stress or harass (which is illegal and will end up showing in your photographs) wildlife if you understand what it's communicating. You'll never worry if you were responsible for a nest failure or a young calf being taken as prey if you understand basic biology. You'll never have worry that you're part of this huge problem rather than part of the solution!

Basic biology can also add to your personal protection. A grizzly mauling a photographer is nearly an annual event and is the fault of the photographer doing something he should have known

not to do. An elk or bison goring a photographer. A rattlesnake biting a photographer. These need never happen if the individuals understand basic biology. You can get close enough to bison in Yellowstone to photograph them with a 20mm, but why take the risk when you know they just love goring tourists! And for goodness sake, never chase a bear, especially a grizzly over a ridge. Not only are you risking your own safety, but that of the grizzly's if the grizzly does anything to protect itself from you. No photograph is worth risking the welfare of any wildlife!

More Techniques

Success in getting close starts before leaving the house. Aftershave, perfume, scented deodorants, scented laundry detergent, and other unnatural scents

Above left:
**Coastal Grizzly Bear.
Photo captured by D1H,
300mm f/2.8D ED-IF AF-S II,
on Lexar digital film.**

Above right:
**Coastal Grizzly Bear.
Photo captured by D1H,
400mm f/2.8 ED-IF AF-S
with TC-14E, on Lexar digital film.**

Bald Eagle.
Photo captured by D1,
400mm f/2.8D ED-IF AF-S,
on Lexar digital film.

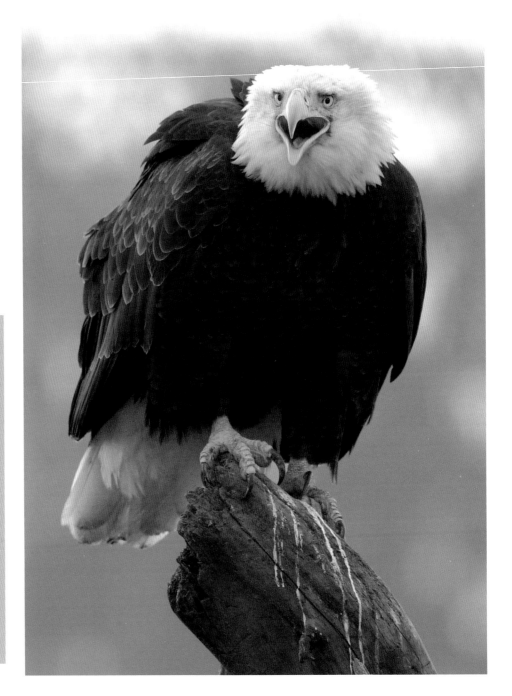

FIELD TIP

One of the great benefits of shooting digital is the ability to slim down! Not having to have to wear a photo vest with buldging pockets of film sticking out from my side and making noise is just fantastic! Instead, with digital media, I can carry nearly the equivalent of 100 rolls of film in a case that fits into a shirt pocket. I wear a small fanny bag that hides behind me, so my profile is as small as it can be while still allowing me to operate photographically.

won't help in getting close. They can make the difference when you're working with an already shy subject. Picture the dirt cloud that surrounds Pig Pen in the *Peanuts* comic strip, and then imagine it as a scent, and you have an idea of the cloud of smells around you. I'm not saying, never leave the house if you've showered or washed your clothes, or that you need to roll around in the dirt

once on site. I'm recommending unscented products. Leave smelling good for when you get back home. Rolling around in the grass or buying hunting scents is not required to get close. Just be neutral-smelling.

The next consideration is the equipment you're dragging, I mean carrying, into the field. You should be carrying only the

equipment you need for that particular photographic adventure. You're asking, What about those times when you're just going out to see what's about and have nothing specific in mind to photograph? You should still take what you'd use for photographing either birds, mammals, flowers, or bugs, but not your whole camera bag. The goal is to minimize our own profile so we blend in better with the world around us.

I once watched a photographer loaded to the gills with equipment approach an incredible scene with two gray foxes. They were completely wrapped up in playing in the sun and had no idea that anyone was watching. Since the other photographer had seen them first and was already approaching them, I just stood back and watched the moment. Well, he got right up on the foxes and had a great shot in front of them. He slowly and properly took his tripod mounted rig from his shoulder and set it down. Just then, the camera bag hanging from his shoulder slipped down his arm. He jerked to catch it but it was too late, the foxes were alerted to his presence and were gone in a flash.

Limit what you're carrying and how you're carrying it. Fanny packs are a good example. Most are made of nylon which is a drawback. Their buckles can be the biggest problem. The "click" noise of the buckle as it's coupled or uncoupled is the perfect frequency for mammals to hear. I don't know if it's the same as a snapping branch or just super-foreign, but they run from that noise lickety split!

Naturally, you might be asking if knowing basic biology allows you to just walk right up to wildlife. Well, not exactly. There's a little more to it than just walking up and taking the photograph. You can break it down to two concepts, physically moving closer to the wildlife (stalking) or having the wildlife come to you (luring).

Moving Closer by Stalking

Stalking is a term with connotations of having to be a ninja photographer. Traditionally, stalking is thought of as a process of moving closer to wildlife by using every rock, bush, and/or tree for cover, requiring some elaborate zig-zag walking strategy. Who's kidding whom? Are most animals so stupid that they don't know when a person is approaching them, especially a pesky photographer? Besides, what subject hangs around long enough for such antics?

Yes, there are times when wildlife turns a blind eye to the photographer. And thank goodness, or else we wouldn't get the photographs we do. The point is to use sound basic biology and not some stalking voodoo to get close physically. This basically means that when I'm out shooting, I tend to walk straight towards the subject. And lets face it, there are very few rocks or trees that are going to hide me carrying a 600mm lens on my shoulder. I might use an available shrub or rock if it's on the path towards the subject, but I don't go out of my way to use them. The wildlife will either stay or flee. Hopefully, my actions are putting the wildlife at ease so it remains.

Before even starting the stalk, there are a few things to check. First, do you have any camera straps dangling from your camera or lens barrel? These are strong vertical lines, something wildlife, especially wary mammals, look for. If it's a shy subject and you have a strap swaying as you're walking, you might not get close. Next, are there any natural obstacles between you and the subject? Water, holes, logs, or any other obstacle which must be circumnavigated will determine your path. Mentally map out a path, one with the least obstacles to hamper a graceful approach, and then select a stopping point where the desired image size can be captured. Lastly, we must make sure that our actions will not jeopardize the subject's welfare.

With all of this thought through, we start approaching the subject. Always keep in

**Double-crested Cormorant.
Photo captured by F5,
600mm f/4D ED-IF AF-S
with TC-14E and 16mm extension
tube, on Agfa RSX 100.**

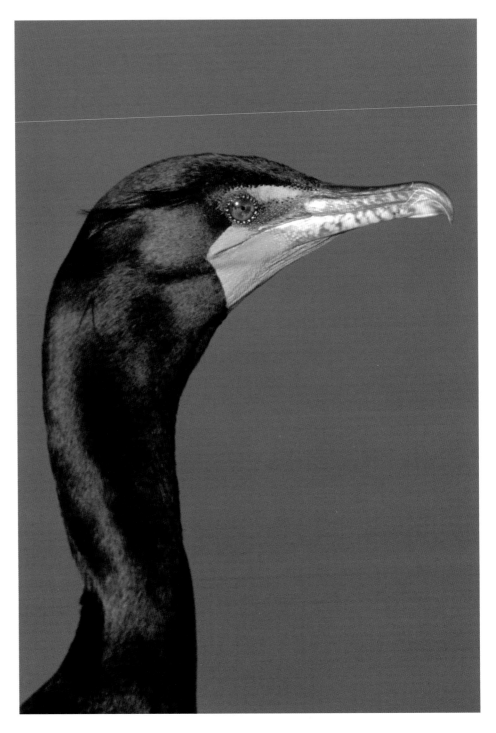

mind that whether it's a mammal or bird, that at any moment it could just disappear and we're skunked. That's part of the game. More than likely, a higher precentage of stalks are successful if we've done our homework. This is due to the fact that each individual subject has its own zone of safety. When we recognize the sign that we are encroaching on this zone, we avoid entering it and thereby causing the subject to take flight. A knowledge of basic biology enables us to see the signs of flight before they happen and helps us get the best possible photographs from the situation. Right?!

Many people concern themselves with being up, down, or crosswind during a stalk. This may get them close or may not. Make the most of the experience by

approaching in the direction that gets the best photograph (generally determined by the light more than any other factor). What good is getting in close coming downwind if the resulting photograph fails because of lighting, background, or any other distraction? Hey, the whole purpose of photography is to have fun, so remember that sometimes the great photograph just won't happen. With neutral smell and an understanding of basic biology, the chances are good for that close approach no matter which way the wind blows.

When handholding the camera, stalking is a lot simpler. Walk with even, slow-paced strides, avoiding at all costs fast, short, jerky steps. Smooth, fluid steps (avoiding any twigs if at all possible) put the wildlife more at ease. The camera should already be just below chin level so that the motion of bringing it to the eye is minimal. Raise the camera to your eye in a slow, fluid motion, keeping elbows tucked in, focusing and operating the camera in a like manner. Any sharp, quick movements imitate the movement of predators just prior to a strike. As far as the subject is concerned, a stalking photographer is a predator. They're unaware that no harm is intended by the photographer.

The hand-holding photographer is able to walk a much easier path compared to someone with a tripod rig. For this reason, stalking is easiest when handholding since there is so much more flexibility in movement. For example, walking over a fallen log is an option not available to the tripod-bound photographer. The speed of taking the shot is much greater if you are handholding your gear as well, since you can have instant response to any action on the part of the subject.

The advantage of the tripod-bound photographer is the tripod with its mounted lens. The fallen tree, boulder-strewn stream, and other natural obstacles might impede progress, but the tripod and its shape more than make up for it. Wildlife generally understand that an upright shape with two legs is a human (predator).

This frightens them. But with the tripod and lens in tow, that basic form is broken up, ever so slightly, but enough to decrease the chances of spooking the prey. This is especially true if you arm press the tripod, carrying it directly in front of you. This really breaks up the human form and in many instances decreases the zone around a critter in which it feels safe. This permits you to get closer physically.

There are two ways to carry a tripod-bound camera setup. For covering long distances, the over-the-shoulder approach is best. The tripod legs are either spread wide open if space permits or are closed up. In either case, the legs are extended to the correct height for shooting. Before the shooting range is reached, slowly and smoothly lower the rig from the shoulder by lowering the body rather than lifting the rig high over the head. Lower it and set it up in a smooth fashion. Make sure everything is ready to shoot. (When setting the tripod down, avoid setting the legs on any small rocks which might give way, causing noise and an unsteady platform to work from.)

With the tripod set up and aimed at the subject, advance slowly. This is done by picking up the tripod by raising it just slightly off the ground and moving it up slowly at arm's length, setting it down and walking up behind it. What's going on is that the animal is connecting with the tripod and setting it as his safety zone limit. (Remember this is a generalization from basic biology.) As long as the photographer stays behind the tripod, that safety zone is preserved. This will give the animal the feeling of being "safe". This process of moving closer is carried out until the appropriate distance is reached (or the wildlife leaves).

One thing to always keep in mind while approaching wildlife is that massive gazing eye, the lens. The front element of a 122mm- or 160mm-class lens is like a giant eye that, believe or not, winks. To observe this, set it up and look at it from the subject's point of view. When your

FIELD TIP

Stalk with your lens caps removed from your big lenses! Many photographers travel about with their lens cap securelly attached to their lens. While this really doesn't protect your front element any more than just having the shade extended, it will more than likely cause you to miss a photo op. Either in the process of taking the lens cap off and stowing it away or just having it on will at some point cost you a great image!

eye is behind the viewfinder and viewing through the lens, the "eye" or lens is just a big, dark circle. But when your eye is removed from the viewfinder, light streams through the viewfinder eyepiece and through the front element. Now the eye is a big white circle. Put your eye back to the viewfinder and it turns black again. It winks! Most photographers are constantly looking through their lens, then they're not, then they are, then not. Black, white, black, white. This will make any critter nervous and a shy subject will just leave! If there is any question that this is happening, just close the viewfinder eyepiece curtain when not using the viewfinder so that the "eye" is always dark.

Speaking of eyes, keep an eye open not only when shooting but when walking through an area. Normally where there's one subject, there are more. We've all heard the saying there's safety in numbers. Well, wildlife is no exception. It's easy to be so completely and totally zeroed in on the one subject that obvious secondary wildlife is totally missed! Basic biology won't help here, good eyes and ears and a mind that's open and alert to the environment will.

This means also distinguishing the movement of wildlife when it's hidden. The breeze can play tricks on a stalking photographer whose concentration is on any movement. Be aware of the habitat and its response to a breeze. Most inanimate objects move in a fluid motion in a breeze. A bird on the other hand, when moving about a bush, will cause the vegetation to move in a sharp, jerking motion as it passes from branch to branch. Sounds of mammals passing underneath brush make sharp noises rather than the mellow sounds of a breeze rustling the branches. Your ears are a critical tool for getting close physically to wildlife!

Listening is a very important part of stalking. This includes hearing the noises made by wildlife and your own noise. Each species of bird has its own identifying call plus a variety of other calls used for communication. Knowing the difference between a normal call and a warning call is important. Many small mammals make very high-pitched warning calls that sound very much like bird calls. Be able to distinguish these sounds in order to take advantage of them for better photographs.

Sounds in the wilds are also important in getting close physically. Note the sound of a branch falling on the ground as opposed to a branch being stepped on by a large predator, the sound of a distant creek from the wind whistling through the pines, or the scraping on the pine tree caused by a limb rubbing on the bark rather than a northern flying squirrel scampering up that same tree. Distinguishing among different sounds is vital in stalking.

Biologists have devised a number of techniques for surveying native habitat. One method is directly applicable to photography. It has been determined that to accurately survey a particular location, the biologist must arrive at a spot and remain there silently for at least 10 minutes. This 10-minute adjustment period is the time required for wildlife to adjust to the presence of the biologist before going back to a normal routine.

When traveling through any area where no wildlife is readily seen, stop for 10 minutes. During this time, prepare the equipment to shoot. Listen for the area's return to life as it adjusts to a foreign presence. Shooting opportunities should occur in a relatively short time or at a short distance away. This basic technique comes right from the methods sections of biological journals. It doesn't guarantee great photographs, but does provide the best possible odds for taking a photograph.

Having the Wildlife Come to You: Luring

There are those times when we just don't want to go walking miles for a good photograph. There are other times when we just can't physically chase down

something with a camera. Have you been sitting in your favorite chair at a campsite, the warm sun beating down on you, and suddenly a marvelous photograph appears right before you? Did it start your mind to wondering if you're going about wildlife photography all wrong? Why not invite the wildlife to come visit you? Make them do the traveling for a change!

For lack of a better word, luring is the opposite process of stalking wildlife. Luring techniques come from the same resources, the biological journals. Biologists have the same need to observe wildlife, gaining insight into their biology. The techniques they've developed can be applied to promoting successful, safe, and ethical photography.

Natural Luring

There are many things in nature that act as natural lures to wildlife. Photographers who know their basic biology can take advantage of these for great photographic opportunities. The most productive natural attractors in the wild are food, water, and good old sex. Having any of these three in front of the lens almost guarantees a photograph.

In the spring termites hatch and leave their colony, creating an incredible natural event. Within seconds of their taking to the air, the skies fill with birds wanting to make an easy meal of the flying termites. And for a short period of time, the birds are fixed on just this one thing. Getting close and photographing them at this moment is quite easy. Finding the termites when they take flight might be difficult, but this is just one example of natural food that attracts large numbers of birds and provides great photographic opportunities.

Is there a fish farm or hatchery in your vicinity? Though not a natural setting, the little fish darting around in the water are a magnet for fish-eating birds. The kingfisher, normally an elusive subject, can be easily photographed in this setting. Simply find its favorite perch and wait.

Herons, egrets, gulls, and the occasional otter also take advantage of hatcheries. Sloughs, duck ponds, dikes, and lake coves likewise attract these same birds.

Many lakes with coves have large perches that host fish-eating birds, such as bald eagles and osprey. Perches are used season after season in many regions of the country, some becoming local icons for the resident photographers. Many national wildlife refuges have photography blinds set up on these perches or roosts because of their frequent use. Species which might be considered unapproachable can be photographed easily and in many instances in large numbers.

Water is an especially strong attraction for wildlife, whether it's a duck pond or a spring in the desert. Springs in deserts, called oases, are particularly valuable for photographing wildlife. Early morning visitors often include large mammals such as bighorn sheep, mountain lions, jaguars (in the right part of the country), and coyotes. Native Americans knew this and made stone blinds at springs from which they hunted these species. Photographers can take the hint and use these same waterholes for photography.

Waterholes (or oases) have their own ecology, often the subject of scientific papers. Not only is large mammal photography possible, so is bird, amphibian, and nocturnal photography. Many of these waterholes are labeled on topographic maps. Some states, such as California, create waterholes, called guzzlers, to attract wildlife for hunters. Information on their location is available from state and federal agencies as well as hunters who use the area. The scientific journals are also excellent sources to find watering holes and to understand their ecology.

Did you know Mother Nature creates feeding stations? Many plants go to seed or fruit for only one short period each year. At that time, wildlife takes advantage of the bounty of food. Cedar waxwings are a good example, flocking

Bison.
Photo captured by F5,
80-200mm f/2.8D ED-IF AF-S,
on Agfa RSX 100.

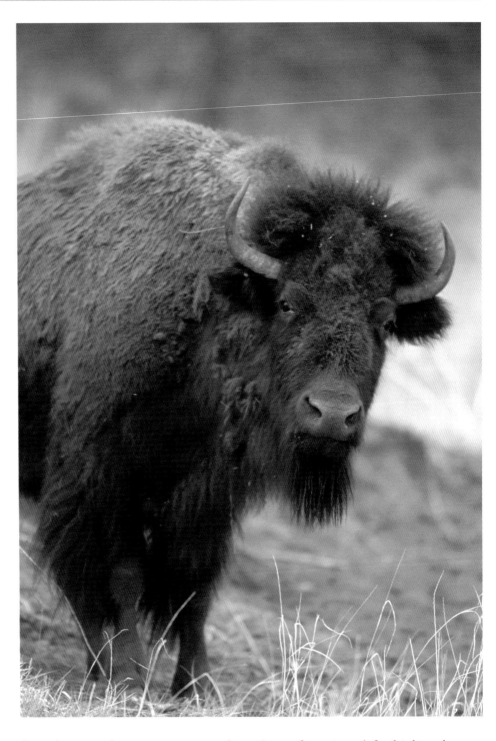

through an area harvesting en masse the fruit of a tree or bush. The fruits of the desert palm when they ripen hit the ground and become a feast for the many mammals of the desert. There are many examples of this in nature, which provide many photographic opportunities.

This requires a knowledge of basic biology and botany. Most species accounts (scientific writeups) for birds and mammals list food preferences. If these are botanical in nature (which most are), then simple research into the ecology of the plant yields a description of it, its habitat, and time of fruiting. This provides the best window of time to concentrate on that particular food source. Investigation of the plant for fruit missing from the branches, fruit rotting on

the ground, and foot tracks confirms that it's time to stake it out with a camera.

Many species create feeding opportunities that other species use. Large predators often leave a carcass that smaller predators and scavengers feed upon and, if found, can be a great opportunity. Not necessarily the scavenger gorging itself on a bloody carcass (not a photograph to be hung on the living room wall), but the scavengers as they approach or leave the carcass. A road kill serves the same function, though the carcass should be moved off the road, both for the safety of the scavenger and for better photographs. The smell and noise of buzzing flies might be bothersome but opportunities for photographing golden eagles, wolverines, or mountain lions stifles any queasiness.

Woods inhabited by sapsuckers offer another feeding opportunity: Sapsuckers strip small slices of bark off a tree or make small impressions called wells in the bark where the tree's sap collects. The sapsucker returns to these wells at a later date to drink from them. Hummingbirds, warblers, mice, and squirrels also take advantage of the sticky, sweet meal. Set up at these trees only when there is still a flow of sap (it looks like water has collected at the base), as they do dry up after about a week, losing their attraction for wildlife. They are normally in shade, so flash and a zoom lens are required. Note that you may be shooting species as large as squirrels and sapsuckers or as small as hummingbirds or mice, so having the ability to crop without constantly having to move is an advantage.

Mammals are a little more difficult when it comes to natural lures, especially small mammals. Small mammals tend not to move from their home territories. So within that home territory, they utilize many natural feeding stations during an evening.

Large mammals, on the other hand, constantly move during a 24-hour period. Some individuals or herds might have a distinct pattern to their feeding, preferring a particular hillside in the afternoon or stream bed in the morning. Some herds have been studied by biologists and have had papers published about their movements, so they are easily tracked. But for many herds, time must be spent studying their feeding ecology. This is not very difficult and something most wildlife photographers find very rewarding. Not only does it provide great insight into the herd's activities, but it can also provide great photographic opportunities.

You might be wondering when I was going to get to the sex part. Wildlife is well known for doing "it" without discretion. Photographers who know when and where "it" is done can avail themselves of great photographic opportunities. We've already discussed exploiting perches used in spring by male birds to attract sex partners. Finding these perches takes only a little time, listening for song and looking for white wash gives most away. But some species don't use perches.

Grouse have a variety of methods to attract mates. Sage grouse gather on strutting grounds called leks. Here, the males perform their ritual strutting and fight with other males to attract a mate. These leks are decades old and easy to find. The ruffed grouse, on the other hand, requires a fallen log. He uses a log that's hollow and will resonate the unique "drumming" that he uses to attract a mate. Finding the log is not difficult. It requires some listening and walking but the reward is a marvelous photographic opportunity.

Large game mammals have traditional breeding grounds where the males strut their stuff and have contests to prove their physical prowess. Bighorn sheep, elk, pronghorn, and deer tend to frequent the same area, if not the same hillside, year after year to contest for strongest male status. These areas are not hard to find with a little research. Hunting magazines, state departments of wildlife, and of course, biological journals,

FIELD TIP

Natural lures come in every shape and size you can imagine. A stranded school of fish in an ice flow that gulls and terns are diving on, mud at a construction site that swallows are collecting for their nest building, a farmer tilling his field, a fish hatchery, these are just a few examples. You don't have to have a camera in hand to find them, just one in hand to take advantage of them!

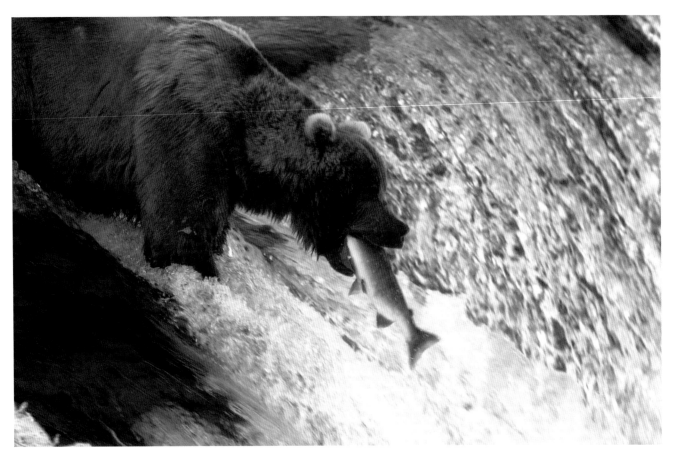

**Coastal Grizzly Bear.
Photo captured by D1H,
300mm f/2.8D ED-IF AF-S II,
on Lexar digital film.**

all have descriptions of such locales. Some go so far as to reveal the time of year and time of day. They also make suggestions on how to get in close physically and what signs to watch for that indicate a contest is soon to begin between two individuals.

Once these natural luring locations are identified, set up in the best spot to optimize lighting and background for the subject. Try to leave some room to move in case the subject doesn't come to that exact spot or is successful in attracting a mate and thereby provides a more elaborate and crowded scene. This means having routes through the habitat and stopping points already assigned for such a move. And for goodness' sake, have that motordrive set to blast, as these situations are almost always fast paced and lively. Don't miss that great shot waiting for the film to advance.

Remember, lighting will constantly change during the day. Preplan and previsualize

every possible scenario such as sun shining through tree limbs, light bouncing off rocks, or any other possible condition caused by the moving sun. Backgrounds also change as the light changes. For these reasons, knowing the parameters of the particular site and the biology of the species is critical for those who have a limited amount of time to spend at the location. If time is not an issue, then spending an entire day at the site will yield not only magnificent photographs, but unforgettable memories!

Ethics of Artificial Luring

Before venturing into actual techniques, a stop at ethics is in order. Many of the techniques of luring used by biologists and photographers involve baiting. Baiting is the depositing of food to attract wildlife to a specific location. In 99 percent of our national and state parks, baiting is completely illegal! This is because of the huge number of visitors who visit the parks. If only a small portion of them

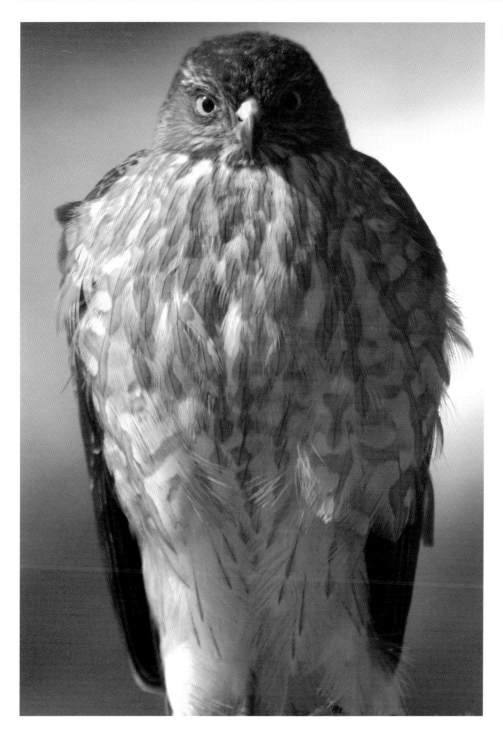

**Cooper's Hawk.
Photo captured by D1,
400mm f/2.8D ED-IF AF-S,
on Lexar digital film.**

feed the wildlife, it would devastate the ecology of the park. This same reasoning does not apply to other regions where its not illegal and the visiting public does not concentrate.

The question of leaving food out (bird seed, fruit, etc.) to attract wildlife is controversial to say the least. My safari clients know that I use baiting; whether it's food or water, to bring wildlife in close (in the form of bird seeds and water drips). They've also been taught when and how to do it without adversely affecting the wildlife. The ethical concern here involves how, when, and what to bait with, something I've learned from working with biologists. The same techniques can be gleaned from papers published in journals. I have no hard,

generalized answers when to bait or not (except that for grizzly bears, no is definitely the rule). This is something you will have to determine for yourself based on the conditions and the subject at hand. Remember that no photograph is worth the welfare of any wildlife. Know and use basic biology. I believe no great harm comes from judicious baiting.

Artificial Luring Techniques

There are numerous techniques for attracting wildlife, nearly as many as there are individual species. Success in attracting wildlife is not automatic with the simple application of bait. The manner in which the bait is made available and where it's placed are very important and varies from species to species. The use of bait to lure wildlife must also be coupled with providing optimum conditions for photography.

The most common means of wildlife baiting is the backyard bird feeder. I know many photographers who never venture further than their living room window for their wildlife photography. In the winter, I'm one of those! The constant variety of species and actions are very rewarding, both emotionally and photographically. Backyard bird feeding is a national passion, so even if you don't have a feeder, it's a sure bet your neighbor does and you can take advantage of the birds it attracts.

You can only take so many photographs of birds at a man-made feeder, so how then do you spend hours or years at the same window? The strategic placing of perches about the area is the first way. Many species will sit on a distant perch, scoping the territory out long before venturing to a feeder. If there are no perches, it's unlikely they'll ever approach the feeder. Placement of natural perches yields photographs of species that otherwise would not be available at the feeder. The goal is to photograph the birds prior to actually getting to the feeder, so finding and placing perches is a major part of your photographic success.

On the West Coast especially, hummingbird feeders grace practically every house. These are by far one of the best opportunities for the back-porch photographer and are great places to learn and experiment with new photographic techniques. Placing the hummingbird feeder in the right place for photography is not the only challenge in this venture. Start by hanging a hummingbird feeder in a photographically attractive spot. Then wait a few weeks.

You're probably jumping for joy with the prospect of a photograph of a hummingbird at a red plastic flower. However, using a little basic biology and creative thought, make this a dynamic venture beyond the red plastic flower. First, if your hummingbird feeder is a multi-holed model, tape off all the holes but one. The one left open forces the hummers to come to it, allowing you to set up on it and be in control. Using your hand as a target, prefocus approximately 3 inches (7.6 cm) away from the feeder on the hole where the hummers will come. Hummingbirds generally stop for a split-second before going to a feeder to look for other hummingbirds. By prefocusing, you'll be prepared for this and get marvelous flight shots of the hummingbird (without the red plastic flower).

Once you've mastered this and gotten all the photographs you want, remove the feeder. Replace it with real flowers that the hummingbirds would naturally use for food (available at most nurseries). Hang the flowers (just one or two blossoms and not bunches) in a natural manner, dropping one or two drops of hummingbird food into each blossom. The hummingbirds have become accustomed to feeding at that specific feeder, so when they come and find the flowers, they will explore them to see what's up. When they get a taste of the hummingbird food in the flower, they'll feed and come back just as if it were the glass feeder. Many question the ethics of such "nature fakes." I personally have no problem with them and believe that this is simply

FIELD TIP

Hummingbird food is a simple mixture of four parts water to one part sugar. Don't use honey or red food coloring in the food, as both can lead to death for the hummingbird. As long as the feeder itself is red, the hummingbirds will find it. In certain areas of North America, hummingbird feeders should be taken down in the fall. Contact local experts in your region to see if you fit into this category.

Evening Grosbeak.
Photo captured by F5,
300mm f/2.8D ED-IF AF-S II
on Agfa RSX 100.

FIELD TIP

In order to capture a hummingbird in flight, use flash. Shutter speeds below 1/125 generally blur the action of the wing beats. You'll most likely shoot many rolls before you perfect your technique. Multiple flash is also required to illuminate the bright gorgets on the males. This too takes practice.

using basic biology and photographic technique to get great photographs!

Another enjoyable and successful lure is the nesting box, such as those often put out to attract bluebirds. These are not only very beneficial to the future survival of bluebirds (their populations have been hit hard by invading non-native bird species), but also provide educational

and photographic opportunities. Bluebirds are such marvelous subjects. Research into their basic biology is almost unnecessary because within a week or two, their actions will lay it all out before your very eyes.

Nesting boxes can attract a variety of species, both mammal and bird. Depending on habitat, the height of the

**Tree Swallow.
Photo captured by D1X,
600mm f/4D ED-IF AF-S
with TC-14E, flash fill,
on Lexar digital film.**

FIELD TIP

Many photographers don't succeed in photographing nesting boxes because they don't use flash. The majority of nesting boxes have a roof that hangs out over the hole. The shadow caused by that overhang kills nesting box photographs. One flash set to - 2/3 compensation is all it takes to remedy the problem. The flash will also make the blue on the bluebird's back "pop."

box and size of the entrance hole, any number of species might take up residence. I've seen and photographed everything from owls and raccoons to kestrels, squirrels, nuthatches, and mice in nesting boxes. Setting up to photograph these normally requires one or two flash units, a 200mm to 400mm lens, tripod, and a little time. Spend only two hours at the box at any one time so as not to inhibit normal activity. If it's an owl in the box, coming during the day probably (though not always true) won't yield the best results.

Luring small mammals is almost as easy as luring birds. Mice, kangaroo rats, woodrats, and others love bird seed.

A pile of basic, generic birdseed can attract many species (you can buy sterile seed so it won't germinate, which is a good thing). Of course, food placed in a typical urban backyard isn't likely to attract anything but—maybe—black rats. However, placing this pile in a grassland, mountain, or desert habitat almost guarantees a nighttime of fun. Yes, nighttime, because the species being lured are nocturnal. To photograph them requires operating on their terms.

The same pile of birdseed might lure ground squirrels, quail, or other small birds during daylight hours. Placement of the birdseed requires consideration of both nocturnal and diurnal activity. Consider not only all the photographic aspects, but the basic biology as well. Most of these little critters want cover nearby in case a predator should happen on the scene, so don't place the pile of seed out in the middle of a clearing. Also consider local laws prohibiting the feeding of wildlife.

Can birds be encouraged to find you in the wild? There are "tricks" (as some refer to them) to bringing birds in closer. Birders use this one all the time. It's called "pissing." This involves simply putting your lips together and blowing air through them, making a somewhat natural-sounding call. Many species of birds will either come to the top of a bush or fly out of a tree canopy to investigate the sound. They might not stay long once they see the sound is not another bird, but for those who are prepared, an otherwise impossible photograph becomes possible.

Birders also use bird tapes to call out species. This involves playing a tape of the bird's call to entice a hidden bird. When applied correctly with certain species, this is a safe technique to get birds to approach. But as a general rule, many question the ethics and safety of bird tapes. In some regions, use of bird tapes is illegal because of abuse and damage to the species. Here again,

Turkey Vulture.
Photo captured by D1H,
Tokina 400mm f/5.6,
on Lexar digital film.

FIELD TIP

Nocturnal work at bait stations requires flash. Normally two flash units work best. Remember to previsualize their effect on the photograph. Many get their film back only to see bizarre shadows from twigs or blades of grass that were between the flash and subject and weren't noticed at the time of the exposure.

knowing basic biology and local laws is the best guide.

Raptors can likewise be called in closer. Owls will call back and often investigate even the worst owl imitation. Once close, an owl can be brought even closer with the old "stick in the leaf litter" trick. This involves imitating the sound of a mouse scurrying about in the leaf litter with the end of a stick. Biologists often use live mice instead of a stick, but unless you're working with a biologist, I don't recommend that the amateur use this technique.

Many biologists "fish" for raptors. Using a mouse lure, biologists cast out the lure and slowly reel it in to attract the raptor. This too is not a technique for the amateur, but a simple toy mouse, the kind a cat plays with, might get a soaring raptor's momentary attention. This can be enough time to get a great flight shot. There are laws regarding this in some regions, so check it out with the proper agency before you try it on your own.

Mammals can at times be called in closer, just like birds. Small predators such as foxes, weasels, skunks, and the like are attracted to the high-pitched call of a predator. This same sound can be made by those talented souls who can stretch a piece of grass between their thumbs very tightly and blow on it. Buying a predator call may be a lot less painful than trying to blow a blade of grass. This call emits a very high squeal which attracts small predators. Large predators such as wolverines and bears are best not lured or bothered in any fashion unless working directly with a biologist. This is not just for your safety but the animal's. The law is also a consideration.

Large game such as elk, deer, pronghorn, and bighorn have been lured during the fall rut with a number of techniques. Rattling a pair of antlers is known to bring in deer bucks. The sound of hammered bighorn horns is also known to attract them (in some regions, possession of bighorn horns is illegal). Although I've never tried them, the scents available for attracting large game come highly recommended. They bring them in for that perfect shot (that's with a camera, not a gun). Hunting magazines are an excellent source for this kind of information. They not only describe the product, but how and when to use it.

All this information can make the difference in achieving proximity to wildlife. Your old English teacher probably once told you that to write a good paper, you had to know the subject. Wildlife photography isn't that much different. Getting in close physically, getting the best photograph, and taking the best care of the wildlife's welfare all come from knowing basic biology of the subject. From a purely logical standpoint, you have everything to gain and nothing to lose by knowing basic biology. When I go out shooting, as much as I want to get the best photograph possible, I want to have fun. When you know what you're doing and have reasonable expectations, everything falls into place and fun just comes naturally!

Blinds

I hate blinds! It's real simple, they make me blind so I can't see or hear a thing. With that said, in the challenge of getting in close physically, many photographers rely on blinds. Biologically, there are some very important reasons why a blind should be used. Biologists use blinds for the protection of the species they're observing and to see the species' natural behavior without their own presence altering it. These are more valid reasons why photographers should use blinds, rather than only the quest to get in close physically.

There are many types of blinds on the market. But before we go into them, let's consider the word. In Europe blinds are called "hides," a more romantic term describing the operation rather than the camouflage tent itself. I feel the word blind fits very well because they do literally obscure the surrounding world except

for that small slice seen through the lens. They dampen the sounds and obscure those making the sounds. They literally block out the natural world. It's for this reason that I really hate blinds!

There is only one situation when I use a blind without reservation. That's when I'm photographing an elegant tern colony in southern California. I'm allowed out on the island where the colony resides for just an hour. During that hour, I'm in a blind to minimize my impact on the birds' activity, at least that's the intended reasoning behind the blind. But it's actually for my defense because the birds know I'm there. How do I know that? Because the bird's main defense against predators (another word for photographer as far as the terns are concerned) is dive-bombing them. And dive-bombing isn't all they do as a defense because after an hour, the blind is no longer green but white. Worse yet, terns eat only fish and what goes in must come out. YUCK!!

What makes photography from blinds successful is having the subject come to the camera. The key to working from blinds comes first from placing them near the wildlife and second from selecting a spot for the best photography. Just as before, in selecting the location where you'll be stationary for a long period, you must take into consideration lighting, background, subject, and lens. One big difference is that, once in the blind, it becomes difficult to move if the subject moves out of shooting range.

After this generally negative commentary on blinds, why go further to describe the different types and uses? Because as mentioned, there are times when a blind must be used. Another good reason is because until wildlife photography is mastered, blinds can make up for any lack of experience. I rarely if ever use blinds, but I always have one just in case. Still, I do hate them.

Tent Blinds
The most common blind looks very similar to a backpacker's tent. In fact, inexpensive backpacker tents with a hole cut in the side make a good alternative. Commercial blinds made with the photographer in mind are also available. The Rue Ultimate Blind (my personal favorite) is an excellent blind. What makes this blind excellent?

The Ultimate is typical in its nylon and aluminum pole design. The basic design for most backpacker tents and blinds, this combo provides lightness and quick setup. In this case, nothing is rubbing on the nylon. If the blind is set up and used properly, you won't have a problem with nylon's characteristic high-pitched noise. the nylon has nothing rubbing on it (and should be set up so that's the case) to make a high-pitched noise. The Ultimate is tall enough to allow me to sit on a small chair and see through the lens. It's wide enough to let me stretch out and it folds up into a very small package, which is handy for carrying.

Movement can be a real problem when working from blinds. The movement can be generated by the blind or the photographer inside. A blind is lightweight and the slightest breeze will make it flutter. Most have means of being tied down, a good idea whether it's windy or not. If the blind can be staked as well as roped, then by all means do both. This of course means taking great care in setting up the blind since the subject is generally nearby during this entire process.

When inside the blind, keep movement and noise to a minimum. Rubbing on the sides of the nylon walls, bumping into them and distorting the shape of the blind, sticking feet out from under the wall and in plain view (the same holds true for tripod legs or camera equipment), all reduce effective hiding.

Is wildlife really fooled by blinds? I personally don't think so. I believe that most wildlife just feel sorry for the poor fools who have lugged this thing in, set it up,

and sat in it for long hours. They figure if we're stupid enough to do that, how much harm can we cause? In fooling wildlife with a blind, there is the "two-in, one-out" trick that is often practiced. I know too many who have done this and have had great success for me to pooh-pooh it, but if any noise or movement comes from the blind after one of the two have left, well, you figure it out.

After the tent blind, the most common is the permanent blind. These are most often found at refuges and are made of wood or rock. These blinds have been placed strategically, usually because some natural lure brings wildlife to the area. Permanent blinds are usually very crude and uncomfortable but they do have one very big thing going for them: Being permanent, they've been accepted by the wildlife. They don't just suddenly "appear," as is the case with portable tent blinds.

This makes a good case for putting up a portable blind and leaving it. There's no doubt that if a blind is left in one particular location for a number of days prior to occupancy, the wildlife will have learned to accept it as if it were a rock. At first they might react for a short period, but that will pass. The drawbacks are two-fold: One, most of the time there isn't enough time to use a blind in this manner because most wildlife photographers work regular jobs. The second reason results from human nature. The blind which might become invisible to wildlife is a magnet to humans. Sorry to say, but in most regions blinds are not left alone by the public. Their curiosity overwhelms them and they visit the blind. This probably upsets the very subjects the blind is set up to observe, causing a threat to their welfare. There is one endangered subject that I waited five years to photograph because I couldn't find a safe spot to photograph them that wouldn't attract the attention of the public. I feel that working in blinds can create as many problems as it solves. Each time you consider erecting a blind, all these possibilities must be considered.

Portable Blinds

Another style of blind becoming very popular is the portable blind. They go by many names: hat blind, hide-a-blind, port-a-blind, and the Rue Pocket Blind. These blinds can best be described as Halloween ghost costumes made of camouflage material. A Rue Pocket Blind is permanently stowed away in my car for those occasions when breaking up the human form is required. On many occasions, a natural lure can be exploited by slipping on the Pocket Blind.

These blinds are much more maneuverable, just like a ghost costume. They lend themselves to short-term projects, such as a road kill feast. However, they're still a blind and limit vision and hearing. They also reveal any movement and some are made of nylon, which causes noise. Keep in mind these are not the perfect solution, but for short-term work where eliminating the human form is required, they can work wonders.

Another version of this is the floating blind. Most of these are a combination of pocket blinds with a fishing float tube. Outfitters such as Cabelas make units very adaptable to photography. One of the tricks to making them work is how you secure a tripod. The beverage can holders, which attach to these float tubes, are an excellent way of securing a tripod. It's important to test it in shallow water with no camera gear attached. Remember, when working in water, security for the equipment is imperative. Another important consideration is covering the outside of the tube. Water birds are not dumb, so camouflage will need to be taken a step further than with the pocket blind. Attaching reeds to the outside of the tube can make a big difference. (Be aware of the ethics of destroying habitat.) Use reeds from the immediate area as wildlife may notice strange plant life. This is not a technique I personally have used, but it's commonly done and very successful.

The approach I like most with water birds is to use a simple canoe. Just being

on the water makes the birds a little more at ease, allowing for closer approach. Keeping equipment dry is as simple as putting it in a large trash bag (this won't provide any protection in a capsize). As you're paddling up to the subject, make slow, steady strides as done when walking. Stop paddling far enough away from the subject not to scare it. Coast up to the subject ready to shoot. This takes practice, mastering the canoe and the camera. This is a great time to have a friend help out by doing the paddling.

Photographing nests of water birds can be done from a canoe. Combining the canoe and the pocket blind is all it really takes. Good boatmanship and an understanding of weather must be combined with basic biology and photographic technique for everyone's safety. Parking on the water in front of a nest is subject to the same rules as photographing any nesting bird. Just keep in mind that flare on the water affects the meter. The shiny aluminum of the inside of the canoe can also cause flare. So by taking to the water for photography, you take on more variables to be solved, but none of them should stop you from venturing out.

Working Inside a Car

The car can make a marvelous blind in almost any environment. The majority of the time, cars are used as blinds on car tour routes in our national parks and refuges. If you've ever been to Yellowstone and gotten caught in a buffalo jam, you know that courtesy and common sense are essential.

Selection of lenses when working from inside the car is strictly a personal choice. The size of the lens and the size of the car are the only restrictions. Most photographers' work is done in the range of 300mm to 500mm. This has a lot to do with how close the subject can be approached. I personally like the 300mm f/2.8 because its focal length, and the fast shutter speed minimizes any vibration from the car.

Bracing the lens in the car is a challenge. There are a number of excellent 'car pods" for attaching a long lens to the a car window. The Kirk Enterprise Multi-Purpose Window Mount is one of the finest on the market. It's a simple L bracket that has an adjustable joint, which attaches to the window and rests on the arm rest. This particular model can support a lens up to 600mm quite easily. The one drawback with this approach is that the lens becomes part of the car. Any movement or vibration from the engine is transferred directly to the camera. Another drawback is that either the lens is always hanging out the window or must be constantly dismounted and remounted in order to drive safely.

The approach many use that I like is simply handholding with the assist of a beanbag (Kirk Enterprises makes an excellent one). You can travel about with the camera/lens resting on a pillow next to you and simply bring the camera up to your eye and shoot out the window. If the engine is turned off, resting your elbow on the armrest or using the beanbag works well. But if there is any movement in the car from wind, kids in the back, or engine vibration, try using proper handholding techniques for support. In this way, some of the movement will be absorbed.

Approaching birds in a car is a little different from mammals, but both require knowledge of basic biology to get close. The one main difference (this is a generalization) between the two is that birds will tolerate the engine noise more than mammals. Both like slow approaches, so if at all possible shut off the engine and coast up to the subject. This requires safe operation of the vehicle above all else. If that's not possible, don't go for the photograph.

It's best to approach with the subject on the driver-side window. If you're fortunate enough to have a driver, set up on the side of the car where the best opportunities

occur. Be aware of obstacles such as side view mirrors, side windows that don't go down completely, and other devices in the car that can hamper photographic efforts. Driving up and shooting out of the car requires the same techniques used in every other facet of wildlife photography. What makes the car blind so effective is that it's completely hiding the human form. Other than the movement of the approaching car (and any movement from inside, which must be kept to a minimum), there is nothing to tip off the wildlife that a human is there. Some wildlife will take flight no matter how quiet the approach. Others will take flight as soon as the vehicle stops. Enough will stick around long enough for you to get off a few frames. So always have everything ready to shoot whatever scenario might occur.

There are times when the car can be used as a portable blind. Getting out of the car is the most difficult problem. Once separated from its "safe" appearance, you take on the appearance of a human again. Move slowly, stay low and avoid exposing your profile. Set up your gear cautiously and you might get a better opportunity. Travel about with the tripod already extended to the proper shooting height and the camera and lens set up with a quick release (for quick mounting). This makes the difference in getting the photograph.

Are there tricks to getting in close physically? Well if there were, there aren't any now! There never were any tricks of the trade to getting in close. It's just common sense, consisting of knowing basic animal biology and applying it. I sincerely hope that everyone ventures out with a camera to attempt to capture images that last a lifetime and to explore and preserve our wild heritage. Also, have fun! Getting close physically has its letdowns. At times it seems like you can't win for losing. But as long as you have fun in the process, you will succeed time and time again.

**Mountain Goat.
Photo captured by F5,
300mm f/2.8D ED-IF AF-S,
on Agfa RSX 100.**

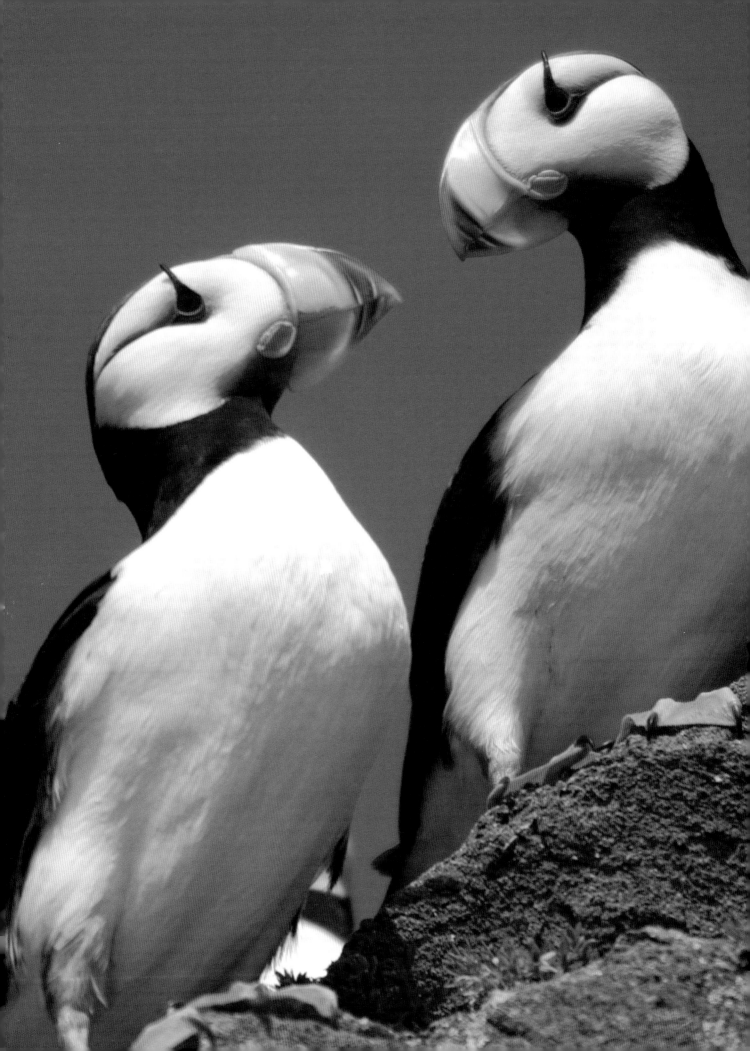

Chapter IV

Bird Tales: Combining it all in the Field

I was a "birder" long before I ever picked up a camera. My love affair with birds began at the ripe old age of nine and is one that continues still. It wasn't until college, though, that this love affair became an obsession. Chasing down every rarity with my binoculars was a daily occurrence (if only I could remember everything I learned back them). I felt so incredibly lucky when I met up with a post-grad student who literally took me under his wing and taught me the science I needed to take my passion beyond just watching birds. Gone were the days of just "ticking." Instead, I was enjoying each and every bird for what it was by learning its unique biology!

At this same time as fate would have it, wildlife photography was becoming a way of life for me. I couldn't have designed a better course of learning for mixing the two passions of birding and photography. While I had to learn to identify birds without the aid of binoculars but rather by habitat, song, and silhouette, I was also learning light, shutter speeds, and focal lengths. Before I ever thought of or knew the phrase "combining biology with technology," I was learning and living it! I had never experienced as much fun as bird photography. I was hooked for life!

I'm not alone in this pursuit. Bird photography is by far the fastest-growing segment of wildlife photography. This is for very good reason! It's darn fun and rewarding! At the same time, the combination of the Web, digital photography, and more photographers in the field, has produced greater images, many never before captured on film. This is great! This raises the bar for what constitutes a great bird photograph. To get your images up to that bar and, more hopefully, beyond it, you need to start by looking at other images. Whether they are good or bad images, others' images can teach you.

What follows are ten of my cherished bird images. These are images that bring back fond memories of the sites, sounds, wind, and the stories behind shooting them. All were created in the last few years and culminate in one image that shows what 20 years of being in the field following my feathered friends with a camera have taught me about bird photography. Besides entertaining you with the stories behind the photos, there is an educational reason I present them.

Birds don't tend to stand still nor are they willing to come as close as we would like. They love to hide, not to be in light that's always favorable to creating great images. Plus, they're not always around when we want to shoot. Despite these obvious challenges, great images of birds are still being made. If you look at these images (these 10, as well as all others in this book or elsewhere) and reverse-engineer how they were created, you can learn new techniques and incorporate them in your photography. Sit back, crank up the music, pour your favorite liquid, and let me tell you a tale or two (bird's tail, that is).

Horned Puffins.
Photo captured by D1H,
400mm f/2.8 D ED-IF AF-S,
with TC-20E, on Lexar digital film.

Red-faced Cormorant. Photo captured by F5, 600mm f/4D ED-IF AF-S, on Agfa RSX 100.

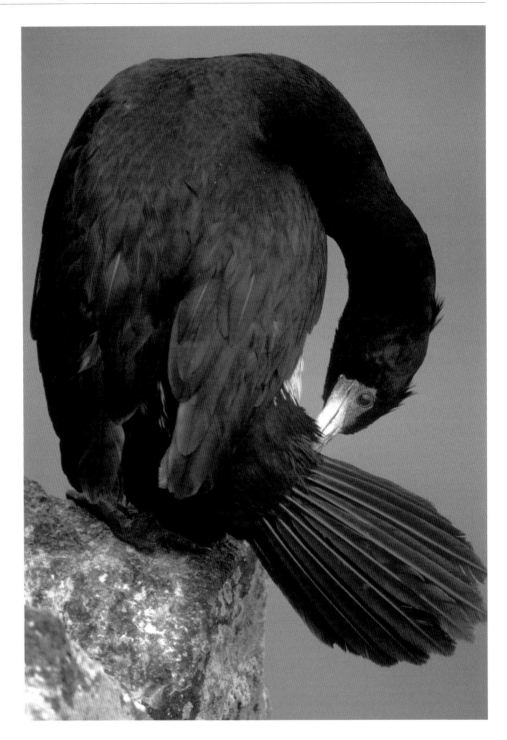

Red-Faced Cormorant

Like the days before and the days to come on this adventure, the dense fog of St. Paul Island, Alaska smacked us in the face as we left the lodge. If I've said it once I've said it a thousand times, the worst weather can make the best images. After twenty days of worst weather, though, knowing this didn't brighten up my shooting attitude!

We got in the van and headed off to the cliffs. On St. Paul, the vast majority of the photography takes place on the edge of the island, literally the very edge! As I stood a hundred feet or more above the crashing surf below, the drop to the rocks was straight below my tripod. Straight below! On a portion of one cliff, rocks jutted out and ledges criss-crossed the face, providing perches

and nesting locales for a number of unique species of pelagic birds, which you won't find anywhere else in the world. It was these thousands of birds that lured me to put on hold what some might see as common sense about not getting too close to the edge.

The tops of the cliffs, including where I perched, were covered in tall, wet grass. I set up my tripod so it leaned away from the cliff, to keep gravity from taking hold and taking everything over the edge when the wind gusted. My normal setup on the cliffs was the 600mm f/4 on my F5. (When enough light was available, I would attach a 1.4x.) I had an SB-25 with a Better Beamer attached to an external power source. (I always carried a towel with me, as the Better Beamer would collect the fog and cause its own mini-rainstorm on my lens barrel.) Finding a secure footing for the tripod so I could shoot down the cliff face was a constant challenge each morning. You might say that only the insane would set themselves and their gear on the edge of a cliff to get a photo. But when you're there, the dampness dripping off the brim of your hat onto your cheek, the sounds of sea birds filling the space between the drops and the spectacle of thousands of pelagic birds on the cliffs below, one tends to forget caution.

On this particular morning, three red-faced cormorants were perched on an outcropping that jutted from the cliff face. It is rare to find red-faced cormorants anywhere but St. Paul Island, so when you find them, you tend to focus in on them. That morning, instead of having to stand on the edge and shoot down the cliff face, I could shoot straight out in front of me. This provided me the luxury of a solid footing and time on flat ground. When shooting down the cliff face, my footing would slowly erode away and my feet would slip on the wet grass. Gravity would slowly pull me towards the water below and I would constantly need to reset my feet, which on occasion limited time with a subject. That was not the case this time. As long

as I wanted to deal with the weather, I could wait out the subject.

Two of the cormorants were not in full view. I could only get head shots, as the rest of their bodies were obscured by rocks. The third, though, was in full view but its pose was awkward at best. With my footing secure, I took the time to wait out this cormorant. I wanted the shot. I persisted because the sheen of iridescent colors on its black back was just glowing. It was one of those magical moments the worst weather makes happen! (The overcast and moisture are what made it possible to capture the iridescence.)

With the cormorant situated on the point of rock, the tail, feet, and long neck just didn't fit cleanly into a vertical-format composition. Let's face it, too, cormorants aren't the most glamorous birds. You need special elements like breeding plumage and iridescent displays to make them an enticing subject. Their very physical build doesn't lend itself to elegance and their all-black plumage is a lighting nightmare. Yet, some of my favorite bird photos are of cormorants. I stuck it out.

The cormorant was asleep, its head tucked in under its wing and out of view of the lens. I knew that once it did wake up, it would most likely do some preening. Since its preening gland was at the base of its tail, I hoped I would get a nice broad side view of its face (from which it derives its name) while still being able to capture the sheen in its black plumage. While that was my plan, the cormorant knew nothing of it.

The cormorant did wake. It just perched there, looking rather drugged as it gazed over the cliff. About this time its two friends to the left stretched their wings and took flight. I figured that was it, the cormorant I had been watching for nearly an hour would take flight as well. It stretched it wings and neck and I tried to make an image, but I was too close with too much lens, I'd cropped it to nothing usable.

153

To my utter joy, the cormorant closed up its wings and started to preen. I was in such shock that when my plan started to unfold the first few moments, I forgot to even depress the shutter release. Then the cormorant flared its tail when it bent over to get oil from its preening gland. The composition magically fell into place in my viewfinder and instantly I had five frames of the pose before the cormorant went on with its preening.

I couldn't wait to get to the roll with those five images. I so hoped that my memory of the event didn't make the image better than reality. When the film came back, I was so happy when I saw in the slide what I remembered! While it's just a photo of a cormorant captured on a rainy day, to me when I view it, all the memories that that month on St. Paul Island are impressed upon my senses!

Northern Hawk Owl

My experience with this subject is what made up my mind to go digital full-time!

I headed off to a long-dreamed-of adventure. I was heading off to Nome, Alaska to photograph the nesting shorebirds and birds of the tundra. I plan such adventures a year in advance in order to get them on the calendar and have everything in place when the time comes. If you don't plan a year in advance, you won't have a room to stay in or vehicle to rent, but one huge disadvantage of doing this is that you have no clue what Mother Nature is planning and what kind of winter that is going to unfold and blanket the Far North. Timing is everything and if the winter is late or early and not what you planned on, you could travel a long way for nothing. That's basically what happened to me.

I arrived in Nome to find that I was either two weeks early or the shorebirds were two weeks late. In either case, there were virtually no shorebirds to be found. It was a great disappointment. However, as it turned out, I did arrive on the scene of an invasion! It seemed that 14 northern hawk owls had shown up in Nome to take advantage of an explosion in the vole population. People were claiming that a hawk owl hadn't been seen in Nome for decades, so it was a rare occurrence indeed.

Now, I had a bad track record with hawk owls. I had seen them many times in Alaska prior to this visit, but I had never in five years been able to get a lens on one for one reason or another. The first morning we went out, we traveled for hours without seeing one bird, not one! It was June, so the light was nearly 24/7. This meant the sun stayed low to the horizon the majority of the day. So while we had light, we had no subjects (I was shooting with my good friend Arthur Morris). We had driven way out on the road without stopping to photograph one bird. We were getting hungry, so we decided to turn back. There is only one road, so the trip back started like the trip out, not seeing a single bird. Where were all of these hawk owls?

As we traveled back, we came upon this unusual beach encampment. Looking at the poles buried in the ground, I saw a unique shape atop one of them, a northern hawk owl. We finally found one and, with our luck, it was on someone's property and no one was around. With no one to ask permission to enter the property, we decided to travel on down the road. Great, our first bird and we couldn't even focus on it!

Luckily, before I went suicidal, not much further down we found another hawk owl. This one was perched on logs thrown up on the beach by the surf. We backed up, got out slowly, and set up our cameras a few hundred yards away from the owl. We didn't want to scare it off (it was our first subject in 24 hours!) but we didn't know how we were going to be able to stalk it. It was on a beach with dried grass everywhere! There was nowhere to hide and every step sounded like an army on the march. There was no way to sneak up on it, so we just walked right toward it to see what unfolded.

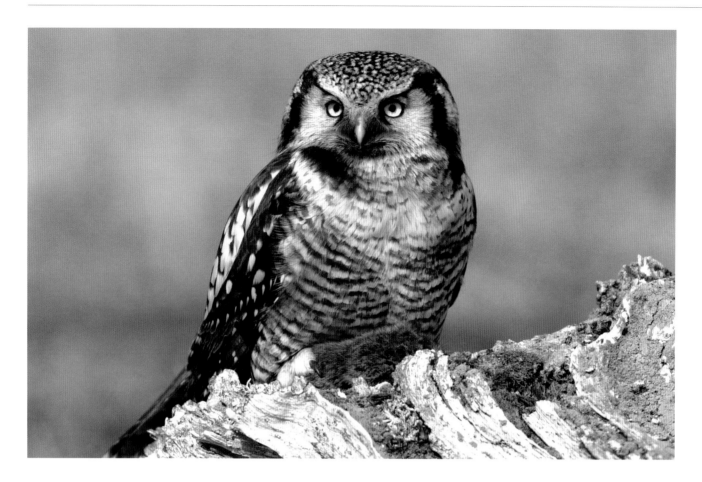

Well, what we found was an owl that couldn't have cared less that we were there, literally! I shot this owl every way to Sunday! I shot every possible image size, format, lighting, background, teaching slide you can ever imagine! We shot it sleeping, foraging, and catching and eating a vole, which you see here. I was in total heaven!

This was the first real, serious, long-term pounding I did with digital. I had with me pockets of film to feed the F5 and cards to insert into the D1. I switched camera bodies back and forth as I photographed the owl, to the point were I was getting tired of doing so. It was really apparent to me right then and there all of the advantages of digital (and these were confirmed for me when I got my film back and could compare the two).

The next couple of weeks, I photographed the exact same owl many times, to the point where I had thousands of images of it, both digital and

conventional (though I wish now the conventional images were digital)! This particular image is a favorite from the entire series. With the D1 attached to the 600mm f/4 with a 1.4x, I watched through the viewfinder as this owl gorged itself on voles. It caught a number of voles, so many in fact that it was cacheing them. When it caught this vole, it just sat on it for a long time. It didn't cache it, it didn't eat it, it just sat on it. Having rehabbed small owls for years, I recognized the behavior. The owl was waiting to cast a pellet before digging into its latest victim.

No sooner had this thought crossed my mind than a pellet was cast and the head was torn off the current dinner. I was in total heaven! During a trip which had the worst possible timing for the target subject, what first appeared to be bad luck turned out to be a gold mine. This photograph brings back with fondness my first adventure into digital photography and the birds of Alaska's tundra. I haven't

Northern Hawk Owl. Photo captured by D1, 600mm f/4D ED-IF AF-S, on Lexar digital film.

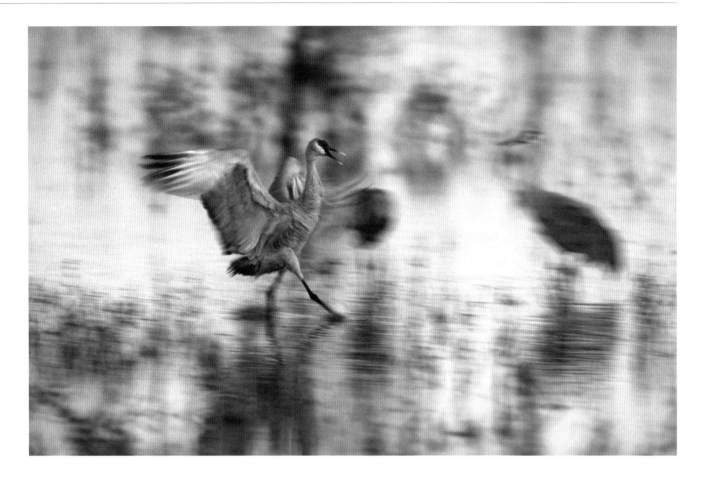

Greater Sandhill Crane. Photo captured by F5, 600mm f/4D ED-IF AF-I, on Agfa RSX 100.

gone back since I captured this image, partially because I can't imagine it could ever be that good again. I will go back again and, if I'm lucky, I again will have a date with that ever-enchanting owl!

Greater Sandhill Crane

The magic that is wildlife photography, while you search for it each and every outing, is not guaranteed except in some very unique locales where you know magic lives. One such place for me is Bosque del Apache National Wildlife Refuge, New Mexico.

This relatively small space is the winter habitat for some 40,000 snow geese and 10,000 greater sandhill cranes (along with various other bird species). It's a given that, each morning, the snow geese flocks explode just prior to the first light of day in a ballet of confusion so well-orchestrated that you'd swear they practice all day long. These

magical white birds with black wing tips fill a sky turning crimson, as they rise to meet the coming sun. At the same time, the roar of the beating wings momentarily overwhelms the calls of the 40,000 geese lifting off. The beauty is so staggering, the sound so deafening, putting the camera down to take it all in is a common occurrence for me. Amongst this all are the greater sandhill cranes.

As still as sticks in the middle of the vast pond, they stand as the warming morning sun strikes them and the geese fly off. Like the snow geese, the cranes roost in the ponds at night because the ponds act like a natural burglar alarm. Any predator that tries to get to the birds makes noise when it crosses the water, warning all in the pond. Unlike the geese though, the cranes leave the ponds slowly after the sun is well up. They all go, geese and cranes, to the fields to forage during the day. And as the day comes to an end and

the sun drops below the horizon, the geese and cranes head back to the safety of the ponds.

I photographed all day at Bosque, before sunup to after sundown. They were long days but quite often incredibly rewarding (photos in this book, such as the Swainson's hawk and prairie falcon, were taken at Bosque). There were various things to photograph pretty regularly, such as the geese exploding and the cranes coming back into the ponds at dusk.

Setting up just east of the flight deck, I had the F5 attached to the 600mm f/4 AF-S. My personal, favorite way of capturing the cranes as they float back to earth and land in the water is to use a real slow shutter speed. I pan during the entire exposure and use the slow shutter speed (1/15 or slower) to increase the blur of the background as well as some of the movement of the cranes (which is why I call this style of photographs "the blurs"). This isn't a technique that you can hope will be successful in one or two frames. This requires lots of film! (This is a great application of digital, since you don't have the pain of throwing away a lot of film when you don't capture the image.)

My image of the crane was taken at 1/8 second approximately 15 minutes after the sun had set. The glow from the sunset lit up the world, at least that's what it seemed like in the big skies of New Mexico. The cranes were flying in from left to right. They were landing right in front of me, coming in and then once landed, walking to my right. I shot and shot and shot, probably exposing at least 20 rolls in less than a half an hour. Using the left AF sensor, I would just pan with the cranes as they landed and stop once they did.

It was not until a week later when I was back in the office and at the light table that I knew whether I had struck gold or not. In the process of capturing blurs, you don't know (at least with conventional) until you get the film back if you captured the image or not. And it takes a lot of film to capture the image because of this. My average is about three to four good images per roll when shooting blurs, which is good enough to encourage me to keep doing them. But this image alone makes all the rolls over all the years worth the price! My Dancing Crane sums up for me the whole Bosque experience in one image. That's quite often the goal of my photography and my pursuit to visually communicate these wonders.

Snowy Egret

One of the cool things about wildlife photography is all the good friends you make over the years. Even though you might only see some of them in person once in a year, the common bond of wildlife photography keeps you in touch. One such friend, Arthur Morris, has always been more than generous in helping me find birds in new places. This photograph is the result of such advice.

Photographs of snowy egrets are a dime a dozen. This is because snowy egrets are such a common yet elegant bird, found across most of North America. Because they are so common, so elegant, and so heavily photographed, making great images of them is a greater challenge than for the majority of birds we focus on. This is where the help of friends can make a difference (so consider this as advice from a friend to you).

On the end of Sanibel Island in southwest Florida is a fishing pier. This fishing pier is not very long but is pretty heavily used by the local fishermen. Nearly every afternoon, the fishermen clean their catches out on the pier. They're provided two cleaning tables that are out over the water. They do this in the warm, low light of the winter sun setting over the gulf. As this gorgeous light bathes the pier, beautiful birds appear to partake in the feast.

The birds actually don't come from far away, they're perched on the roof of a

Snowy Egret.
Photo captured by F5,
Tokina 400mm f/5.6,
on Agfa RSX 100.

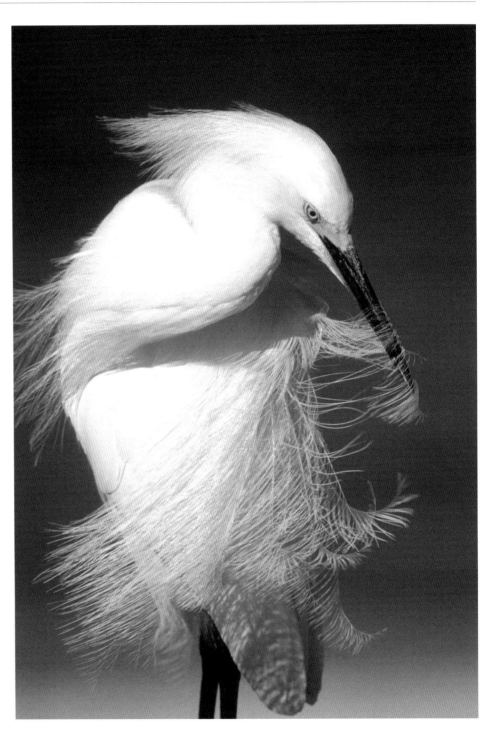

small covering that's not more than 10 feet (3 m) from the cleaning station. Snowy egrets, great egrets, little blue herons, and brown pelicans, along with other species, stare over the roof like Snoopy on his dog house, waiting for the fish to be cleaned. Once they see the process start, they glide down the short distance to the railing next to the cleaning table and beg. The fisherman like

their friends standing there and happily provide them little morsels to munch on as they clean the fish. Standing just eight feet (2.4 m) away, making great images is literally a snap!

Having a captive subject, so to speak, doesn't necessarily guarantee you the perfect image, though. Like I said, we're photographing a common species

commonly photographed. My setup was pretty simple, the F5 attached to a Tokina 400mm f/5.6. This very compact yet very sharp combo made working in the small space easy. I just waited until the birds flew down, framed, and shot. But I wanted more than that, so I would watch the birds to get a shot once they finished feeding and did their normal preening. Herons tend to do quite a bit of preening after they've eaten. In this case, there was a slight gulf breeze and since it was late winter and coming up on breeding season, this snowy egret had its breeding plumes. When the egret started to preen, I instantly saw the wind wrap the plumes around its bill. I moved quickly. The background was not pure blue but had some boats creating white out-of-focus dots. I then had to get up on my toes because otherwise the horizon line of the water and the beach way off in the distance created a sharp line through the egret's head. Once all of this was corrected, I was able to concentrate on the subject, the blowing breeding plumes.

Much to my regret, the egret had stopped preening by the time I had set up for the shot. That's just how it goes sometimes, so I lowered my camera and prepared for the next show. I no sooner lowered my camera then the egret bent over. I threw the camera up to my eye as fast as I could and was able to capture just this one shot.

Some might say, "You've cut off the feet." Can't argue with that, I did. Does it bother me, nah, I wasn't photographing the feet. These birds were almost driven to extinction a century ago just for their breeding plumes. So when I had the opportunity to celebrate this beauty, the plumes blowing in the gulf breeze, I concentrated on the plumes and not the feet. When I see the plumes wrapped around the bill, I still feel the sun burning the back of my legs and the gulf breeze dancing off the waves. And those egrets standing there waiting for their handout, I bet they're still there, being well taken care of!

Red-Shouldered Hawk

Incredible, once-in-a-lifetime moments come very infrequently to the wildlife photographer, at least they seem to, to me. I get more than my fair share but I recognize and cherish each and every one of them. This photo was just such an opportunity.

Hosting a fundraiser for the National Audubon Society at their Corkscrew Swamp Sanctuary in Naples, Florida, I was out in the early morning with a hundred other eager photographers on the boardwalk. The handful of photographers I had in tow were dying to capture that great image. Cruising along with the F5, 600mm f/4, and flash on my shoulder, I looked for subjects. About midmorning we came upon this red-shouldered hawk perched up on a branch in harsh sidelighting. We stopped and I gave a little lesson on light and exposure. I had just gotten through saying I wouldn't take the shot because the hawk was perched up against the blue sky in harsh sidelight, when the hawk flew.

It glided down towards us and landed on a branch in solid shade not more than 25 feet away! So this beautiful bird went from horrible, bright, harsh sidelight to horrible, dark shadows. In both scenarios, a good photograph was not to be had. I stood there explaining this to the group along with some other trivia for a few minutes. Then I said that even though the light was bad and I wouldn't even try to photograph the hawk with flash, we should focus on the hawk because we didn't know what was going to happen. The word "happen" had just left my lips when the hawk hopped less than a foot to where you now see it in the photograph.

What the hawk had seen that we hadn't was a corn snake in a resurrection fern. The hawk landed right on it, spearing it with one of its talons. It did this in the path of the one single "God beam" streaming through the canopy, which provided light! Wow! I didn't hesitate for

Bird Tales: Combining it all in the Field

Red-shouldered Hawk. Photo captured by F5, 600mm f/4D ED-IF AF-S, on Agfa RSX 100.

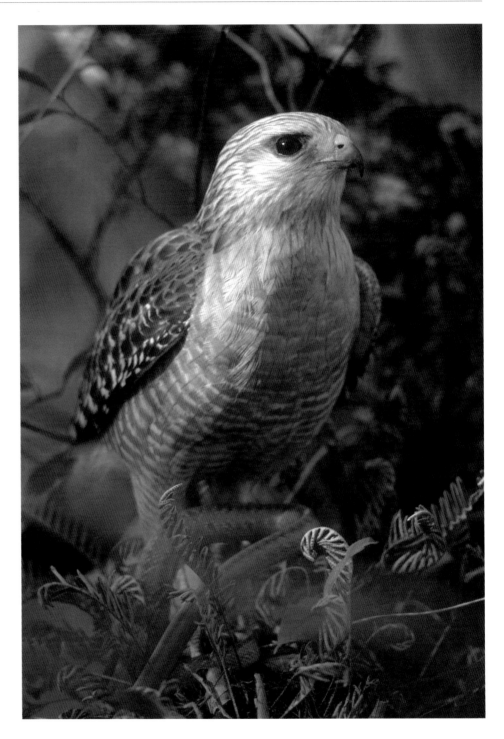

a moment and composed the photo you see. Once the F5's AF locked in I started to rip the film. I got just five frames off before the hawk took flight. It flew right at me with snake in tow, hitting me in the head with the tail of the snake as it passed by.

The whole encounter didn't last more than seconds. Knowing the F5 fires 8fps and I captured just 5 frames, you can do the math and figure how little time I had with this scene!

While I would love great moments like this to last forever in the wild, they rarely do. They are mere heartbeats in the subject's life and, if we're really fortunate, we're there to see it. But it's because of this possibility that we need to be finely

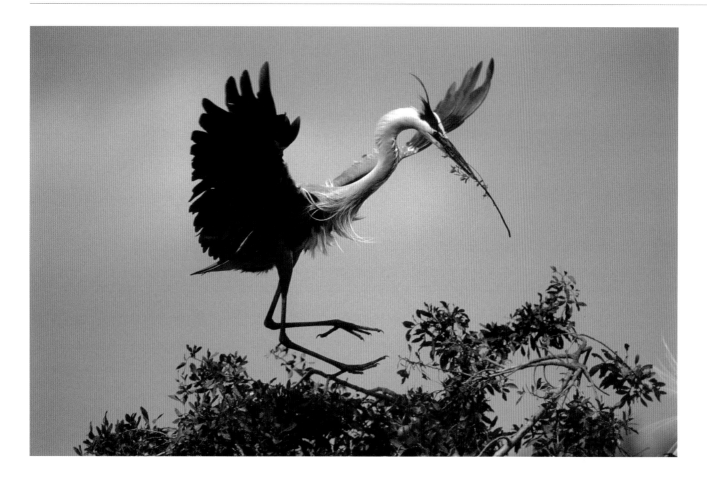

tuned machines, mentally and photographically, so when the moments appear, we can capture them. While I have many such images in my files, I have even more exposed forever on the thin emulsion of my mind. It's a lifelong quest to change this ratio.

Great Blue Heron

There is a magical place in the middle of urban Florida, the Venice Rockery. Located behind a Highway Patrol office and next to a road maintenance yard is a pond the size of a couple of swimming pools containing a small island in its middle. From a pine-lined green lawn, one can stand and gaze into one of those miracles of the natural world with comfort and ease. Surrounded by civilization, it seems to be a throwback to the dinosaur ages! Filled with great blue herons and great egrets (with a sprinkling of other species), the island is alive with life!

I like to arrive at the rockery very early in the morning, about half an hour before sunrise. I think the shooting is at its best when there is ever-so-slight a haze in the sky to mellow out the rising sun so I can shoot as long as possible. The main subjects are the nesting great blue herons. You can easily see about a dozen nests, all at different stages. It's a visual delight and photographic temptation of unparalleled proportions. One of the drawbacks of the rockery is that once the sun climbs past the pines, the light immediately becomes too harsh for any quality shooting to continue. You typically have only about an hour of good shooting. On this day, that was not the case.

I arrived at the rockery in a dense fog, a fog that wasn't burning off. I stood there talking with a friend and drinking a cup of coffee he had made for me. We watched as other photographers came and went. The sun had risen but not the fog and, as the morning passed, so did the

**Great Blue Heron.
Photo captured by F5,
600mm f/4D ED-IF AF-S
with TC-14E, on Agfa RSX 100.**

161

patience of most photographers. Soon we were alone, but I stayed along with my friend because we knew at some point the fog would burn off and we would have a little quality time with the herons. If we were going to get up so early, we were determined to get something!

Ten a.m. came and went and there was a hint that the fog was starting to burn off as the light brightened the area. We set up. I was shooting with the F5, 600mm f/4 AF-S with a TC-14E attached. I started to look through the lens at the herons, watching the light. It was right then that the fog almost instantly became less intense.

Right then I noticed off to my left a great blue heron picking up a stick from the shore. That meant he was going to fly back to the island with the stick and present it to his mate. A photographic opportunity in what was really nice light, at least for the moment.

I selected the far left AF sensor and started to pan with the heron as it flew. When I liked the background I started to fire. I kept firing and I panned with the heron as it flew and then put on its air brakes and started to stall to land. I kept firing as it took a flap or two before landing on its nest. Once it landed, I stopped firing and went on to other subjects. My shooting time was drawing to a close as the mellowing effect of the fog on the light subsided.

I knew I would get an image out of the morning, especially the series of flight shots I had ripped. What I didn't know was that I had captured, for me, the image! You see, there is no way you can see the perfect image in an action sequence, then tell your finger to fire and the camera to react fast enough to actually capture the image. One "trick" is to know that in a sequence there will be a great photo, but the most important "trick" is to know to set up for it in advance and be ready to capture it as it happens. In this case, I didn't know what the exact image

would look like until I got my film back, but I knew the image would be there if I was ready to rip the film.

To me, the primary wing feathers folding up perfectly just prior to the down stroke, the legs coiling up ready for the impact of landing, the head up with the stick, and the slight breaking of the fog in the background giving the sky a little variety, are all elements I would have hoped to be able to wrap up into one photo. This is what wildlife photography is, knowing the perfect moment will come, waiting for it and then being able to make the most of it when it does unfold. It was a great day!

Horned Puffin
Oh, how I wanted this photo!

For over a decade, I have wanted to be at a puffin colony. Mainly, I've wanted to capture a photo of a puffin with a mouthful of fish headed for its young. I always thought it would be an Atlantic puffin, since the Atlantic is where most photographers go to get this image. I had tried to make contact with a biologist on the East Coast and even tried the old boat ride out to Machias Island off the Maine coast. All efforts met with no success. In the summer of 2002, I finally found myself shooting at a puffin colony. But it turned out to not be on the East Coast but the West Coast!

On the west side of Cook Inlet in Alaska is an island that has a very large breeding colony of horned puffins (as well as tufted puffins and black-legged kittiwakes). I had visited the island many times, circling it for hours photographing the puffins from the boat as they flew by. It's a magical place where the puffins at times are so numerous the sky is jammed with buzzing black dots. For years, I had wanted to get off the boat and onto the island to spend an afternoon with the puffins.

It was a beautiful, blue-sky day with incredibly calm waters. Our boat ride to

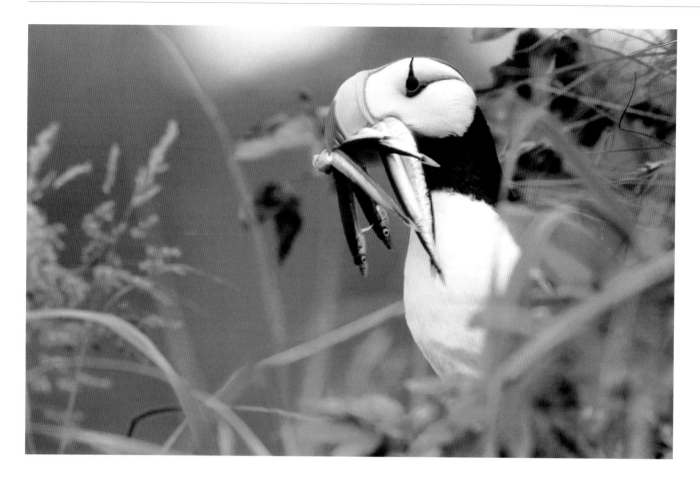

the island was pretty quick and the landing very smooth. So in a heartbeat, it seemed, my dream was coming true, as there I was with this whirling mass of puffins flying overhead. There were hundreds perched on the rock cliffs as well, but none had any fish in their mouths! The photography was grand but I wasn't seeing my goal at hand. A couple hours passed when I saw the first puffin circling overhead with fish. I was so excited, this might be it!

I watched, seeing one, two, three, four, and then more puffins coming in with fish. I started to watch them and saw a pattern. A puffin would fly a giant circle that would encompass the cliff face and the ocean. These circles were designed so that when the puffins flew in front of the cliff face, they would be heading into the wind. Each large circle, each pass would take nearly a minute to complete. I counted how many times a bird would circle before landing and

one puffin circled 27 times! At the end, without any real sign, the puffin would simply "crash" into the hillside with its mouth of fish.

The hillside was covered with dense green growth, so dense you couldn't see the burrow entrances. The puffins nest in natural (and some dug-out) burrows. On this island you could never see the burrow entrances, let alone a chick, so I wasn't sure how I was ever going to get the shot I had in mind.

I watched and watched, photographing the birds circling overhead with fish, using the 300mm f/4m AF-S attached to the D1H. It was great fun! Some of the puffins with fish would land on a ledge where they could be photographed. I had my other D1H attached to the 400mm f/2.8 AF-S with a TC-14E. When a puffin would land, I would quickly focus on it with this rig and shoot.

**Horned Puffin.
Photo captured by D1H,
600mm f/4D ED-IF AF-S,
on Lexar digital film.**

We had been on the islands for a few hours and I filled lots of cards with images but not the image. The tide was going out and it was time to get back on the boat, when I had noticed that one of the folks I was shooting with was standing a ways from me, shooting with her Leica rangefinder! Now, what could she be photographing with that camera and a 35mm f/1.4 lens? I wandered over because curiosity got the better of me. I saw that she had this one puffin standing at point-blank range with fish in its mouth. At that same moment, I saw a puffin go into the grasses at the top of a little outcropping. I pointed my 400mm f/2.8 at it but I was too slow, it had already ducked into its burrow. I had just raised my head from the camera when I saw it pop back out. With a mouthful of fish, it seemed to be looking at me to see if I would be joining it for lunch. I quickly put my eye to the viewfinder and shot. I shot two captures before it ducked back in.

Many of the images I capture are ones that I've thought about for years prior to ever having the opportunity to actually take them. I've mentally planned the shot, not just how I was going to take the image but the actual image I wanted to capture. Wildlife photography is an activity where slow and easy wins the race normally. It is also one where you get better with time and more opportunities seem to present themselves. If you want to capture that great image tomorrow, you've got to start today!

Bald Eagle

My first images of bald eagles were terrible! My wife Sharon and I would head to a couple of locales in California well-known for wintering eagles, but at best I would come back with microdots. While not the most charismatic of species, eagles are really spectacular fliers.

I had seen, like most of us, some of those incredible shots of eagles in magazines. You might not remember, but Canon ran an ad some time back with a series of shots of a bald eagle taking off right into the lens. I had to find the spot where these killer eagle shots were being made! I told my tale of woe to another shooter who let me in on the secret. So, off I was on my first trip to Homer, Alaska.

Every winter for many, many years, the Eagle Lady of Homer has been throwing out fish scraps (as in hundreds of tons of scraps). Coming to clean up what she tosses are 300 to 400 bald eagles! They are so thick, perched on everything possible including the ground, they look like pigeons! There are two places you can photograph the mayhem that follows the throwing out of scraps, from your car or, if you are invited, in the Eagle Lady's compound. It's from the compound that you can be out in the open and photograph from any angle. You see, you can't get out of your car to shoot, so photographing flight shots can be a challenge.

I personally enjoyed going up to Homer in March. That's when the sun starts to come back over the Kenai Mountains, creating great drama. This particular shot came on my third trip up to Homer. I was in the compound, shooting with the 80-200mm f/2.8 AF-S on a D1. Now you might be saying to yourself, "Just how hard can it be to get this shot when the eagles are coming to you?"

This will sound hard to believe, but capturing just one eagle in the frame is a real challenge! When the feeding begins, the eagles flock to the air in such numbers that getting a clean shot of just one is really difficult. I have hundreds of great flight shots with another eagle's head, tail, or wing tip in the photo. One should have such problems all the time!

The other obstacle is the weather. Cloudy days are the rule and not the exception. You can't photograph flying birds on gray-sky days, as gray sky is the worst background and a metering nightmare. Next is the wind. In order to get a photo of the eagles with their wings fully

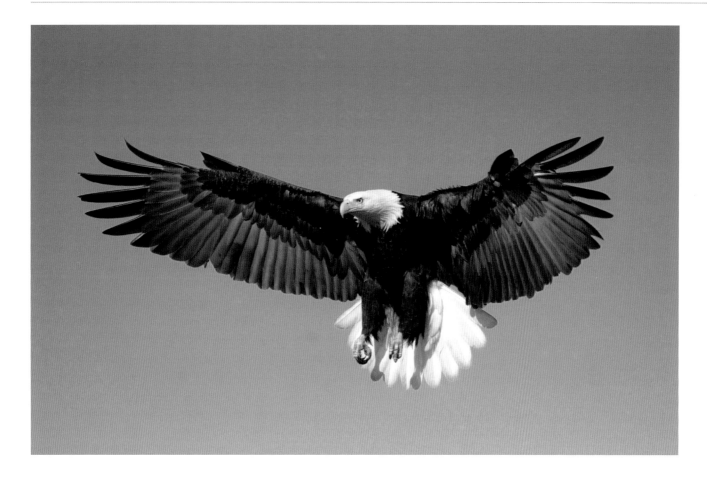

open, landing gear down, and the sun lighting underneath, you need a southeast wind. This doesn't happen all the time either. Finally, you need to be in the right spot in the compound to be able to pan with the eagles and get the shot as they land on the right perch.

Why did I go up to Homer three times? Because it took literally three weeks, one week a trip, to get this shot! This is one darn expensive photo that will probably never generate the income required to even break even. That's perfectly fine with me! This, like most photographs in my files, comes from a passion for the subject and the photograph. In this case, I had in my mind a photograph I wanted to capture and I went after it. The main tool in making the photo a reality was simply the drive and vision to keep going back again and again until I got it right!

Short-Billed Dowitcher

One of my very first projects 20 years ago took us Palo Alto Baylands, San Francisco, California. What was supposed to be just a quick use of a boat launch turned into a lifetime succession of visitations to one of urban wildlife photography's grandest locations to shoot!

There is a pond at the Baylands right next to the visitors' center, that we've always called the morning pond. This is because each morning, no matter what day of the year, there is always at least one shorebird to photograph. Most of the time, it has a flock or two or three to photograph and in beautiful dawn light. I have captured thousands upon thousands of images from that pond over two decades!

Even more amazing is the variety of photographs to be captured at this one pond. In the early spring, there are shorebirds in breeding plumage migrating north.

Bald Eagle.
Photo captured by D1,
80-400mm f/4.5-5.6D ED VR AF,
on Lexar digital film.

**Short-billed Dowitchers.
Photo captured by D1H,
600mm f/4D ED-IF AF-S
with TC-20E,
on Lexar digital film.**

In late spring, there are nesting black-necked stilt and American avocets with chicks to spend hours with, making images. In late fall, there are the same shorebirds that went through in the early spring, but are now on their way back south. And in the winter, there are the resident shorebirds in their winter plumage to photograph. This particular photograph is from winter.

Setting up on the deck of the visitors' center, I aimed my 600mm f/4 AF-S, TC-14E with the D1H at the sleeping flock of shorebirds. I like to arrive just as the sun is breaking the horizon, while the birds are still sleeping. The very first thing I do is focus in on interesting groupings that are creating reflections. Once I find these, I focus the lens on the scene and check for any obstructions in

the water that might ruin the reflection. If everything checks out, I fire.

This photo of the three short-billed dowitchers was captured in this way. On this occasion though, I was shooting with the TC-20E 2x teleconverter. This sucked up one more stop of precious early morning light, dropping my shutter speed down to 1/60. Why was this a problem? Depth of field was already pretty shallow at f/8 and when you do the math, you can see that in closing down to f/16, which I used for this photo, my shutter speed plunged to 1/15! When you're shooting from a boardwalk with folks walking around, really slow shutter speeds are just not an option.

The three birds are not as sharp as perfection would call for. While I would have loved to have the three birds and their reflections tack-sharp, it just wasn't going to happen. The reason? At this shutter speed, any slight movement by the dowitchers might have made them ever so slightly sway back and forth, which couldn't be stopped by the slow shutter speed.

If it's not tack-sharp, why didn't I throw out the image? I don't throw out images I like, it's that simple! I feel most photographers have read way too much in magazines that provide bad advice and information when it comes to editing. Most photographers over-edit. That's to say, they throw away too many images based on what these articles report. In photography, especially wildlife photography, if your images make you happy, then that's really all you should ever worry about! This image makes me happy, I enjoy what I captured, and in this case, I can include it in my book even though it's technically not perfect. Enjoy your time behind the camera and you too will have such images in your files!

California Gnatcatcher

The vast majority of my time behind the camera is spent pointing my lens at threatened and endangered wildlife, especially California's. I've been doing it for a long time, over 20 years, and some of my images have been so pounded and published so much that I get tired of sending them out even though they are in demand. I wanted to see something new in print of one of my really pounded species, the California gnatcatcher.

The images in my files of this bird are classics, used by the Fish and Wildlife Service and published in National Geographic, so coming up with new images required more than just a shot here and there. Like normal. I had to come up with something that was better than what I already had to offer my clients. I started by finding biologists in the field working with the gnatcatchers. Two biologists were recommended to me, both working with the gnatcatchers though in slightly different capacities. They both ended up helping me reach my goal big-time!

The first biologist was actually finding and monitoring nesting gnatcatchers and the second was simply surveying for them. I first went out with the biologist monitoring nests, as he had a number of nests for me to photograph. We went out to the various nests but, as luck would have it, I couldn't really photograph any of them better than what I already had in my files. All but one had safety problems and I felt if I worked the nests, I might jeopardize the nestlings. The one I could photograph was in pretty dense cover. While I did photograph it for an hour, it was pretty obvious I wasn't really getting any good images. That's how it goes sometimes.

When I went out with the second biologist doing the survey work a couple of weeks later, I was hoping to capture a nice perch shot at best. The first site we visited, I saw gnatcatchers but never got close enough to get any images. I did photograph a nesting coastal cactus wren for a while, which was cool, but that wasn't what I was after. We left that site and drove to another site located next to a toll road work yard. I parked there

Bird Tales: Combining it all in the Field

California Gnatcatcher.
Photo captured by D1H,
600mm f/4D ED-IF AF-S,
with TC-14E,
on Lexar digital film.

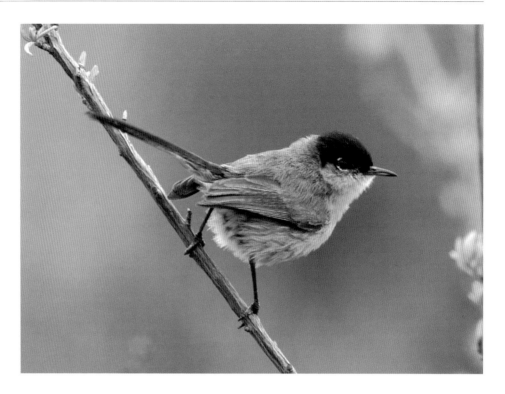

with little hope of getting the image I wanted. I set up the 600mm AF-S with TC-14E attached to the D1H and started to walk around. The biologist was going to go survey so, while he was doing that, I tried to track down a gnatcatcher. It wasn't long before I found one, but it wasn't very cooperative. It walked me around for awhile because it didn't have a mate or nest. It was then the biologist called to me and said there was another gnatcatcher over where he was, so off I walked. What happened then explains why I like working with biologists.

After showing me where he saw the singing male, off the biologist went to continue the survey. I watched the gnat-catcher. It was a male, I knew that because of the black cap. I saw him go off in the distance and then head back to a certain location. He did this repeatedly. I started working my way closer to that location while not interfering with his activities. I watched him and only when he was gone did I move closer and closer to where he seemed to be hanging out. After 30 minutes, I had focused in on a bush where the male was going in and out, when I saw a female pop out as the male disappeared inside. It was a nest!

I worked my way closer until I could see the male peeking out at me from the nest cup. There was no way I could get a shot of the nest itself, but I thought I might be able to get some shots of the parents as they came and went. That's how this image came about.

I watched the male leave the nest when the female returned, and I saw him con-sistently go to the same branch to watch the female enter the nest. What I did then was to focus on the branch and wait until I saw the male in the viewfinder. When he showed up, I shot. The really strong diagonal of the branch and the relatively clean background worked for me. Every time the male would come back to the nest, I would look through the viewfinder, waiting for him to land on his perch. When he landed this particular time and looked over his shoulder in the direction oppo-site to the branch, I knew I had the photograph I wanted.

As for reaching my goal, I'm very happy to be able to offer to my clients a really strong photo of the California gnatcatch-er that isn't 15 years old. They seem to be quite happy as well!

Downy Woodpecker.
Photo captured by D1H,
300mm f/2.8D ED-IF AF-s,
with TC-14E,
on Lexar digital film.

Are these the greatest bird photos ever? I certainly hope not! Why? Because I would hate to think perfection had ever been achieved by anyone; there would be no more challenge. But these are my favorite images of the last few years, my best efforts to capture not just what I saw but also what I wanted to communicate. This will sound sappy to some, but that's where I'm coming from. Regarding the last photo of the California gnatcatcher, I wanted to replace my old images for another, very personal reason. You see, those original great images, the ones published in National Geographic, were of a bird in a habitat and area that was paved over shortly after I took the images, literally made into a road. Everything in those photos is now gone except what I captured on film. Don't sell your heart short, it could be the one edge you have in creating the one image no one else ever has created before!

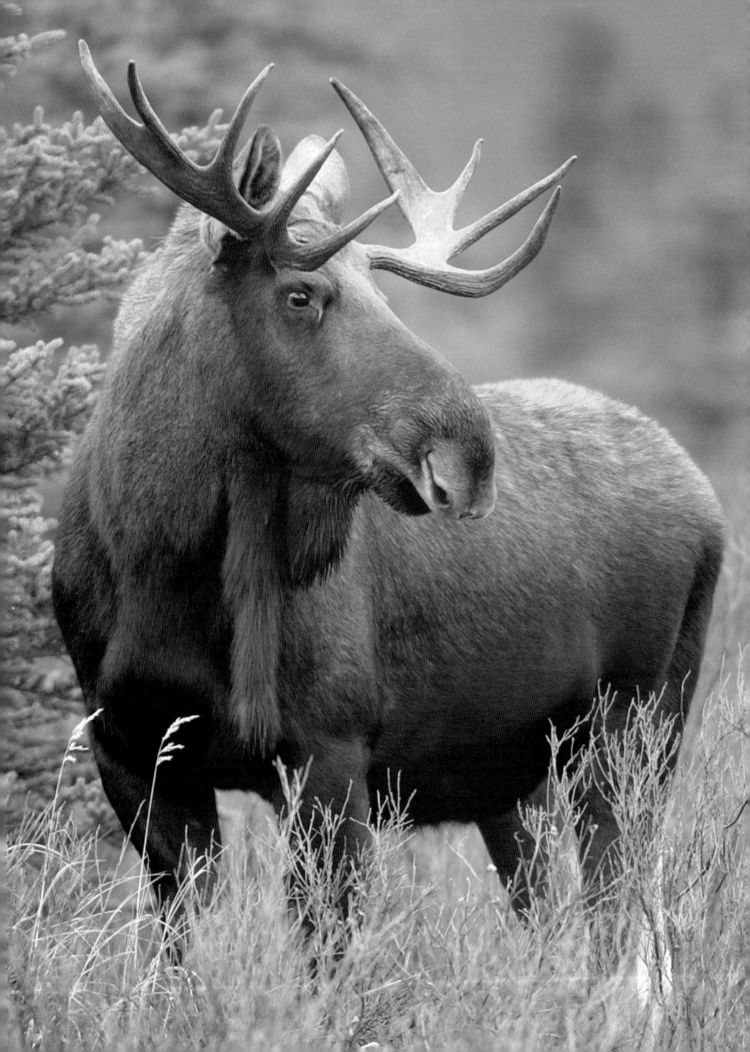

Chapter V

Mammal Tales:
Combining it All in the Field

I grew up in California and spent most of the school months in urban southern California. Other than our dog and the neighbor's dog, there weren't any mammals roaming about. Unlike wild birds that would come into the yard to the feeders to feast, there were no critters like grizzly bears or kangaroo rats to grab my imagination. There was also no such thing as the Discovery Channel or the Web. All that was around to clue me in on big mammals of North America was the television program, *Mutual of Omaha's Wild Kingdom*. That was enough, though!

As we traveled either by car around the countryside or by foot in the backcountry, I saw more and more mammals. I had no camera in-hand, though, like the time when my father and I came around a corner in the Sierra backcountry and found ourselves standing under a mountain lion. Episodes like this stayed with me until the day I did have a camera. But then, when I went looking for mammals with a camera, I found only the easy and typical ones like harbor seals or mule deer. This wasn't enough to quench my mammal thirst!

My wife made a call one day that would change my life. I had read a brief description about the endangered giant kangaroo rat and I thought it would be cool to photograph it. This charismatic critter lived not to far from my home. Sharon made a call that ended up putting me in touch with a biologist who would not only open up the doors to the

world of mammals for me, but would become a great friend for life!

So began my quest to photograph all the small mammals of California. Besides just making a portrait of each one, I also wanted to record as much of their life history as possible. I started with the endangered critters, hoping to photograph them all before any one of them should become extinct. (I wasn't successful. The Morro Bay Kangaroo Rat went extinct not too long after I began to photograph it.) After a few years of working towards my goal, I felt that I needed to have photographs of some big mammals like grizzly bears to become a "real wildlife photographer" (which of course is incredibly silly, looking back). But so began my search to capture on film the life history of big mammals.

These goals continue today. While I have accomplished in part many of my goals in photographing mammals, there are still lots left to accomplish. I've spent years now with grizzly bears, yet I'm just starting to understand how these gentle giants rule their world. I've photographed more than one hundred of California's small mammals but have hundreds left to see and photograph. I've made my first foray in the world of the musk ox, a really cool creature I've longed to photograph and get to know. While birds are a passion for me, mammals evoke the same passion!

The photographs in this chapter, like those in the previous chapter about

Left:
Moose.
Photo captured by D1H,
400mm f/2.8D ED-IF AF-S,
on Lexar digital film.

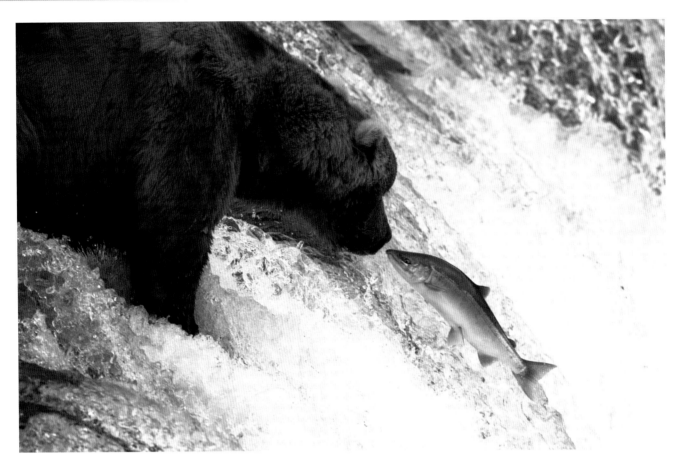

**Coastal Grizzly Bear.
Photo captured by D1H,
300mm f/2.8D ED-IF AF-S II,
on Lexar digital film.**

birds, hold a special spot in my heart. The stories you're about to read will explain why that's the case. But more importantly, I hope you will feel the emotion I have captured and communicated in each photo. Mammals great and small have a unique role on this earth, each struggling in their own way to survive. It's these mini-novels their daily lives tell that I bring to you here. My goal is not only to educate you about who they are and how you too can photograph them, but also to grab your heartstrings as they have grabbed mine!

Grizzly Bear

Have you ever seen that photo of the grizzly bear catching the salmon in midair? Of course you have, who hasn't? Ever wonder just how much work went into capturing that shot? Was the photographer really just incredibly great in his craft to make such film magic come alive? The answer to these questions

should not depress you but inspire you in your pursuit of great mammal images.

The photographs of grizzly bears catching salmon in midair are most typically taken at McNeil River or Brooks Falls, Alaska. I ventured to Brooks Falls the first time to capture the image, just like I had seen so many times before. What I discovered in this pursuit was the death of another of wildlife photography's great myths!

Brooks Falls is perhaps 70 to 80 yards across and at most 5 to 6 feet tall. In this small space might be as many as 20 giant grizzly bears in desperate need of Jenny Craig! These otherwise very unsociable creatures come together in tight quarters for a brief time when the salmon are running. Tension is high as all the bears work at getting their bellies full of salmon. Since the prime space for catching salmon with the least amount of effort is very limited, fights that occur amongst the bears are generally over this real estate.

In this photo, you can see the number-two easiest location for catching salmon. At the top of the falls, a bear can slowly walk over to this spot and, like magic, it's able to step right down and place its front right paws on a rock hidden in the cascading fall. With its feet in place, the bear is in the perfect position to catch salmon.

So, how hard is it for these thousand-pound monsters to catch a salmon? That's kind of the joke on the viewer of the photograph. At the peak of the salmon run, you have thousands of salmon jumping the falls. The bears, knowing this, literally just stand there with their mouths open. When a salmon tries to jump the falls, it literally hits a bear's mouth and the grizzly simply closes its jaws, the salmon caught. That's it! When the salmon numbers are low, as the run is just starting or is ending, the bears are less successful, so it's at the peak that the action is the hottest.

Well, how do you capture the shot of a grizzly capturing a salmon? You pay the bucks to get to Brooks, that's the hardest part! After you're there, you literally just stand at the falls and focus on the bear, placing it in the top left corner of the frame as you look through the viewfinder. As soon as you see a salmon start to jump in the lower right corner of the frame, you depress the shutter release and let 'er rip! Voilà!

Once I saw just how simple the photo was to capture, I set out to mock the ease of getting the great "griz catching salmon" shot. Here you can see my success. What appears to be a stare-down between a jumping salmon "daring the bear to try to grab it" and a bear thinking twice is, in reality, just one of the frames in a series I shot while trying to capture the great caught-salmon shot.

If there is any trick in getting the great shot of the griz catching a salmon, it is having great light. Rain and/or overcast is the norm at the falls. Plan on spending a week and working the dinner hour at the falls, as that's normally the best light. I would encourage every wildlife photographer to venture to Brooks at least once in their life. Not so much to capture the one great image, but rather to capture in your heart a very unique part of our wild heritage.

Moose Calf

This is a one-in-a-million shot that you never can anticipate. My good friend Dr. Wayne Lynch, when he saw this photo, asked, "Was Sharon holding the flowers for you?" Of course she wasn't. That's the magic you wish you could make happen, but you almost never can.

This is a drive-by shooting of the wildlife photography kind. Sharon and I were driving back to Anchorage, Alaska from the Kenai and had just gotten back in the car after watching the Dall sheep at Beluga Point. We hadn't even gotten up to the speed limit when Sharon yelled, "STOP! MOOSE!" Well, I naturally stopped and pulled over. Grazing there, literally right beside the highway, were a cow moose and two new, spring calves. They say that moose start getting uglier the moment they are born and, once you see a newborn calf, you know it's true! They are so cute, especially when they are with their mom.

There we were, parked alongside the road with cars ripping by us. The moose were grazing in this man-made cut in the hillside with all sorts of lovely roadside debris everywhere. There was little time and no space to set up the 400mm f/2.8, so I grabbed the 80-400mm and D1. At first, all I could photograph was the moose family with the cars as they were right beside the road. They were slowly moving as they grazed, not fast enough for the time I had to be illegally parked. I shot what I could, trying to make the most of what was in front of me. All of a sudden, a big rig went by and let out its air brakes. The moose jumped and moved up slope. How lucky could I be!

Mammal Tales: Combining it all in the Field

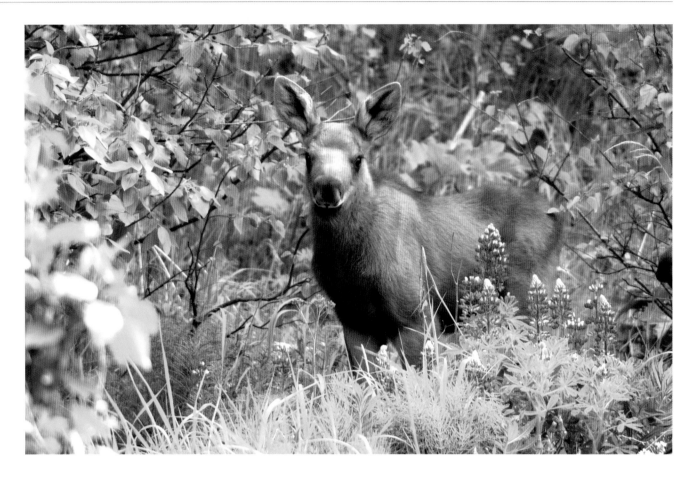

Moose calf.
Photo captured by D1,
400mm f/2.8D ED-IF AF-S,
on Lexar digital film.

The moose family was now up in the green shrubs and out of the roadside gravel. The one calf, the smaller of the two, was out in front but hidden; the other two were moving up slope and away from me. I was watching with my naked eye as mom came down and seemingly was trying to get the wandering calf to move on. What mom succeeded in doing was pushing the calf, ever so briefly, out in the open for this photo. No sooner did I have my camera up to my eye, focused, and got off just three frames than the calf was once again hidden in the shrubs. But what a moment!

The bush lupine in the corner, with the calf dead-center in the frame but still working compositionally, made the whole image come together. Without the blue lupine, the photo would not have worked at all but, as luck would have it, all the elements came together. This included the overcast light, which prevented the contrast from totally doing in

the photo. This is the magic of wildlife photography I seek every time I'm out!

Santa Cruz Kangaroo Rat

Possibly one of the most endangered mammals in North America, the Santa Cruz kangaroo rat is also one of the least-known. It was one of the funniest projects I've worked on for some time!

With perhaps only a dozen individual animals surviving, the site where they are found is a guarded secret. I can tell you it's a unique habitat that is surrounded by various developments including a sand mine that wiped out the other known locale for the species. I've forgotten how many traps the biologist I was with had put out to survey for the kangaroo rat, but it took a few hours to go around and check them all. After three days all we had caught were the dozen, which was really depressing!

174

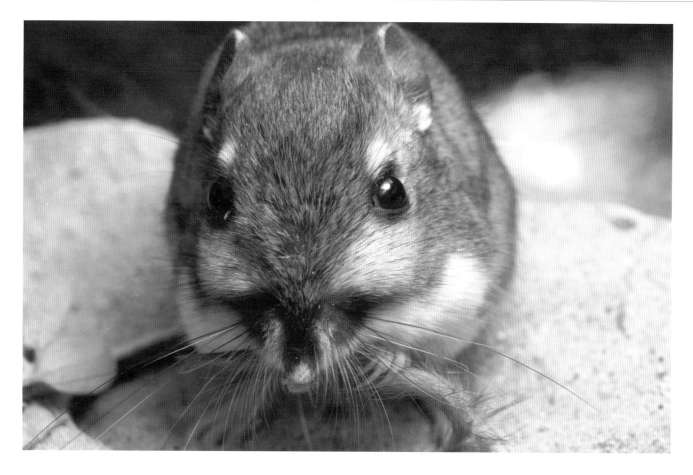

Because of the locale and the very sensitive nature of the critter, its plight and habitat, photographing on site at night was not feasible. This meant I could not photograph the kangaroo rats just doing their thing at night. Since no photographs existed of the Santa Cruz kangaroo rat, my mission was to not only photographically record its existence, but also create images that could be used to help it. To accomplish this, one of the kangaroo rats we had captured, the best-looking, would be kept for a couple of hours and photographed in one of my tanks. So I had come prepared. What followed, though, was all new to me!

Sitting at a picnic table out of view of the public, I set up the tank. Very carefully, I placed the kangaroo rat inside. Inside, the tank had sand from the kangaroo rat's habitat and a little shrubbery that it could mess with. Typical of small mammals in the tank, they spend the first five or ten minutes walking around inside, smelling. They typically then go to sleep. Remember, they are nocturnal critters and this being daytime, they normally sleep. So while it slept, I took some test shots to check out lighting and background.

My lighting for critters in a tank is typically just a single flash unit in the camera's hot shoe. The background is generally a shaded area 15 to 20 feet (4.5 to 6 m) behind the tank. This is so it's totally out of focus as well as outside the flash range, so the image has some feel of night.

After a couple of hours, the kangaroo rat awoke and did the normal small mammal stretch. It then proceeded to give itself a bath. It was an incredibly mellow little guy (they normally are) and didn't do any one thing very quickly. So I just sat there and shot away. In fact, it got to the point where I got all I needed many times over, so I scratched my head to think of what else I could do. That's when it struck me to try shooting with the flash off-camera.

Santa Cruz Kangaroo Rat.
Photo captured by D1H,
60mm f/2.8D AF, on-camera flash,
on Lexar digital film.

175

Mammal Tales: Combining it all in the Field

Rocky Mountain Bighorn Sheep. Photo captured by D1, 300mm f/2.8D ED-IF AF-S II, on Lexar digital film.

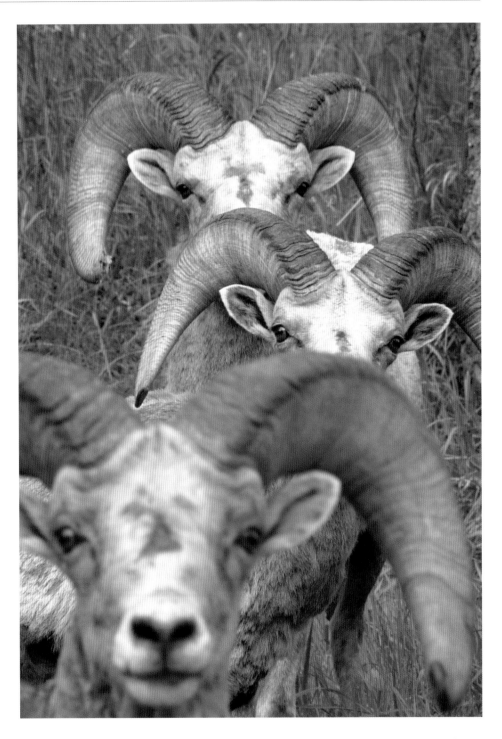

With the flash on-camera, the lighting is a pretty flat and even. For most scientific work, this is the best because we want little shadow. I was thinking now, though, of applying the best portrait lighting I could to this miniature subject (the kangaroo rat is not much bigger than two Ping-Pong balls). I grabbed my Bogen tabletop tripod and SC-17 cord and placed an SB-80DX to the right of the tank. I then placed a crate with a white towel draped over it on the left. I then took a shot and looked at the monitor of the D1H. With a little fine-tuning of the flash position, I went on shooting. The final shots turned out to be killer images!

Here, you can see the kangaroo rat cleaning its tail as if it were an ear of corn. The

1:2 ratio of lighting on the face really worked to give more shape and definition to this activity and the character of the kangaroo rat. After I was done shooting, the kangaroo rat was returned to its home and the next day's trapping showed it was still there, taking advantage of the free seed available inside the trap.

This entire experience was only possible because I worked with a biologist. Trapping and handling such critters not only requires permits from state and federal agencies but also vast knowledge of the critter itself. What I thought would be just another small mammal shoot turned into a whole new learning experience for me. Since this shoot, I've developed a whole new methodology for photographing California's small mammals that I like so much better. Now I've got to go back and re-photograph all that I have already photographed! Darn.

Rocky Mountain Bighorn Sheep

One of our country's natural treasures is Custer State Park in South Dakota. I'm real fortunate that my close friend John (who's also my son's uncle) happens to live just a few miles away. It's always nice when you can combine visiting family with some great photography!

On this occasion, five of us were out cruising the park on a gorgeous spring morning. The park has a lot of Rocky Mountain bighorn sheep but you don't always see them. So, when we drive through the park, we're always on the lookout for them. Whether it's a group of ewes or rams, we always stop to look, watch, and more than likely learn. On this occasion, it was also to be entertained!

We came around the corner on the lookout for sheep, because they frequent this one picnic area. At first we saw the ewes. It wasn't difficult since they were standing in the middle of the road. We naturally pulled over and got set up. These sheep are usually approachable if you just walk slowly, I grabbed the 300mm f/2.8 as that was all that was needed. We started to walk up to the ewes and photograph them. Then, we heard limbs being snapped and leaves rustling. We looked up the slope to see some rams heading down. We stood there and watched to see where the rams were going to go.

At this same time, my two sons were now beside us while the two of us were shooting, so Uncle John and I started to fill them in on what we were seeing. Knowing your subject is essential in getting the image, even with park animals! We were on one side of the road and the rams were on the other. They started to pile up as they stopped to look at us as we looked at them. Then they started to eat and we started to shoot. After capturing the one or two single head shots, I started to look for something a little different to capture. This is when I saw the two rams, one in front of the other (the middle and back ram in the photo). I took a couple of shots, when this third ram just popped right into the frame and looked at me as if to say, "Hey, what are you doing?" Without hesitation I shot and I'm so glad I did, I just love this picture! It makes me laugh every time I look at it.

Some might ask, "The front ram is out of focus, you can do that?" It's very important for wildlife photographers to understand that there are no photo cops out there waiting to bust you. I have always made images that I enjoy and I've just been very fortunate that others do as well. This often means, though, that my images are breaking the "rules." I was taught long ago that the best images are often the ones that break all the rules. Try it some time, you might just find it works for you as well!

Dall Sheep

This is the shot I took after I missed the image!

You've got to make the magic happen, which starts by just getting out. In this case, I went way out, out into the

177

Dall Sheep.
Photo captured by D1H,
400mm f/2.8D ED-IF AF-S,
on Lexar digital film.

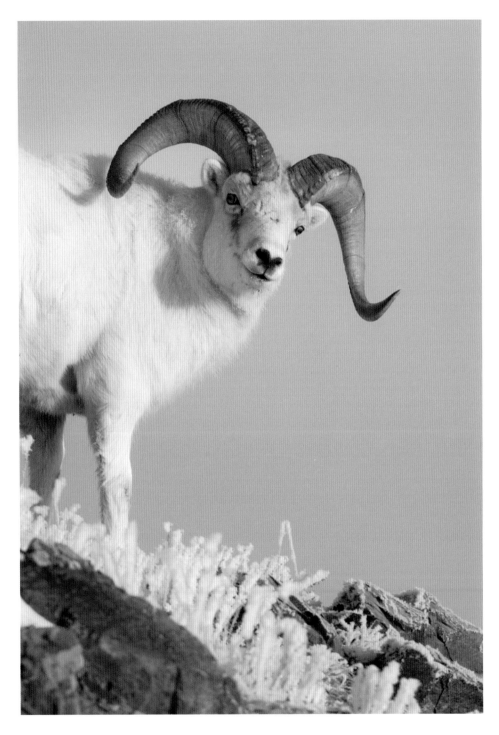

Yukon Territory one cool, gorgeous November. I was with two good friends, both great biologists who know these critters, Dall sheep, inside and out! It was a grand adventure as we started our trip in Fairbanks, Alaska and drove eight hours into Canada. The frosty, frozen, dimly lit world of the north is really spectacular and rewards the visitor with incredible sights!

When we first arrived on the mountain, we couldn't help but be awed by its size and its steep slopes. We were even more amazed by how the Dall sheep bounce and run around on it like it was some nice, flat field. The shale and loose rock that were covered in places with either hoarfrost or waist-deep snow were no challenge for these master mountain climbers. Since the days were short, we

had only six hours for shooting. Our first day was dark and gloomy as a storm front passed by, but it didn't stop us from climbing the hillside in our bulky snow boots and photographing the sheep. It just didn't provide us with killer light. The next morning started out the same way.

We had climbed up the old highway nearly to the top of the closest ridge when we saw some rams just below us. We stopped and watched for awhile. Then a ray of sunshine appeared and magically lit the ram just below us. It was magical as the light glanced over its white fur and lit up the hoar frost covering the rocks at its feet. I was so entranced I forgot one of my own rules, always look around! I must have photographed that ram in the sun for a good hour before I remembered to look around. We were all hooked into the scene below when I turned around.

Standing right over our shoulder, watching us photograph the ram below, was the biggest ram on the hill! I was speechless as this incredibly majestic creature stood there, perfectly perched on one single boulder, in a shaft of sunlight. It was the quintessential photo of a Dall sheep on a rock outcropping! And where was I? Mesmerized! The word, "Shoot!" was screaming in my mind, but I was frozen too long and the ram moved down from its perfect perch.

It was only then I swung into action, turning my camera around to focus on the magnificent critter in the ray of light. This is the photo I captured when I finally came to my senses. I had only shot a few frames when the magical light that had been with us for an hour disappeared.

I hate to admit it, but this was not the first time nor will it be the last time I missed a shot because I'm overwhelmed by the subject! Yeah, I could have had an incredibly killer shot here to dazzle you with (even though this one isn't too bad). For me though, it's not always about

capturing the image but more often, the experience. I can always go back and try to capture the same scene and, if I put in enough time, I bet I will with what I've learned. But more important to me was the experience. I want to tell the story, share it with others, and I want to go back. There's no way I can express in a photo how good the sun felt as we stood there at -10° F (-23° C) on that barren slope. I can't show you in the photo me busting my rear end up that slope with my gear to get in the best place to shoot. What I can hope to show you in one image is the magic and wonder these creatures possess to live in such a world and survive.

Bull Moose

Do you know what one photograph I want most that I still don't have after years of actively trying to capture it? A 60–inch-plus bull moose standing in fall color! This photo is as close I've come, but it's only a 50–inch bull.

Alaska grows the biggest moose, the biggest being just over 1700 pounds. I've been with this bull, he wears a collar and is part of the 30-year research project on moose. And while I've traveled to Maine, Wyoming, and Montana and for the last six years to Alaska, I've been skunked in getting the shot I have in my mind. That doesn't mean, though, that I've come away with nothing.

A good friend in Alaska is also a moose fanatic (the four-legged kind). He has shared with me a number of locales, all in the pursuit of finding the big bull. On this occasion he took me, my assistant, and my good friend John on a hike to capture the shot.

We had climbed a short ridge and were staring over a big valley just outside Anchorage. Way off in the distance amongst the green was what appeared to be a sheet of plywood. When we glassed the bright object, we saw it was a big bull moose that had just shed its velvet. Off we walked in our hip boots, carrying gear over our shoulders. (We were wear-

Mammal Tales: Combining it all in the Field

Moose.
Photo captured by D1H, 300mm f/2.8D ED-IF AF-S II, on Lexar digital film.

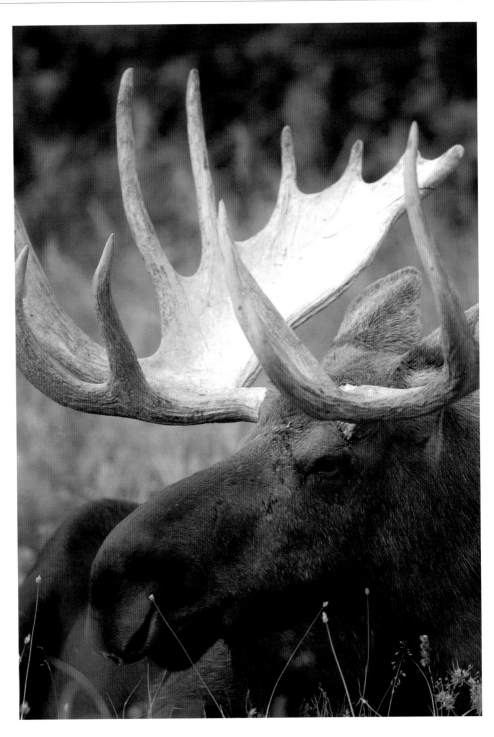

ing hip boots because of the mud we had to go through. At one point, my assistant disappeared up to her thighs in the muck!)

The walk down to the bull was gorgeous! The tundra in the fall was ablaze with reds, mostly from the blueberry bushes. Note I said down, and we had to walk down just over three miles to

where we saw the bull moose (which meant that we would have to walk back up and out in the dark when we were done). As we went down, we passed a number of cow moose as they grazed. We came upon a small bull moose, perhaps just a couple of years old, whose antlers were still wrapped in velvet. After what seemed like a hop, skip, and a jump, we were with the big bull.

There we stood in front of this magnificent giant of the wilderness as it slept! It lay amongst some shrubs, so we couldn't get a clean shot while it slept. So we put down our tripods and waited, and waited, and waited.

After awhile, we started to get a little bored so we started looking for other subjects. There were a number of cows nearby, so we focused on one of them. (We ended up counting 18 cows in the area.) With no notice or provocation, the bull rose and started to head away from us. We got off a couple of shots as it moved through the brush. Moose are to be respected all the time and this was rut time as well, so we kept our distance. The bull kept wandering off, and I figured that was it, all this way to see a sleeping bull. That would go with my luck in capturing the photograph I'm after. The bull traveled no more than 50 yards when it lay back down again! But this time it was out in the open, so off I went.

When it comes to moose, I have a bad habit of throwing caution to the wind, so I started to move in on the bull. In fact, I was probably closer than common sense dictated, because my partners weren't having any of it at first. I slowly moved in on the bull. When its ears went back, I would stop and wait until they came forward again, then I would slowly move up. It didn't take long until I was right where I wanted to be to capture this image. I shot it vertically then horizontally with the 300mm f/2.8. After getting what I wanted, I switched to the 24-85mm and started to photograph the overall scene. About this time, John and my assistant Laurie joined me. It was quite an experience to be just 15 feet away from this giant!

But another season has come and gone and, once again, I don't have the shot I want. This means that next fall I'll have to travel to Alaska to see if I can't meet up with my "cousin" and get that shot that's eluded me!

Musk Ox

This was a long-time dream come true!

One of the great blessings of being a wildlife photographer is all the other wildlife photographers who become friends. One such friend has a family lodge on the "haul road" in Alaska. Not too far south of the Arctic Ocean, the lodge is right in prime musk ox habitat. A unique critter of the north, the musk ox is a mammal I have long wanted to see, learn about, and photograph. That dream came true one April.

Musk ox are not big creatures, more the size of goats than cattle but with tons of hair. In fact, when you look at their hindquarters, you can see how "cousin It" from the television show The Addams Family got his look. These creatures live in an incredibly beautiful, austere world during most of the year. When winter comes, the land is a frozen landscape with virtually no plant life to be found. Yet they can literally scrape enough from the earth to survive. They're probably best known for the defensive circles that they form to protect their young from predators, and I was up on this trip to photograph the newborn calves.

It's not until you've driven the "haul road" from Fairbanks that you will truly appreciate just how far north, how barren, and how spectacular the Arctic region is! While you pass herds of caribou, groups of Dall sheep, and giant flocks of willow ptarmigan, with a red fox here and there on your journey, the landscape is a white blanket stretching farther than your imagination!

Our adventure was near the end of winter, so the temperature was a warm -30°F (-34°C). Photographically, working in this environment is not really that difficult. As long as you've dressed to stay warm and comfortable while being able to still function, your equipment will work right along with you. I had no equipment problems at all because of the cold. But I did have my first-ever equipment problem when I was taking this photo.

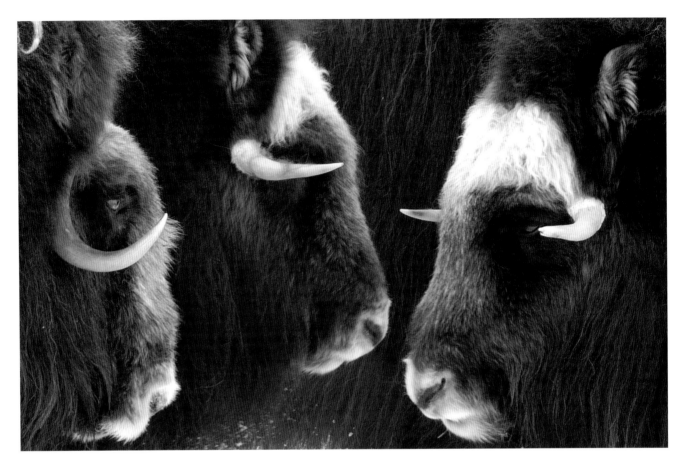

Musk Ox.
Photo captured by D1H,
400mm f/2.8D ED-IF AF-S,
on Lexar digital film.

I was out on the third day with the herd when the wind and snow came up. The snow blowing by horizontally was piling up on my side, the sides of the musk ox, and the inside of the lens shade. I tried to keep the snow buildup inside the shade to a minimum, but to be honest with you, my mind was on the musk ox. In this really horrible weather, they went on with life just as if it were a sunny day. This included the usual herd dynamics of bulls and cows. The herd's two lead bulls were constantly messing with the cows, stirring things up.

The very dramatic dark and light colors of the musk ox pelt were a constant subject for me. The design patterns were continually a photograph to be captured. This photo came about when the bull started to push one of the three cows from behind (the one on the right). It was right then when she looked up at the other cow as if to say, "Make him go away!" I was fortunately looking through the viewfinder when it all lined up and I

captured three frames. Shooting in the incredible wind at 1/30, I was hoping what I captured was sharp.

Moments later, I checked my front element again only to find quite a buildup of snow. In fact, it had gotten to be so bad that the wind had forced some moisture behind the front element! This was literally the first time I had an equipment problem from weather. The lens had to go to repair when I got back home, but it was more than worth it! We didn't get to photograph the calves, they were born just a day after we left, but I did get to start living a lifelong dream. I came back with over 3,000 images of musk ox but I haven't even started to capture everything I'd like to communicate about them on film. Darn, just means I have to go back!

Arctic Ground Squirrel
This was supposed to be a big, big bull moose. Can't you tell?

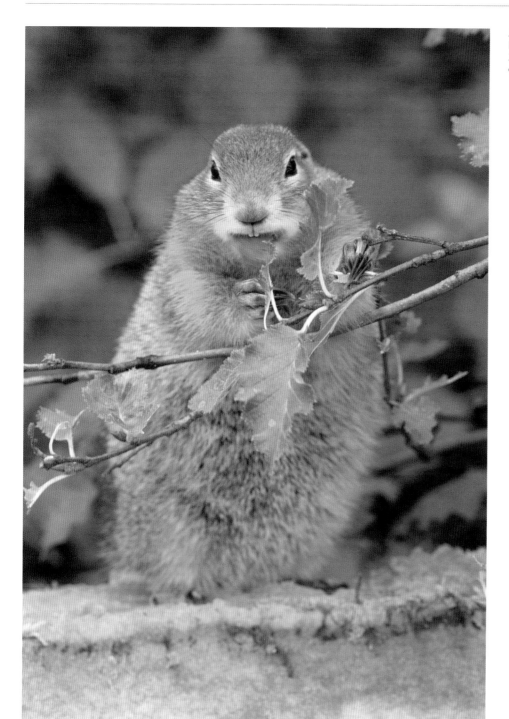

Arctic Ground Squirrel.
Photo captured by D1H,
300mm f/2.8D ED-IF AF-S II,
on Lexar digital film.

We had flown into the base of a glacier in Alaska one fall to photograph these monster bull moose. I mean monsters! We had seen them the year before when out scouting by air and we saw them when we flew in this trip. Big, beautiful, monster bulls in the most picture-perfect setting. And there was not just one but many, along with cows and grizzly bears. It was the Shangri-La of moose photography! To say I was excited is an understatement. Remember, I don't have that big bull moose shot!

Camping at the base of a glacier is worth the experience! To hear that thing moan and groan and feel the cool breeze that swats off the bugs is quite an adventure. Once we were on the ground, plane unloaded and the camp set up, we started

to explore ways of getting to the moose. Our first runway was overgrown so we couldn't put down on it or get really close to the moose as we planned. It became apparent after a few hours that there was no possible way to get close to the moose. The bushes and shrubs were so thick that taking a step forward meant losing a piece of clothing or skin. If we had proceeded, we would have ended up in front of the moose buck naked! So now that we had three days to kill, what to photograph?

The next morning I went out for a walk, only to find fresh moose tracks literally right behind our tent. A moose had walked up during the night to the camp within feet of our tent. Talk about insult added to injury! Well, I guessed if we couldn't get to the moose, maybe we could get them to come to us. Our guide started calling for the moose but after a good part of a morning spent calling, nothing. Oh brother, can wildlife ever be a pain in the rear!

After lunch we started to explore with our cameras. We walked up to the old mine buildings that are not too far away to see what might be up there. We were halfway through the buildings when a movement caught my attention. I stopped and saw an Arctic ground squirrel popping out to grab some berries to eat. He turned out not to be too friendly, so we wandered on after a while.

It wasn't too much longer when we saw another squirrel. This one was on the move, he had a mission. We slowly walked behind him as he darted in and out of shrubs, burrows, and mine debris. Finally, he ducked into a pipe that was partially hidden under a shrub.

There must have been a hole in the middle of the pipe because, while we were watching the two ends, he suddenly appeared atop the pipe right in front of us. You can see the pipe, it's what he is standing on in the photo. It doesn't look like a pipe, does it? It's covered in asbestos and lichens, and the combination fools most

into thinking it's a fallen birch tree rather than an old pipe.

We watched the squirrel and photographed him as he ran back and forth, foraging. We were just about to move on when he stood up on the pipe right in front of us and grabbed a branch and started munching on it. It was one of those really cute shots that are real money-makers. The squirrel just kept eating his meal while the shutter ripped away.

I didn't come back from this adventure with any moose images, not a one, again! What I did come back with, though, is an image that will probably make me a whole lot more money. More importantly, it illustrates how a subject doesn't have to be physically big or grand to capture my attention. This little squirrel atop his pipe was a winner to me!

Northern Fur Seal
The really funny thing about this photo is the very next frame. These two northern fur seals are standing next to each other as happy as can be!

There were times on St. Paul Island (which lies off the coast of Nova Scotia) when we just didn't want to hassle with the winds, overcast, and moisture. It just wears on you, when you've been on the island for three weeks. When these times came up, we would get our permit and head over to the blinds overlooking the seal rookery. Once nearly hunted to extinction, the seals have made a slow but gradual return. One of their big areas for coming ashore and birthing is St. Paul Island.

The blinds were in place so we could watch the seals without causing them undue stress. This was done even though on some places on the island the males are so numerous they blocked the trails. They were so large and aggressive that at times we couldn't proceed on the trail because they were blocking it. Once you got up to the blind, which

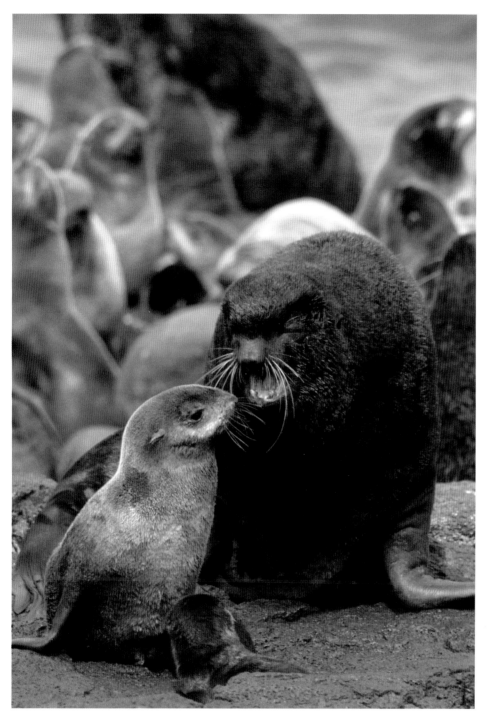

**Northern Fur Seal.
Photo captured by F5,
600mm f/4D ED-IF AF-S,
on Agfa RSX 100.**

was no more than sheets of plywood with holes, the activity on the other side was quite an eyeful!

The big males jealously guarded their own little stretch of rocky beach front. Battle was a constant event between bulls who didn't like the look of each other. In the midst of all of this were the very small females, mostly on shore to give birth. God help any females or pups that got between two battling males because they would not be seen, just smothered, sometimes to death.

Now it's really hard to tell in this photo, but the male is trying to win the heart of this female. His approach isn't on the warm or gentle side but quite the opposite, it's quite loud and pushy. I was

always curious just what the male was yelling in the ear of the female because like I mentioned, heartbeats later they were best of friends. Those moments, though, when the male is being a bully are tense ones for the female. In this case, you can barely see the newborn pup under the front of the female. In her attempt to backup and away from the aggressive male, she walks over her own pup. No harm came to the pup this time, but it sure does seem a hard, early lesson in life.

One of the keys to shooting in the harem was really low contrast. This required either the sun to be really low on the horizon or an overcast day. Since on St. Paul there is no shortage of overcast light, that was what we ended up with most of the time. The other requirement was a strong stomach; it wasn't the most pleasant-smelling place.

Once past all of that, one could stand for hours and watch the commotion. Photographically, there were subjects upon subjects upon subjects at any given moment. Part of the trick of capturing an image was to find a good-looking animal and then follow it. You knew you were bound to have a photographic opportunity in a relatively short time. While all seemed like chaos, life was going on as normal.

San Joaquin Kit Fox

I am the luckiest wildlife photographer! Let me tell you why.

I've worked with biologists since the very first day I started photographing wildlife. It is something I continue to do today for all the reasons I've mentioned over and over again in this book. But this photograph, like so many in my files, only came to be because of my working relationships with biologists. I've shared with you images captured in some of the most remote and romantic wilderness North America has to offer, but the locale for this photo couldn't have been any further from wilderness!

In the heart of Bakersfield, California, lives a thriving population of San Joaquin kit fox, an endangered species I've worked with for nearly two decades. Any follower of my images knows of the countless images and stories I've told about these foxes the size of house cats. The passion I have for them has taken me to many places, but I had never before sunk this low, literally, to capture this picture.

Throughout the housing developments of Bakersfield are sumps, large holes 20 to 25 feet (6 to 7.5 m) deep, the size of four average residential lots. They collect the surface water and keep the homes, which are built in a flood plain, dry. The sumps are usually filled with old storm water at their bottoms, along with all the crud humanity discards in all the wrong ways. But what appears and smells bad to us humans creates the perfect, safe environment for natal kit fox dens. Many of the sumps are populated in this manner. Behind locked, wire fences with nice sandy slopes inside are nearly textbook-perfect natal den habitats. The foxes, being incredibly smart, have figured out how to sneak in and out of their little islands of solitude and through the housing developments to find food to bring back to their pups.

The female (or vixen) at this den site was an old friend of mine. I had photographed her a number of years back when she was just a pup. Now it was her turn to be a mom as well as part of a biologist's study of urban kit foxes. If you look really closely, you can see the collar with telemetry antenna that she's wearing so the biologist can track her nightly movements. It was this telemetry that gave me the information that put me in the bottom of a sump 15 feet away from the den entrance.

There I sat in the sump, an inch of water and mud at my feet, in the 100°F (38°C) heat of a beautiful summer's day (I won't mention the choking smog). The first day I was there, I saw the male and female but only heard the sounds of the pups inside the den. I shot some images,

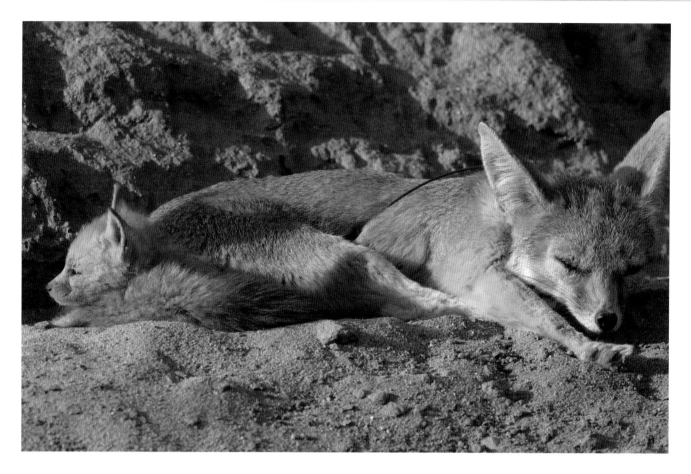

but more importantly, I let the parents get used to my being there. I wasn't in a blind but just sat out in the open on my old, favorite, lucky kit-fox chair . The kit foxes could see every movement I made, but being kit foxes and knowing my limits after spending years around me, they couldn't have cared less that I was there.

The next day I went through the locked gate, walked around the sump rim with my lens and chair in hand, and headed for the den site. I had no sooner sat down and focused on the den entrance when I saw a teeny-tiny set of eyes staring back at me. These pups had not yet emerged for the first time from the den and were no more than four weeks old. I swear, my heart stopped for a second as the thought crossed my mind that I might be present when the pups first emerged. No sooner had my heart started to beat again than the first pup emerged. I just watched, careful not to make any fast movements or noise. I didn't take a photo.

I was rewarded, because in no time all four pups were out for their first glimpses of the world. I have always wondered what they thought when they got their first look at a new world that included this big guy pointing a lens at them. Whatever it was, their only thoughts after that were about exploration and playing. The first time the shutter went off, the pups froze in their tracks and just stared at me. But within minutes they didn't even notice the shutter, which was flying, I can tell you.

It was near the end of their first day out, as the last light was skimming the sky, that the image that has to be one of my all-time favorites appeared. Two of the pups were still outside playing. Mom was tired and lay down out of the way of the playing. She had no sooner lain down and curled her tail around her than one of the pups came over and lay down inside her tail. The pup looked around, looked at me, and then went to sleep.

San Joaquin Kit Fox.
Photo captured by D1,
400mm f/2.8D ED-IF AF-S,
on Lexar digital film.

187

There are many rewards in wildlife photography and most put capturing the image and monetary rewards at the top of that list. Granted, these are nice but they are fleeting; I'm talking from experience. But one reward that sticks with you forever, to which no price tag can be attached, is the moment a wild creature so accepts you that it ignores you and goes on about its life as if you don't exist. I've been very fortunate that this has happened to me many, many times. But to have this happen with a critter's young present, so close and so vulnerable, is a reward that can't be described in words!

A Last Word from the Moose

My photographs this day were the first ever taken of such young San Joaquin kit fox pups out of the den. Shooting digitally, I was able that night to e-mail them to biologists around the country so they, too, could share in the excitement. This illustrates the magic that digital wildlife photography has in store for all those willing to take up the challenge to follow their heart!

That's what is waiting for you right outside your door if you go out and look for it, I guarantee it! It's waiting for you and your imagination, passion, and skill as a communicator. Wildlife photography is an experience, a lifelong experience meant for anyone who takes up the challenge to seek it. The images you see here in this book or anywhere else for that matter can just as easily be your own, the ones you captured. Don't let anyone convince you otherwise! Each and every one of you can take the knowledge of biology and techniques I've described here, build on them, and be as successful as your imagination will allow. And once you understand that the greatest unspoken "trick" to wildlife photography is no more than time, time spent in the field watching, learning, and loving what you see, you'll have all the tools to be successful. Take it from one very blessed photographer, the rewards are well worth the effort!

I wish you a lifetime behind the camera, following your passions and capturing your imagination on film, be it digital or conventional!

Dall Sheep.
Photo captured by D1,
600mm f/4 AF-S,
on Lexar digital film.

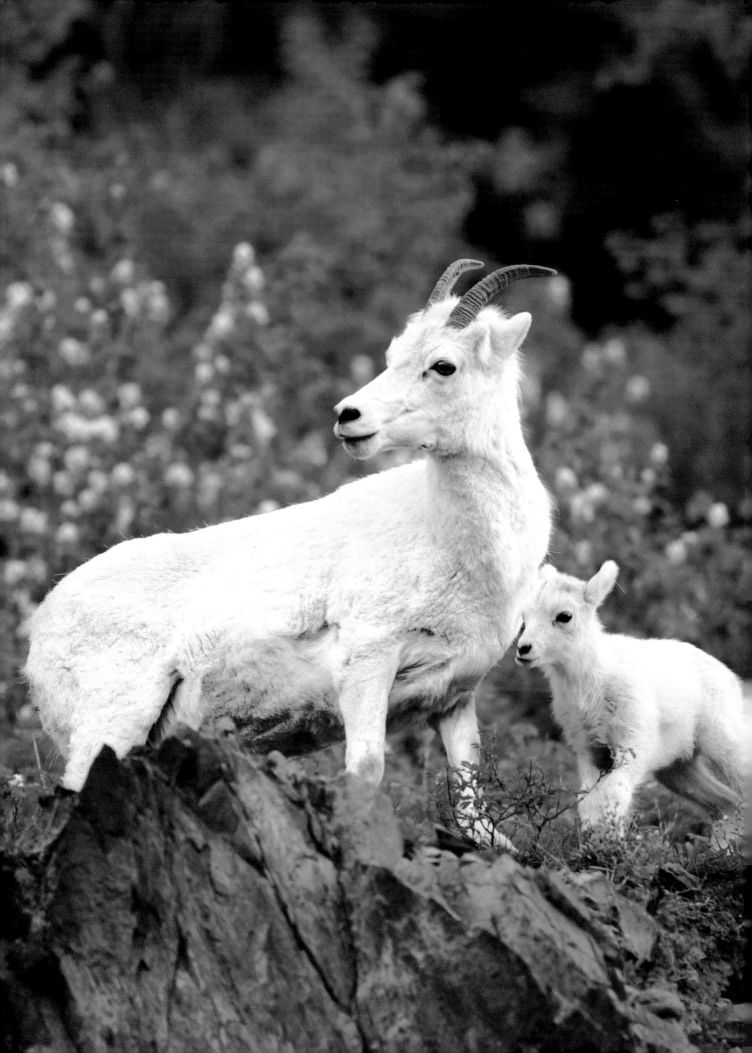

Resources and Equipment

Awards and Seminars

John Muir Conservation Award
John Muir Memorial Association
(JMMA)
PO Box 2433
Martinez, CA 94553
(925) 229-3857
www.johnmuir.org/martinez

Walk Softly Seminars
Wildlife Research Photography
PO Box 3628
Mammoth Lakes, CA 93546
(760) 924-8632
www.moose395.net

Books

Sibley Guide to Birds
by David Allen Sibley (Knopf, 2000)

National Geographic Field Guide to the Birds of North America (National Geographic, 2000)

A Guide to the Nests, Eggs and Nestlings of North American Birds
by Colin J.O. Harrison (Academic Press, 1977)

The D1 Generation by David Cardinal and B. Moose Peterson (Moose Press, 2001)

The Focal Encyclopedia of Photography Third Edition, by Richard Zakia and Leslie Stroebel (Focal Press, 1993)

Equipment

Better Beamer
Arthur Morris/Birds as Art
805 Granada Drive
PO Box 7245
Indian Lake Estates, FL 33855
(863) 692-0906
www.birdsasart.com

Canon Equipment
Canon USA, Inc.
(800) OK-CANON
www.canon.com

CompactFlash Cards
Lexar Media
www.digitalfilm.com

DigitalPro Products:
Image Management Software,
MP1 Backpack, MP3 Fanny Pack
Wildlife Research Photography
PO Box 3628
Mammoth Lakes, CA 93546
(760) 924-8632
www.moose395.net

Eclipse Sensor Cleaner
Photographic Solutions, Inc.
PO Box 135
Onset, MA 02558
(800) 637-3212
www.photosol.com

Floating Blind
Cabela's, Inc.
One Cabela Drive
Sidney, NE 69160
(800) 237-4444
www.cabelas.com

Gitzo Tripods
Bogen Photo Corp
565E Crescent Avenue
Ramsey, NJ 07446-0506
(201) 818-9500
www.bogenphoto.com

Kenko Extension Tubes and
Tokina Equipment
THK Photo Products, Inc.
2360 Mira Mar Avenue
Long Beach, CA 90815
(800) 421-1141
www.thkphoto.com

Lens Clens
General Production Services
883 S. East Street
Anaheim, CA 92805-5356
(714) 535-2271
www.lensclens.com

Moose Filter
Wildlife Research Photography
PO Box 3628
Mammoth Lakes, CA 93546
(760) 924-8632
www.moose395.net/gear/moosefltr.html

Mounting Plates
Really Right Stuff
PO Box 6531
Los Osos, CA 93412
(805) 528-6321 or (800) 777-5557
www.reallyrightstuff.com

Multi-Purpose Window Mount
and Beanbag
Kirk Enterprises
333 Hoosier Dr
Angola IN 46703-9336
(800) 626-5074
www.kirkphoto.com

Nikon Equipment
Nikon USA
1300 Walt Whitman Road
Melville, NY 11747
(800) NIKON-US
www.nikon.com

Pocket Wizard WaveSensor
Mamiya America Corporation
8 Westchester Plaza
Elmsford, NY 10523
(914) 347-3300
www.pocketwizard.com

PowerEx 1800ah NiMH
rechargeable batteries
Maha Energy Corporation
1647 Yeager Avenue
La Verne, CA 91750
(800) 376-9992
www.mahaenergy.com

Rue Ultimate Blind and Pocket Blind
L.L. Rue
138 Millbrook Road
Blairstown, NJ 07825-9534
(800) 734-2568
www.rue.com/equip.html

Sigma Lenses
Sigma Corporation of America
15 Fleetwood Court
Ronkonkoma, NY 11779
(631) 585-1144
www.sigmaphoto.com

Sto-Fen Omni-Bounce
Sto-Fen Products
P.O.Box 7609
Santa Cruz, CA 95061
(831) 427-0235 or (800) 538-0730
www.stofen.com

Tamron Lenses
Tamron USA, Inc.
10 Austin Blvd.
Commack, NY 11725
(631) 858-8400
www.tamron.com

Wiha Screwdriver set
Micro Tools
a division of Fargo Enterprises, Inc.
P.O. Box 6505
301 County Airport Rd #105
Vacaville, CA 95696-6505
(707) 446-1120
www.micro-tools.com

Wimberley Flash Arm
Wimberley
974 Baker Lane
Winchester, VA 22603
(888) 665-2746
www.tripodhead.com

Index